The
*Fearless
Spectator*

The Fearless Spectator

Being a Collection of
Original Observations and
Profound Pronouncements
by *Charles McCabe* ESQ

Chronicle Books
San Francisco

*F*or Mary, Peter
Nini, and Beetle.

Copyright 1970 by Charles McCabe

Library of Congress Card No. 78-133452

Printed in the United States of America

Designed by Wolfgang Lederer

10 9 8 7 6 5 4 3 2

Contents

3. Booze

4. Youth

5. Personages

6. Women

7. Love

8. English

Introduction

The reflections, mutterings and exhortations which compose this book are part of one man's search for himself. Necessarily they are also a part of my search for my fellows. This search has been, I should say, the most enjoyable part of my life.

"No matter how much we seek, we never find anything but ourselves," said Anatole France.

The search sometimes threatens to become a solemn matter. When this threatens, it becomes necessary to tell people that I am not the law and the prophets.

It must be duly noted that the views expressed in the following causeries are not graven into marble tablets. They are just the opinions, of a given morning, of a decidedly fallible man.

I not only have to tell this to people, from time to time. More important, perhaps, I have to tell it to myself.

There is a real danger of being carried away when you are given wide latitude of expression in a daily newspaper. It is too easy to slip out of your soiled Levis into the senatorial toga. The difference between being full of common sense and full of what makes the grass grow is not so slight that it can go without permanent scrutiny.

So I cannot too often harp on the fact that what I deal in largely is a single commodity: opinion. This generalized opinion is the mass of my personal opinions, and my personal opinions are simply myself. Everything that has gone into forming my life has gone into forming my opinions.

My views on almost any given subject are unquestionably tied up with the fact that I was a poor kid in New York City, that I grew up in the Depression, that I like baseball, that I hate authority, that I was for years an altar boy and couldn't stand it, that I had a dominant mother.

A man's opinions are his emotional signature. A lot of

these opinions and beliefs are the product of received wisdom and Revealed Wisdom. It is my pride, and perhaps my folly, to believe that more of my opinions come out of my nature than out of wisdom, whether received or Revealed.

My written opinions have caused me joy and also trouble. I have received letters which would burn the mail off a medieval stalwart, and others which have moved me to tears. Neither has greatly surprised me, because when you offer your opinions freely, you become public property in a way. It's a kind of intellectual strip tease. You are rewarded by the cheers, and you pay for it by the boos.

Yet the letters which have been inspired by my newspaper writings have been priceless. They have been the major educational influence in my life. Opinions thrown on the water are returned manifold. Out of one thing grows another, in a kind of symbiotic way.

So I wish to express my acknowledgment to all those folk who have written me from time to time to express anything from total hostility to warm affection. None of these letters have left me unaffected, and many of them have caused me to grow. My debt to them, in the little pieces which follow, can only be known by me; but it is considerable.

On the whole, I see the merit of the sour view taken by Samuel Butler of public opinion: "The public buys its opinions as it buys its meat, or takes in its milk, on the principle that it is cheaper to do this than to keep a cow. So it is, but the milk is more likely to be watered."

But there is another public, too, as I have learned. These people are as opinionated as I am, because they have found that great treasure in life, the ability to be themselves. It is a pleasure to write for these people, and an even greater pleasure to hear from them.

Finally, my opinions have brought me many good friends, and you cannot say a better thing than that about anything. You may find these offerings either a feast or a famine. In either case, bon appetit.

<div align="right">CHARLES McCABE</div>

I.

Ego

*Being autobiographical
oddments of interest
to the author and,
hopefully, others.*

Shower Folks, Tub People

*J*ust as there are morning people and night people, there are shower folk and tub people.

I throw my lot in with the tub people.

I am convinced that people who slosh around in a big tub of water, lazily playing games with soaps and washcloths and toy boats are more civilized, more scholarly, and more privy to the secrets of life than the laddies who stand under a shower, and run.

Naturally, the shower sector does not agree. They take their aberration seriously. They are of the view that tub people simply marinate themselves in their own dirt, and that the pores cannot be properly unclogged unless they are assaulted by those thousands of morning pinpoints of water.

There is a puritanical streak in the shower man. Most of them tend to start out tepid, or even hot, and to end up freezing cold, in some obscure immolation.

Also, they talk. The shower man is constantly explaining his techniques and his pleasures. I've heard 'em at it. You know all this talk is hiding some basic insecurity.

Your true tub man or woman is poised. We know that bathing is not a grubby little ritual of cleansing, but a part, and a most important part, of life. We don't talk.

We go into a tub to edit our life. Here it is that the galling frustrations, the insensate demands of existence are laved away. The whole idiotic show begins to fall into place, as we roll about lazily in the water.

I think it entirely likely that the pleasure tub people have comes from the association of tubs and bathwater with the wonderful carefree days before birth, when the child rocks about lusciously in the fluids of its mother's body. All problems were solved then.

I will not get into the footless argument about which makes you cleaner: tub or shower. The cleansing action of the bath

on the body is really a minor matter, compared with the cleansing effect on the mind and spirit. Dirt passes. Scrutiny of the verities is eternal.

The time you spend in the water depends on your basic security, as I indicated, and your freedom from guilt. If I'm at peace with the world, I give myself ten minutes. If harassed by the sad comedy, five. On certain memorable occasions when I feel myself bigger than life, even, I go for twenty.

On the theory that one should put one's self in the enemy's place, and see how the other half lives, and be fair to the opposition, what? and all that, I took showers instead of tubs for a couple of weeks.

Like most such sorties into hostile territory, the experience merely hardened me in my belief that there is something wrong with those who shower and run, and something supremely felicitous about those who wallow and rise above it all.

My two weeks under the shower made me more of a nervous wreck than usual. It is no exaggeration to state that it wrought some kind of personality change. Partly this was due, no doubt, to withdrawal symptoms. You do not abandon a long-time habit without paying for it in psychic pangs.

But there is more to it than this. You cannot, for one thing, think under a shower. This may be why they are so popular in this country. The average American is a shower cat. And thinking, in our fair land, is less popular than bank robbery.

You would think that not thinking would placate the old nervous system. It doesn't seem to work that way. I need a spot of thinking—in, and not under, water—to order the quiet frenzy of my existence. So it's back to that human hog wallow, the bathtub.

Ah, it just came to me. What most bugged me during those daring two weeks under the shower. I was beginning to feel like a nice, clean American fella. And this is a fate I've been trying to avoid throughout the course of my life.

4

Of Gallowglasses

I've never been a great one for probing into my ancestry. It is sufficient for me, more or less, that I am here, that I knew my father and my mother and that I respected them.

Beyond that, the vast deeps of time are just as well left to themselves, and the primal ooze is a subject for the geologist, not the family historian.

I am perfectly willing, for simplicity's sake, to acknowledge that I am a descendant of Adam and Eve, and am therefore brother to you, and you, and you.

(My children, as a matter of fact, have among their cousins a pair of twins who live in East Texas, and who bear the resounding names of Adam and Eve.)

Yet it was not without interest that I read some poop on the McCabe family recently collated by Reg Willis, the heraldic artist.

This researcher says that I, and all the rest of the McCabes, am descended from a medieval tribe of gallowglasses.

It came as a bit of a blow to me to learn that our ancient family was originally from the Western Isles of Scotland, although of Gaelic origin. The Scottish connection was always stoutly doubted by my father, who said he wouldn't be caught in the same room with a Scot if he could avoid it.

The McCabes, like most of the families of the Scottish highlands, claim descent from the Irish adventurers under the leadership of King Ferdus who established the kingdom of Dalraida in the west of Scotland at the opening of the sixth century.

In Scotland they earned a great reputation as fighting men. The family coat of arms shows most prominently a helmet of mail.

Also on the coat are three fishes, perhaps to commemorate the fact that the early McCabes did an amount of commuting between the Scottish Isles and Ireland.

The family returned to Ireland from the West of Scotland about 1350. They came as gallowglasses.

This is an Irish term for a foreigner hired as a fighting man. In those days it was the custom of the great Irish chiefs to hire mercenary soldiers, often from Scotland, just as the British hired Hessians to fight in our Revolutionary War, and African governments today hire foreigners, including many Irishmen, to do battle for them.

In due time, the McCabes came to be accepted as Irish, and their home was reckoned to be in counties Cavan and Monaghan.

My father was born in Cavan, in the pretty little village of Ballyjamesduff-down-in-the-Mud.

I visited that town a few years back, accompanied by a friend. There was no doubt as to who lived there. The main street showed virtually the butcher, baker and candlestick-maker as McCabes.

There were several pubs bearing the ancient name of the men who fought other people's battles, for pay. We went into the nearest one.

My friend caught it first. "My God!" she exclaimed.

I caught it, too. The youth behind the bar was about 17 years old, black of hair and brown of eye, slender and just about six feet tall.

He was, in fact, an identical twin of my oldest son.

We had a couple of pints and parlayed with the young fellow. He was most agreeable and well up on the history of his town, and yes, there were quite a few McCabes around who were cousins of his and looked quite like him.

I gave him the few clues I had as to where my grandfather might have lived. He suggested a couple of roads.

When we got outside it was raining. I decided to leave my ancestors for another day and proceed on to Galway. As we drove past the pretty pastel buildings I thought of the biological persistence of the McCabe strain. I thought, too, of having fighting blood. I thanked the McCabes for having been paid for their bellicosity. This is more than you can say for most of their countrymen.

Start of it All

Brother Patrick was a big, burly Irishman. He wore the black cassock and white jabot of a Christian Brother, of the De La Salle branch. He was president of Manhattan College, the order's institution of higher learning in New York City.

Brother Patrick was livid, as he strode up and down the quadrangle. Nothing like this had ever happened in the history of the quiet college.

In his left hand he held a wad of copies of "The Quadrangle," the student weekly publication. He was not distributing them; he was *collecting* them. When he saw a student or a teacher with a copy of the publication in his hand, he summarily snatched it away.

Later on, he burned them. For reasons sufficient to the educator, he wanted to extirpate that particular issue of the paper.

This was the very first issue on which one Charles McCabe served as managing editor. As managing editor, he appointed himself a columnist, which is what he wanted to be in the first place. Columnists were big in those days—much bigger than they are today.

As a columnist I wanted to make a big splash with my first effort. I decided to do a hatchet job on Alfred E. Smith, who in 1936 was perhaps the most respected Catholic layman in the country.

Smith was a love-gone-sour for me. In 1928 he had run for President: brown derby, calling it the "raddio," and saying cheerful words about the restoration of the Demon Rum, then prohibited in this country. He lost big.

But lately old Al had turned up in strange company— a collection of highly conservative old birds who called themselves The Liberty League, and opposed the efforts of President Roosevelt to aid the anti-Nazi cause in Europe. This was bad hat, in the view of most bright young men of the time. We

thought the less of Mr. Smith for his association with these fellows.

So, for my first column, I brought out my blunderbuss and uttered a furibund piece called "The Oligarch of Oliver Street." Oliver street was the lower East Side birthplace of Al.

It was a furious and infuriating piece. I thought it would make waves. I could not have predicted what kind or how many.

For what I did not know, and what I don't believe the faculty adviser of the weekly knew, was how great a friend to the college Mr. Smith was.

I was to learn later, and in no uncertain terms, that Mr. Smith had just made a large bequest to the college; that he was thinking of endowing and of fixing his name to an electrical engineering building, and that he had—also recently—used his political influence to divert a road the State had scheduled to go right through the college athletic field.

For neither the first nor the last time in my life, I had opened my big mouth at precisely the right time to have kept it closed tight.

Yet that column changed the course of my life. The presidential suppression of the entire issue naturally made the New York dailies.

The next day came a telegram from Mr. E. D. Coblentz, a transplanted San Franciscan who was publisher of Hearst's New York American. Mr. Coblentz asked if I was interested in a job on his paper. Was I interested in going to Heaven?

Forthwith I got myself down to the East River offices of the paper. I had a few minutes with Mr. Coblentz, and rather a longer time with his editor, Mr. Arthur Brisbane—a sober old dog who hired me in a ceremony something like the laying on of hands.

I stayed with The American until it folded, about a year later. I had not intended to offend Brother Patrick personally; but I came to be quite glad I had written that piece about Mr. Smith. (I don't think he ever did come through with the dough for that engineering lab.)

The Decline of Everything

\mathcal{D}uroy was promoted to the rank of staff columnist of the Vie Francaise, but as he found very great difficulty in discovering ideas for his articles, he specialized in denunciations of the decadence of contemporary morals, the lowering of the standards of conduct, the decay of patriotic feeling, and the anemia of French honor.

Duroy was the central and unlovely character of de Maupassant's tale, Bel-ami.

It cannot escape the careful reader of newspapers that the Duroys of the world, far from disappearing, have vastly proliferated since the days of de Maupassant.

"Weepers," as they are sometimes called in the trade, are with us everywhere, viewing with alarm and pointing with scorn, and worrying, often, about the length of people's hair and whether they are clean or not.

There is never a columnist who can wholly get away from fake piety; or if there is, I've never read him. We are all human, though there are some among our breed who are above acknowledging it.

We have quarrels and hangovers and moods of black depression and the boy comes into the hotel room when you are writing in spite of the "Don't Disturb" sign. You have your ups, and your downs. It is during the downs that you are tempted to take the way of easy moralizing, and sometimes succumb to the temptation. It's an easy way to do things. There are days when the easy thing is irresistible.

Of course, it is part of your honor to fight against this thing. I do this for a simple pragmatic reason: I feel like hell when I have not done my best. Deploring the decline of morals, just for the sake of deploring them, is not doing one's best.

My method is this. I work immediately on rising. Once I put down the lead of a piece, I always finish it. If I feel,

however, that I am not sufficiently gravid, that I am likely to end up sawing the air rather than saying something, then I simply go back to bed. I try to get another half-hour or hour of sleep.

Nearly always, on rising the second time, I feel ready to do battle with old typie. When it happens that I am not, I shall really begin to think I'm running out of gas.

The question most frequently asked of me, as a columnist writing five times a week, is where I get all the ideas for the work. This isn't the hard thing. Being Irish and garrulous, notions teem like maggots in my head. The problem is keeping up one's enthusiasm for them. The places where I work are filled with manila envelopes that contained something which was once, the germ of a column. When reviewed, the germs turn out to have been hit by DDT, or something.

As a general rule, if an idea stays hot for three days, it gets uttered as a column. If it isn't written in five days, that's about it, though I've carried some around in my head for years before excreting them.

I have a friend who says, "When I see you starting in on the Jesuits, or Catholic education in general, I know you have been having a bad morning." She is righter than I care to admit.

I should say that writing a column daily is just about as tough as hitting against good major-league pitching. You're doing very well indeed if you hit .300, which means you get the good wood on the thing maybe one time out of three. The rest of the time you're honestly trying, of course, since you are a professional; but there are a lot of professionals in the field who are bent on holding you down. There may one day be a boy in baseball who hits everything that is thrown at him. When that day comes, baseball will go.

If you think this column has been waffling because one feels a bit crapulent or something, you are wrong. It is a beautiful sunny morning, and I'm about to totter across the street for a pint of stout, and read the paper, and think about some of the people I love and look forward to seeing them, I hope soon.

That Was a Gone World

The paved streets of lower Harlem, in New York, were filled with the leavings of horses. In the White House was an intellectually constipated man called Silent Cal.

Far more important than this frail figure was a barrel-chested Irishman named McGraw, who managed the fortunes of the Giants up at the Polo Grounds, and was the biggest thing in the world except for the spindle-legged fellow named Ruth, who headquartered across the Harlem River.

Girls were something you had nothing to do with, ever. You squirmed on a Sunday when your mother put on a particularly pretty flowered hat, and marched you off to Mass. Al Capone went to jail regularly, to get out of range of the sawed-off shotguns of his former friends.

Beer and wine were unknown, except in speaks and blind pigs. You could get two Tootsie-Rolls for a penny from the old Jewish gent in the cellar down the stairs who wanted for his son to be a doctor, which of course he became.

Everybody, from Lucius Beebe down to me, was madly in love with Ina Claire, the leading comedienne of the time. Andrew Volstead, the man who thought up Prohibition, had to get an unlisted phone because indignant drunks berated him at all hours.

A quarter was a lot of money. That's what I got when I went off for school each day. A dime went for subway transport, to and fro. A dime went for lunch. The nickel either went for candy or a big soft pretzel or a hot dog, or it was saved until it became a dime and one snuck off to the glory of the warm, womblike local movie house. Here we saw a world we could never share, and loved it the more for that.

You could still get Moxie, though Coke was beginning to saturate the market. Gin was made in bathtubs with cut spirits and lashings of juniper elixir. A lot of juniper elixir was sold in the drug stores, in the 20's.

A Tammany leader watched fretfully a clubhouse meeting where all the women were madly cheering a natty young Greenwich Village lawyer who had just wowed 'em. This was Jimmie Walker, and he was out to become Mayor. The leader asked a friend: "Will this guy make a good mayor?" He was told: "Most likely not; but what a candidate!"

A guest at the Algonquin hotel asked a bellboy if he could get some bootleg gin. What flavor? asked the bellboy. Just plain gin, said the man. He was told the bootlegger had it in chocolate and raspberry. He chose raspberry.

There were gangs and gang fights all the time (mostly in Central Park) but the Irish, the Italians, the Jews, the Puerto Ricans and the Negroes of south Harlem (together with the old-line German burghers and their kids) got along as if they belonged to the same species, and accepted the fact.

It was great fun to come upon a rich kid in the park, and beat him up, and steal his wrist watch. I never knew quite who got the wrist watches in the end. I had to wait until I was 22 to own one and that came as a school prize.

Here Charles Lindbergh, the son of a fire-eating Congressman from Minnesota, married the daughter of a partner of J. P. Morgan, and the ladies of the Nation burped with glee.

The whores, we were told by our knowing elders, always said, "Not on the lips, dear." None of my friends, or his family, had a telephone. The only automobile was owned by the street bootlegger. That was, indeed, another world.

What Was it Like?

I suppose it was hell. It was the ebb tide of our national life. In the Civil War period, nearly everybody was at least DOING something—fighting the war, or producing its sinews.

I'm talking about the Depression of the Thirties. My daughter, who now goes to school in England, asked me, "What was it like?"

I lived through it, of course, and came of age just as we were getting out of it.

It was an eerie time. For me it was rather a limbo than a hell, if I were to be quite accurate. Unlike other men, I did not lose much. During the days of the Wall Street boom, my family was just about as poor as it was in the Depression, which was very poor indeed.

The Depression just added a quality of hopelessness to everything. Something inside you, the thing which should make a man of you, just quietly gave up. You knew you couldn't get a job, because there just weren't any around. The few that were around would go to experienced and qualified men, not to kids trying to start out.

Since I went to the movies a great deal when I should have been job-hunting, I suppose I must have had a little money, but I cannot remember where I came by it. There wasn't even much chance to steal, in those bleak days.

In any case the movies were what saved me. I would sit through dime double features in Times Square, and wonder about the splendid private lives that must be lived by Gable and Cagney and Joan Blondell. Warner Brothers meant more to me than Franklin D. Roosevelt, and he meant a great deal.

When the job-hunting started, one went down to the financial district, hoping to land as a runner or a stock clerk, or something.

But being rejected, and rejected, and rejected again was a grinding experience. You began to feel truly unworthy, and

this is not a nice feeling. With all the energy and optimism of youth, you still could not see that there was a slot for you in life.

So you gave up, and some little thing inside you broke, and you took to the movies, and you lied to your mother about your job-seeking, and you felt terrible about that because you had been taught that you did not lie to your mother.

To this day I feel simultaneously comfortable and guilty when I enter a movie house. I feel I am doing something sinful. In truth, in those dark days of my youth, I WAS doing something sinful. But I honestly did not feel I had any alternative.

The word boredom is not enough to describe the tone of such a life. Yet, since you hadn't known anything much better, you somehow stood it. One of the main reasons I knew I was having a rotten time was that the newspapers were constantly telling me so.

It was a sour and unlovely period, and I hope nothing like it ever hits the country again. Your dreams of grandeur and affluence could not be stopped, but there was nothing you could do about them.

Much of the time, of course, I was going to school, but I would gladly have left school if I had ever got a steady job. School was something like the movies. It kept your mind off your failure.

The summers were the worst time of all. The pressure to find *anything* to do to produce money was prodigious, and so was the market of kids who felt this way. The Depression did something bad to all of us. But, being human, we recovered from it, and were perhaps strengthened. I honestly wish I thought so.

Graduation Day

The other day I went to the graduation (is that not a lovely word! "to qualify or perfect one's self") of a young friend who is sluicing himself from the Cathedral School to the higher world of a place called Thacher.

He is one of those boys of whom it can confidently be said that he'll do all right. Being good at math and sciences, he is attuned to the world he will enter when he gets out of university.

I found the occasion rather a moving one. These Episcopal fellows do things well, what with Bach, and plainsong, and motets and the canticles of Wm. Boyce.

These boys were reminded by their headmaster, and by their dean, that they were receiving a religious education, and that one of the many glories of God was the existence of fully alive people—which tribe they were expected to join, fully, one of these days.

You believed it. I think the boys believed it. I surely hope so.

One thought back, of course, to one's own time of qualification and perfection, and of how ironically those words would have fallen on the ear in my time, and how in fact they do today.

I was qualified and perfected in 1929, a year in which excess and dishonesty capitulated before the way the world is. The world could take so much. That year began a part of American history as searing and as significant, if not more so, than what was set in motion at Fort Sumter.

For a decade, almost, these United States were in a kind of purgatory.

Purgatory, of course, is not all bad—"a place or state in which souls are after death purified from venial sins."

The cleansing, of course, is rough.

Men who broke their backs building skyscrapers were in the business of selling apples. Bright theoretical physicists

15

were working as clerks in the Automat, and considered damned bloody lucky.

The dime movies were the universal balm. You went in and listened to that marvelous con artist, FDR, tell you that everything was going to turn up roses if only you believed him, and believed him, and believed him. And most of us did.

The country was united in those days. We all wanted one thing: A job.

We often said, "I would do anything before I would go hungry." And we would have. And when we were saying it, we were hungry.

My family lived on the charity of the Paulist order of priests for more than a year. My mother accepted that charity on terms that were, at her level, quite awful. She was a good-looking woman, and the man who brought the weekly order of groceries from the priests perceived this fact early, and made his claims forcibly. Like, "Me or no food."

I was too young to know how she handled things like this, though I knew of them, because I had the big ears of all small children.

When an entire nation is poor, and much of it hungry, an extraordinary number of people are humiliated. Not once, not twice, but often.

It was bad enough being a kid then; but being the parents of kids must have been something else, as the kids now say.

The Depression was not merely an economic thing. Nothing economic is ever merely economic. The depression was a spiritual and emotional depression, of a deep and wounding kind.

I was going to say permanently wounding; but I have grown, as a journalist, to suspect large words, and especially that large word. Of course, it wasn't permanently wounding, or I could hardly write the words. When you are really wounded, you can never talk of it again.

And, you know, I would rather be entering that funny depressed world of mine when I was being qualified and perfected, than the world my young friend is on the threshold of. He has to deal with a world that has solved nearly all its problems, but its own nature—that final, and perhaps insoluble, problem.

Copyboy Days

When I was a copyboy on a New York newspaper, I used to think of it as a miserable job, largely because you never got to write anything, when all about you were writing.

I was cheered somewhat the other day, when reading a history of the British wire service, Press Association.

This outfit had a man named Mr. Cattermole, who was straight out of Dickens. He dressed the copyboys up in uniform, and relentlessly drilled them. He dispatched them on their errands with enormous solemnity, as if they were diplomatic couriers of Queen Victoria.

A "Boy's Admission and Discharge Book" from about this time reveals that one copyboy was sacked for being slow, another for taking a tube instead of a cab, and pocketing the tenpence difference, and a third for "making a noise in the editorial room."

Things weren't quite that bad in the '30s, when I broke in. Money was scarce. Any boy allowed to handle stamps almost had to be personally guaranteed by a bank or a bishop; but we didn't wear uniforms.

The worst thing about being a copyboy, aside from the frustration of waiting for the day you would be dubbed reporter, was the hazing.

Initiations, hazings, rites of passage—these are all, I am assured, part of the mysterious business of growing up.

The newspaper business, being peculiar in the first place, has rather peculiar initiation rites.

Or used to have. I've not been privy to the way kids are broken in for a couple of decades.

First, of course, you got hired. The hiring fella, usually a city editor, decided you were a budding literary genius, and then told you you would be given several years in which you would not be permitted to fulfill your promise.

Thus you became a copyboy, an office boy who ran copy from copywriter to desk to printing shop, and did other chores.

On my first day at work, the city editor sent me to a private telephone booth in the city room to "take an important story." Somebody on the other end of the line was dictating a story far too fast, spelling the names far too fast, and in general making it hell for me to understand what he was talking about.

I, being a copyboy, could not object to the great man, whoever he was, who had been dictating. Following the dictation I was sent on an extraordinary round of errands— to the ad department, to circulation, down to the trucker's headquarters, and even to the building cop, and the barber shop. They all seemed to find something amusing in my appearance. I attributed this to my ineptitude.

It was not until I got my goodnight from the desk, and went down to the Rain Barrel for a drink of beer, that I got a look at myself in the mirror. My right ear was coal black, from the printer's ink my hazers had put on the telephone receiver.

But my oppressors were not finished. The next day I was told that, at precisely 3 p.m., I would be assigned to go up to the roof, to "meet the carrier pigeons." These birds were dispatched each day from Floyd Bennett field, with hot news dispatches from all over.

When you reached the roof you were supposed to hold aloft a 20-foot long aluminum pole, until the lead pigeon came, when you manipulated the pole and a loop around the bird's neck, bringing down your quarry. And you MUST have the pole in the air at exactly 3 p.m.

Of course, there were no carrier pigeons. Just a dog-tired copyboy, who finally had to drop the pole from exhaustion. And there wasn't even anyone around to laugh at the joke. You felt a proper fool.

And how did I handle that unintelligible "important story" of the day before? I couldn't make head or tale of my notes. My eye, however, fell on the same story in The Sun. I rewrote it, changing a few words. I learned *something* that first day.

Breaking The News

I cannot recall for sure what my first newspaper assignment was. Most likely it was to put a drunken police reporter in a cab, and try to make sure he could get home safely, sleep it off, and make it to Mass on Sunday.

The one I think of as my first happened in the early days of my employment by a Hearst newspaper in New York. It remains memorable to me for many reasons, including that it was my true baptism into this loony craft.

The paper I worked for had its offices on the East River, in the lower part of New York. It was organized like many institutions of that time—the two city editors were Irishmen named Ryan and Dunn, the managing editor was the son of a Russian Jewish immigrant, the publisher was a former Socialist named Arthur Brisbane, and the owner was a blue-eyed Renaissance prince, who happened to be a WASP named W. R. Hearst.

I was working out of the Bergen street police headquarters in Brooklyn—a place that smelled of sweat and whiskey and lysol. The guys all seemed middle-aged to me (maybe 35 and up) and you had been warned beforehand never to show zeal, which was as unpopular in this fetid room as it had been earlier in the offices of the Duc de Talleyrand.

About 2 p.m. of a hot summer's day I tore a slip off the police message machines. This is where most police stories originate. They register just about everything that requires action by the cops.

The slip I pulled was about three Boy Scouts, all aged around 12. They had been swimming in Long Island Sound when they were caught in a strong tide and carried to their death. Besides their ages, the slip registered the home addresses of all the drowned boys.

I phoned the item into the city desk, mimicking the other reporters who were doing the same things, in various degrees of excitement.

The guy on the desk said, "Get out there to those places ahead of the competition, break the news to the old lady after you have asked her to identify a picture of the kid. Then, when she starts weeping, grab the photo and bring it back here to the New York office.

"You will usually find the picture will be on top of the piano."

I was running down the stairs of the police station before I realized the enormity of what I had been asked to do. I was going to be the first (if lucky) to tell a woman (the man of the house would presumably be off at work) about the tragic death of her son. Then I was to *steal* his picture, for the chop-licking readers of the paper which had recently hired me.

My life could have changed in those few seconds. I could have quit the newspaper business for once and all, and become a professor, or an auditor or a thief.

But, on minutest reflection, I could not. My desire to be another Richard Harding Davis or Floyd Gibbons was too great. And, right then, my wish to beat the competition was something my teeth felt. I got my taxi.

The rest was simple. All three were mothers, and all three were home. When I knocked on the tenement doors, in fact, two of them expected their sons.

"Are you the mother of Martin? . . ." I began, in what I tried to make a suave, clerical voice. "Is that he?" I would ask, pointing to a picture of a kid.

Then she would sit down and cry. Or turn her head and cry.

That day I stole two pictures out of a possible three. The Daily News got to the third home before me. I wasn't even admitted, since I had no hard news to impart.

The next day the desk told me, "You didn't do bad, kid." I suppose that afternoon's work told me something: but it does not stick with me—except maybe that journalism can at times be a hard dollar.

The Golden Years—1

*W*hen I think of the golden years, I think of the four or five I spent in Puerto Rico when a young man.

The island was a great place to be young in, and it was a good time. I got there in 1939.

For me it was the real cutting of the cord, breaking away from home and New York, the two great influences—and inhibitors—in my life. I was on my own. It was both scary and good.

It was my job to publicize the tourist attractions of the place, in the paleolithic age of what is now called public communications. We did a good job, but people weren't as travel-minded then as they became.

I was nearly always on the move, as opposed to a kind of inert life in New York. The island—100 miles long by 30 miles wide—then contained 77 municipalities. I guess I must have slept in every one of them.

I travelled mostly with a photographer from Chicago, who was a marvelous driver. (You had to be, with the dirt roads and the mad curves.) We liked to travel at night, when it was cool. Years later I discovered that Ralph had been asleep at the wheel for about a third of the time we were driving; but we never failed to get there, or ever had any accident. The photographers in Chi were trained real good.

Each tiny town had one American girl, who taught, or tried to teach, English. We always sought them out, and they always welcomed us. They introduced us to their Puerto Rican girl friends, who were nearly always more attractive and lively.

The island girls, of all classes, were the best thing about the place. They had been trained to please men. We could not understand each other's language, thus avoiding those crises in verbal communication which blight many a budding little male-female thing. With the unchaperoned girls there were no

such things as preliminaries. It was all, as the French poet said, as simple and faithless as a shake of the hand.

The mountain towns, like Joyuya and Villalba, were the best. The food was better, the music was better, the wiry little jibaros were stronger and the nights, with their land breezes, were a cool delight. I can still hear the sounds of the land frogs on the coffee and vanilla plantations of the interior.

I once stayed with a vanilla planter, a young fellow who had been an assistant district attorney in New Jersey, until hit by unfortunate circumstances, like getting caught selling gold bricks. Literally.

At the time he was engaged in a boundary dispute with his neighbor, a distinguished Puerto Rican lawyer. It was over about four square feet of land, but it had become as prolonged as the litigation in Bleak House. It was now in Federal Court.

Carlos, the Puerto Rican, worked up a splendid 42-page complaint in Spanish, going back to the days when Ponce de Leon was governor of the island.

Phil, the American, entered an answer which must be the shortest ever submitted to a Federal Court. It consisted of one word: "Balls!"

San Juan, the capital, was heavily a U.S. Navy liberty port in those days. Its waterfront was in a class with Port Said. There were fights in the bars all the time, but especially on Sunday. The toughest joint on the Malecon was called, appropriately, the Bar None. I got my own there, a couple of times.

At La Mallorquina, the town's leading restaurant, you could order orange juice, tinned and from the mainland, for a quarter a glass. Outside, three feet away, vendors sat peeling the delicious island oranges, which you could buy for a dime a dozen, either peeled, or with a single hole through which you could suck out the juice.

I used to say the place was a nice mistress, but would make a lousy wife. Yet there was never a place I left with such a feeling of regret. The people on the boat said "Vaya con Dios," and they meant it, as they tugged your hand, and their eyes glinted.

The Golden Years — II

In all my born days, I had never met anything like the Puerto Rican men. They were a major educational influence in my young life.

I had been brought up in the almost Calvinistic severity of Irish Catholicism in New York City, where the whole ethic was painfully simple: If you enjoyed anything, it was bad. If you enjoyed it a great deal, it was sinful. People who went about promiscuously enjoying themselves were to be avoided as instruments of the devil.

It was a confirmed anti-hedonist, then, who got off the S.S. Borinquen at San Juan in 1939. A young fellow who knew that pleasure was hard-bought, and paid for in the sternest of currency: Guilt.

I began to meet a lot of chaps named Moncho, and Carlos, and Fernando, and Julio and Jaime. Their view of the world was as different from mine as steak from salad. The world was their friend. I had been taught to believe it was my enemy.

In their work, everything was manana. The American notion of a clean desk every evening was totally foreign to them. They quite literally fought their work. A pile of unanswered letters, or unfiled orders, was somehow necessary to their security. Their work was not so much what they did, but what they managed to leave undone.

But if everything was manana in their work, in their living there was no such word as tomorrow. What they were doing at the minute, which was usually drinking or throwing dice or making love, occupied them passionately. And when it was finished, it was finished, and off to another game.

That life could be thought of as a game was a notion totally new to me. That it could be enjoyed for its own sake was an idea both unsettling and exhilarating. That you could daily commit acts defined as sins by Holy Mother Church, and dismiss the lot with a tolerant smile, was of course heresy, and was of course charming.

23

I had encountered the *alma Latina*—Latin soul.

Not that these boys didn't have their own rather odd hang-ups. Chief among these was their insistence that the woman they married must be everything they were not—upright, faithful, loyal, sober, steady and above all—*virgo intacta*.

They did their level best to seduce every lass in town. If in marriage, however, they found on the marital first night that someone had succeeded before they had, they were likely to throw the lady out of the window, as one fellow from Humacao did, or shoot her, as another fellow from Ponce did.

A well-born lady who was found not to be a virgin on her wedding night could have two fates open to her: Get into a nunnery, if the nuns would have her, or go through life with a reputation as a tart. Sometimes they went to New York and became models at Bergdorf's. These were the rare exceptions.

But apart from this passion for purity in spouses, the Puerto Rican gent had things worked out pretty admirably. His especial passions, apart from the ladies, were children, and music, and flowers—and none of these things are bad.

No pub crawl made any sense unless, after the fourth drink or so, a band of strolling musicians did not join the crowd, and remain with it until the very small hours.

Everybody sang, and quite shamelessly. At some point or other, the musicians and the roisterers were bundled into taxis, and the lady friend of one of the gents was serenaded while she presumably was sleeping. If the music kept up long enough, the girl's mother came to the window and feigned anger. It was all part of the game.

The funny thing is, these fellows got older, and got married, and had kids—and they didn't change a bit. They kept doing the same things they were doing after they grew their first bit of lip hair. They never questioned that the world was a playing field, put there for them to gambol on. And because they had this innocent belief, the world on the whole was very kind to them.

The Melodeon

If only I hadn't gone to Dublin in the first place, and if only I hadn't gone to that place where they play the music on Saturday nights, and if only the master of ceremonies had not used the word melodeon. Well

A melodeon is what most people call an accordion, or a squeeze box, or many other names, and it is something my mother used to play, sitting there on the best chair in the house, and looking satisfied, and the melodeon on her knee, and the sounds of things written by Tom Moore and Bobby Burns coming out.

After my mother threw the old man out of the house she had to find some way to support the children, and she was too proud to peddle herself. The times being what they were, New York City in the 1920s, the best thing she could do was to make whiskey and peddle it.

It wasn't bad whiskey. I used to help her make it, in the big stone tub where I had my weekly bath on Saturday night. There were a lot of copper coils involved, and the operation was very honest indeed, for my mother would never be involved in anything that wasn't honest.

She sold the stuff for a dollar a shot. The clientele was entirely male, naturally. I grew up in what was very like a cat house in atmosphere, except that booze instead of sex was sold there.

There were cops and firemen, the elite of the neighborhood. They would come in and sit around the kitchen stove, and the old girl would take out the melodeon, and with that fixed smile on her face play, Oh Paddy Dear and Did You Hear, and that sort of sweet nonsense. The cops would get up, with their blue jackets off, and do a clog dance.

Every once in a while, dazed and dreaming, I would wake in the middle of the night to go to the gents, which meant crossing the kitchen, and I would see all these fellows getting

sloshed and my mother playing the melodeon, and she would say to me, "Sing for the boys."

And I would sing something called The Sweet Galtee Mountains, which had, at some point, thirty-two verses dedicated to the thirty-two counties of Ireland, including the ones owned by the Protestants up there.

And they would throw dimes and nickels on the floor and I would pick them up, which possibly explains why I am now in the entertainment business.

With all those dollars she got for all those shots, my mother became in time respectable and bought us a house in a neighborhood where the rich Jews lived, and I remember one of her strongest moral injunctions.

We would be having one of those catastrophic confrontations which the Irish call a family difference, and she would conclude it with the stern words, "You're raising your voice, Charlie." And then she would add, "The Jews will hear you."

What with one thing and another, it wasn't a bad life. I grew up in the firm conviction that I hated my mother, and I'm sure she thought I was the world's smallest stink. It has taken a long time for me to know that she loved me, and that I loved her. It was all a part of being Irish, or human.

None of this would have come to mind, or been expressed, if that guy in Dublin hadn't said the word melodeon. The sound of the box comes to me now, loud and clear, and I think of the courage of that dear good dead woman, and of our failure to know each other, and I am fit to weep.

My Greatest Scoop

One of the great pleasures of visiting the achingly beautiful city of Paris is that I frequently run into an old San Francisco friend, Mr. James V. Coleman, in a small bar on the Rue Castiglione which we both favor.

We met a while back, after lunch, and we had a little whiskey and talked of things that might be happening in Northern California.

And I thought, as I always think when I am talking to Mr. Coleman, of the considerable journalistic scoop he once gave me, and how he didn't really know what had been given. Nor, as it turned out, did I.

It was in 1962, in Reno. James Coleman was there on a little gaming holiday. I was there because there were some interesting characters, under the leadership of Mr. John Huston, making a movie called "The Misfits." Starring, as you will recall, Clark Gable and Marilyn Monroe.

Mr. Coleman, Mr. Coke Infante of North Beach, myself and a couple of gaudy ladies were sitting around a table in the Coach Room of the Mapes Hotel. Gaiety was general. Mr. Infante was earnestly trying to get the bubbles out of some Taittinger by using a gold swizzle stick someone had given him.

Mr. Coleman rose, and asked to be excused. He had to make a phone call to a lady he was related to by marriage, and who was at the moment in Virginia City.

James Coleman is a tall and courtly man, with a quiet humor and a sometimes dismissive way about him. He learned French the hard way—by being entered in mid-term into a school in Paris where no boy spoke English, and he spoke not one word of French. He is not easily pleased; but when he came back to the table there was a wide smile on his face.

"Kay," he said, "is pregnant."

There was a part of me which knew perfectly well what he was saying. Kay Spreckles, who was at that moment Kay Gable,

wife of the film star, was going to have a baby. And the father of that baby was to be Clark Gable, a man of legendary importance on the American scene. And, further, Mr. Gable had never had any kind of child before. And, finally, Mr. Gable at that time was some 60 years of age.

My total reaction, as I recall it, was simply that I was pleased for Mr. and Mrs. Gable, as indeed everyone else seemed to be.

Did I feign indifference so I could rush to the phone when the moment was right and call the city desk? Was I thinking about front pages all over the United States, with my name on them, as author of a spectacular copyrighted story? Did visions of a bonus for my initiative dance before my eyes?

Hell, no. The training of a lifetime went wholly by the board because of a quirk on my part which made me turn off my journalistic eyes and ears when I was in a social situation. This is one of the reasons I never got into social situations with important news sources if I can help it. You can't tell tales on a man you're drinking with, and his friends. At least, I can't.

Of course, I didn't go through this process of moralizing when I heard the great news. I really wasn't thinking. As a newspaperman, I just funked. Homer just bloody nodded.

How badly I nodded I really didn't know until some three months later when a lady named Hedda Hopper electrified the world with the news that Mrs. Gable was expecting a child. The warming news hit the civilized world with the impact of a thunderclap. For a day, the thing was almost as big as the Dionne quints.

I walked around, wiping the egg off my face. I had long suspected I was no Hildy Johnson. The suspicion was now fully confirmed.

I don't know who, in the end, gave the story to Mme. Hopper. It must have been somebody who knew a great story when he heard it. That surer than hell wasn't me.

Are You a Morning Man?

I've always suspected I was something of an introvert, and I've always known that my life was pretty well spent by 10 a.m.

I am a morning cat. This has often worried and puzzled me, and worried and puzzled others. In the days when I did my work in a newspaper office, I started my writing stint when only the janitor was in the city room, and ended it just as the copyboys were arriving.

I used to think these working habits were dictated because I liked to work in total quiet. This is to a degree true. But the real reason was that the only time I really could work was just after I rolled out of bed. And the quicker, after rolling out of bed, the better.

Now I find that some medical researchers in Cambridge, England, are speculating that the difference between day and night people is all tied up with body temperature.

The Cambridge fellas claim that everybody's temperature is normally lowest in the early hours of the morning and rises to a peak around 9 p.m.

They add that in the mornings the temperature of introverts begins to rise sooner than extroverts and starts to fall earlier in the evening. Body and mind are sluggish when temperature is low, and pulsate as it rises.

All this is comforting to this here introvert, because I was beginning to think there was something peculiar about my habits of work and way of living.

I had, in truth, known there were morning and night people before. A large number of writers were depleted characters by noon. To name two, Ernest Hemingway and Somerset Maugham.

We ante-meridian introverts are veritable tigers around 8 a.m. I hate to think of all the brilliant insights I've had, and all the just words I have written down, while most of the human race was wrestling with its coffee.

Contrariwise, I'm nearly a total loss when others are up and going, and performing the business of the world—i.e., stealing from each other. When there is a specially challenging social occasion of an evening, I've been known to doctor myself with lashings of coffee, or a No-Doz, or even, on occasion, with a benny. Otherwise, my hostess might just as well have invited a zombie.

There was a time I tried to lick this thing by taking naps in the afternoon, and persuading myself that, when I woke at 4:30 p.m. or so, a new day was dawning, and the old afflatus would descend on me. Alas, that didn't work. The body temperature wouldn't cooperate, or something.

I used to think all this was neurotic, like so much in my composition. It is cozy to think that my aberration may be caused by something as prosaic as the fact that I hotten up early, and cool off early. Someday, soon, somebody may invent a pill.

Actually, I don't regret my working habits. Whether it be body temperature or what, I quite love the morning. And I like being a little bit ahead of most of my fellows.

But as a result, most of my work is virtually done in secret. As a further result there are those, including some of my superiors, who don't think I work at all.

How About the Gout?

There are few pleasures on earth to equal the end of a bout with the gout.

As I always say, it's like being beat around the head with a hammer. It's yummy when it stops.

Gout is said to be the result of luxe living—much wine and ardent spirits, and such goodies as liver and sweetbreads. It is marked by joint inflammation, usually in the great toe, much uric acid in the blood, and the deposit of sodium urate crystals about the joints. It tends to recur. Man, it hurts.

I have always assumed that the last word on treatment of gout was spoken by my English country doctor who told me: "Some drugs like aspirin and cinchopen can help, but the plain fact is that those liable to gout cannot have sweetbreads and wine, liver and spirits, without having gout as well. Most people, perhaps, would prefer the food and wine, but those who dislike gout must abstain."

My last episode was probably precipitated by the fact that I had been on a diet, to lose weight, composed entirely of steak tartare, salad, some fruits, and various potables, including a good amount of solid old Napa red.

It got so bad I went to see my doctor. This lad is great, and deserves a few words of explanation.

You go to him, and you tell him all the bad things you have been doing of late, and of their consequences, which are of course what brought you to his door in the first place.

He looks properly learned for a while. He is figuring out how you can retain all your old bad habits, and yet avoid their consequences. Then he writes some things on some paper, and you nip across to the drug store, and before too long you're up to your old tricks again.

In my ignorance, and in the face of British medical opinion, I did not know that gout was curable nowadays. My English doc, now that I look back on him, was a spare, ascetic fellow,

who disapproved of many of my habits as enthusiastically as my American doc approves of them. I would not put it past him to have held back knowledge from me, on high moral grounds.

For years I had worn a copper bracelet on my wrist. This is something greatly favored in some British circles as a way of warding off various rheumatics. I never suffered from the gout while I wore it. It was my contention that these bands worked quite well if you were Irish, Catholic, neurotic and superstitious. I am.

Alas, I left the ring in a bathtub in the Ritz Hotel in London and never saw it again. Assessing the situation, I decided that maybe I wasn't as Irish, Catholic, neurotic and superstitious as I thought. I did not leap down to Savory and Moore's chemist shop on Bond Street to buy another ring.

As I write these words, it is the first day I have been able to put my right foot on the floor with ease, and the first time I have been able to get into my most comfortable shoes without a shoehorn.

I am armed with two bottles of pills. Their effect is magical. I face, with serenity and confidence, a goutless future. And I can stick with my old, wicked ways.

It all just goes to show that picking the right doctor is almost as important as picking the right father-confessor, and just about as hard.

One of These Days

One day recently I made a rather unsettling discovery, about two hours after dressing. While paying a visit to the facilities in my local pub, I found I had put on my undershorts backwards. This should have confirmed that it was going to be that kind of a day.

There had been earlier indications. I do my work in the morning. Work done, it is my custom to totter off to my local and read the dailies, to the accompaniment of a couple or three bottles of ale.

My progress to the saloon/office is serpentine. From the front door of my place, I ascend exactly 75 steep concrete steps, no small feat for a man of my heft. A winding country road takes me to the post office, and the newsstand where I buy the two city papers. Thence a leisurely progress past the city hall and police station, and the local cinema, to the family entrance to the pub, a clean and quiet place.

As I was about to enter, on that day, my hand went to my chest. Horrors! My spectacles, which usually hang there like the scapular in a monk's habit, were absent. I had forgotten them. It was a good 45 minutes later before I was planted before the bar to begin the day's scrutiny of the follies of my fellows, and the latest asinine utterances by "distinguished scientists"—often no better than itinerant psychiatrists.

The editorial trance, my wife once called it, and not without a trace of bitterness. For once I am caught in the grip of composition, the outer world becomes as irrelevant as the politics of Tibet. I can carry on what seem like perfectly coherent conversations without being aware of a word I say, or what is said to me.

The inside is so full that the outside has to remain vacant. This is sometimes called absent-mindedness. It is a peculiarity of the racket I engage in that you are busiest when you seem most idle. When I am most glassy-eyed, I am most productive.

Like a lot of other writers, I sort of dream my pieces during the daytime and even at night, and especially just before waking up. Then one hurries to excrete the vision of the day. The excretion is not fully completed until the stuff has been dropped into the mailbox. Then, off we go on another dream.

Finished at the pub, I went into a supermarket to buy three nectarines. So intent was I on not forgetting to stick them in my Pan-Am bag, that I had to be hailed back to the counter to pick up my change.

Later in this misspent day I got a phone call from my youngest daughter. She and one of her brothers had gone off for a day on the town in San Francisco. She reported that they had missed their ride home and would I come and get them?

As I motored into town it gave me small comfort that my malaise was probably hereditary.

I must have had something massive, editorial or otherwise, on my brain that day. Trouble is, I still don't know what it was.

Grow Old Disgracefully

\mathcal{T}he older I get, the more I enjoy things I should be ashamed of at my age. This is surely wicked; but I would not change it if I could, and I greatly doubt I could.

Old age, and the years approaching it, are supposed to be the time when rigidity of character sets in. If present signs are to be believed, the reverse is going to be the case with me.

At age 20 I was such a farrago of complexes, phobias, rules of conscience, and sets of principles as cannot be believed. I was one of those people who quite literally lived by the book. I never quite knew who wrote the book, but I lived by it.

My opinion about any situation, had I but known it, was settled before I met it. From women to third base—men to the philosophical opinions of Descartes—I had already been handed the graven tablets, with the answers carved out, loud and clear. I knew good from bad. God help me for it.

The Spanish Loyalists were right. Neville Chamberlain was wrong. Franklin Roosevelt was good. Adolf Hitler was bad. Labor was right. Capital was wrong. Man was bad, and God was good, and God could make bad men good.

For me, as for a great many of us, life has been a complex of unlearning. Like a great many of us, my education prepared me for a life I never found. It was more harmful than otherwise as a tool to cope with life as I found it. I was brought up to be a saint, and thrown into a world that had precious little use for saintliness.

Many of the things I was taught were bad, turned out, by some mysterious perversion, to be quite enjoyable when I got over the idea that they were bad. And that, for one brought up in the severe Jansenist tradition of Irish-American Catholicism of pre-ecumenical days, wasn't a bit easy.

Though it was never phrased in quite this way, the burden of my moral education was this: Anything you enjoy is bad for you. Try going out in the world wearing this proud banner,

mate, and you will know truly what it is like to have two strikes on you, and a fast-breaking curve coming up.

It has been uphill work, but I've done a pretty good job of scuttling my education. I have learned to enjoy a couple of things, and I intend to spend the rest of my life learning how to enjoy more.

If I live long enough, I doubt not that the final pleasure I discover will be the one I have been most sedulously avoiding all my life, thanks to my high-minded moral training.

I'm not rapping what used to be called a strict upbringing. In fact, I'm rather for it. I do believe honesty is the best policy, as I do believe I should love my neighbor—and my labor—as myself. It is just that cold miasma I dislike, that forest mist which tells you that self-realization is not something which should be left in the hands of the priests.

I have learned to like women and flowers, and even paintings of women in the nude by Frenchmen. I have learned to like homosexuals and Protestants, and other lesser breeds. Most of all, I have learned to like, a little bit, myself.

I once knew a clean old man who came into my saloon each morning and said, as he quaffed his first shot of bourbon, "Let's go to hell with our top hats on." I liked that. More than anything I would like to live to be 90, and see a well turned feminine ankle, and say, like the late Oliver Wendell Holmes, "I wish I were 70 again."

Of Ties, and Tyranny

When I was a young sprout, and living in the Caribbean island of Puerto Rico, I had a considerable crush on a gent named Luis Munoz Marin.

Don Luis was about 15 years my elder, and at the time an unemployed politician. He had a fine mind, and a great way with words, but he had some habits that were thought to be drawbacks, even in Puerto Rico. He drank too much, he smoked too much, he womanized too much. He was altogether, in the phrase of a later time, too much.

And he never wore a necktie. "When a man puts on a necktie," he would intone, "he ceases to be a free man."

Later, Luis became a great man in a small way—President of the Senate, and then governor of the island. Power changed him in many ways, as it changes all of us. His thinking became responsible—i.e., fossilized. He wore neckties more often than not.

Yet I say he was right the first time. And I say this as a confirmed necktie wearer. More than confirmed, obsessional, for I have several hundred neckties in my possession, one place and another. Some of them are 30 years old.

I wear neckties, but I dream tieless. What I would like to be, if I could escape the cage of convention, is one of those swashbuckling 19th century English gents who raped inferior civilizations (and their finest feminine flowers), made puns in Sanskrit, rode and shot like a dream, and turned out a neat sonnet—all the while wearing one of those splendid white silk open shirts made famous by Lord Byron. And no necktie, ever.

I once knew a woman named Connie, who lived in the Carmel Valley. "My day ends," she once sighed, "when I put on my shoes." That's the way I feel about the cravat.

It's just that much harder to dream with a tie on. In fact, a tie is a physically constricting thing. But it is also, on a symbolic level, a choking of the spirit.

37

When you tie the loose Windsor knot, or those tight little Italianate things, or work out the intricacies of the bow, you are entering the implacable world of prose, where people like to think of themselves as rational, and every question confidently expects to be answered.

Think about it the next time you affix your tie. Give a good look back to the world you are leaving, and the one you are about to enter. If you are a fair-minded fellow, I think you will acknowledge that your act constitutes a frontier in your day.

A little of what God gave you went out of you when the tie was firmly backed up to the windpipe. Thus I aspire to tielessness, as any man of moment should.

Of course tielessness, like tie-wearing, can be a fetish, and a tyranny. I feel proud of wearing a tie in Las Vegas or Palm Springs where no one else does. You wear a tie in these parts and you are openly flouting the values of the indigenes.

And that is, as we see, the object of the exercise. Among the tieless, the cravatted man is king. Among the tie-bearing mammals, the open-throated baby is playing it loose, and picking up the marbles.

So I guess it comes to this. You wear a tie, or you blow your brains out. Or you go to Palm Springs or El Centro and swelter within a neckband. But you're free, buddy.

What's Good About It?

$$===$$

When the world gets too much with me, there will intrude on my morbid meditations a cautionary voice.

It says: "No matter how bad things are, no matter how they weigh upon you, there is no man so bereft that he cannot find things to love, if only he can and will."

Of course, can and will is the canker. We all dearly love our disabilities. Feeling sorry for yourself is the cheapest of luxuries. For some of us, the great love of our life is our misery.

But when can/will are admitted to the respectable front parlor of the conscious, I do this thing:

I count my blessings.

This is not easy for those of us who live in the tenebrous precincts of the Celtic Twilight. We guard our calamities as a mother does her child. We hold onto our gloom with the tenacity of a third-string end. In fact, we tend to value ourselves by the distinction and pertinacity of our misfortunes.

The worse off we are, the better we feel. The ultimate comfort is a vision of ourselves, friendless and alone, dying on Skid Row with a jug of muscatel at the ready.

So counting my blessings, or even beginning to, is bound to be uphill work.

Though I am a bit long in the tooth, the ones I have are all mine. They look more like an old horse's than an old newsie's. I have four great kids, and the luck to be living apart from a wife I cannot live with. I have a much-abused, but seemingly intact liver. I haven't gone sour on life, or most of the people who live it.

I am not bugged by the alienated, questing, scornful young. I am not even bugged by the young who think I am a boring dotard. I can never forget the way it was when I was a kid, and a good ear was so hard to find, even in the confessional.

Truth to tell, I'm something of a parasite on the young. I derive great strength from them. The best of them continually

remind me of things that are so easy to forget in the old buck race:

That admiration is better than arse-kissing, that every damned thing on this planet is made to be bettered, that life and power corrupt, and the old men most likely to send the young to their death are the ones who seemed least likely to do so when *they* were young.

I've got a peasant constitution and a robust appetite. I can eat just about anything but fried eggplant. I can drink just about anything except ouzo and American beer. And I like women, especially women with strong appetites. Since the age of 16, I've been in love with some wench or other; and have seldom regretted it.

I have always liked reading, and know it is one pleasure that will stay with me to the end of my life. Dr. Johnson is more real to me than Lyndon B.; Montaigne is more of a presence than de Gaulle. And I don't know why I should be thinking this is rich and strange. They *are* more real.

Travel still takes me out of myself, which is the greatest favor I can do me. Music means much to me, and painting is increasingly pleasurable. And I still like a good stiff game of craps.

But before I knock myself down with another fierce pat on the back, let me tell you what the old goat is like at four in the morning.

Do it Over Again?

I was talking to a trio of youngish fellows in a financial district saloon. They were, respectively, two stockbrokers and a public relations man.

I interrupted a discussion about women and home runs and the Wall Street Journal—that sort of footless thing—with an old question that just happened to pop into my mind.

"If you had it to do all over again, would you?"

The trio, all of whom were in their 30s, reacted like a flash.

"God, no!" would be a fair summation of their reaction.

I did not necessarily believe them, for they are what might be called swingers. They play life very loosely, and waste enormous resources on what is called, reverently, keeping their cool.

Soon they began to qualify their first, almost instinctive, reaction.

"Well, if we could make just a couple of changes . . ." If they had a different first wife, if they had been in another business, if they could have arranged to be born in another country, if they had been smart enough to know what those girls in high school *really* had on their minds, etc., etc.

But I insisted on the more classical statement of the proposition: Would you do it all over again, if everything were to turn out just as it has?

When asked how I stood on that proposition, I answered cautiously that I though I would be pleased to play the whole scenario over again, but I would have to think about it a little.

Well, I have done so. To my surprise, I believe I would accept the deal fiercely.

Not that I am exactly what you would call a happy man. The agony and the ecstasy have been pretty evenly portioned out to me; but with a favorable difference.

The agony, most of it, came when I was a young lad and man, and really did not know how agonizing it all was.

The ecstasy, or most of it, has come in my later years, when I have been able to savor it more fully, both because of age and previous bondage.

Of course, the ancient pains never really go away. They nibble at us until the day we die. They make us cautious when we should be courageous, prudent when we should be precipitate, and complaisant when we should be angry.

In my life I have sought more pleasure—and more pain—than most of my fellows. I have received a great deal of both, in full measure. As they say, if you're gonna play, you gotta pay.

Most of us know when we are acting foolishly. We know the piper is going to come around with his little collection box. We should be neither astonished nor distressed that our folly has a price on it.

Whether the hangover is worth the rum and riot is one of those tricky metaphysical tidbits that none of us are really ever going to determine.

But, over the long run, the game is worth the candle.

This is largely because of one little word: Growth.

For me the great satisfaction of the adventure is that I have grown. Gradually, to be sure, as all growth goes; but almost certainly.

Baudelaire spoke of "the universal and eternal law of growth by degrees, of 'little by little' or 'one thing at a time'— a growth accompanied by a steady quickening accumulation of strength, like the accumulation of money at compound interest."

It is this slow and steady quickening of strength which enables one to accept the offerings of life—both pleasant and painful. A fully grown man, which I certainly do not claim to be, is the noblest work of God.

For growth always seems to move in the direction of love. It is, in fact, almost a definition of that often-defined word.

I can say without reservation that I would be willing to replay the whole record, scratches and all, if I honestly thought I would end my days a loving man, and a grown one.

On First Seeing Frisco

I arrived in this town in July, 1955. It was cold and foggy. I had what is sometimes called thin blood, from long residence in warm and hot climates. My constant companion was a blue cashmere topcoat. It was many months before I could go abroad without it.

I was starting a new life. Everything I had done, both good and bad, was left behind me. Among these was a marriage which didn't work, and four children who did.

I knew I was starting anew; but how starkly anew I was soon to learn. I knew only one person in the city; but he was a useful man. I called him, only to find that he had just moved from the city, for a new job in Washington, D.C.

My health was poor. I was recovering from the effects of a massive internal hemorrhage that was not unrelated to my marital break-up. I was also in the grip of a nervous disorder which seriously incapacitated me.

I never felt so alone in my life; but this was not wholly unexpected, and I had in those days a much greater capacity for being alone than I do now.

I was fascinated and terrified by Montgomery street, and its fauna. Though I spent my youth in a busy and crowded city, I had recently lived in peaceful villages, and had lost both the pace and feel of a city.

I almost cringed with envy as I watched those alert and good-looking men, complete with the Brooks Brothers vests, as they walked down the street, going from one brokerage office or bank to another brokerage office or bank.

How, I asked myself, could I ever compete with these marvelous specimens? How could I ever share in the rewards which life was so patently holding forth to these accomplished fellows?

I began to feel, inside myself, an outlaw.

I had not had a job for a long time, having elected to opt

out of the system, and even my own country. Newspaper jobs were not easy to get. I had funds, but they were not limitless.

Finally, all pride gone, I began to canvass the ad agencies for work. They would not have me, and for this I am eternally grateful. I'm just good enough at that racket to be quite successful and certainly unhappy.

The tide began to turn for me in a way it has turned for many people who were strange to San Francisco. I discovered the Buena Vista Cafe, at Hyde and Beach.

I found the BV at just about the time the owners were making their first great splurge with Irish Coffee, an event which deeply changed the character of the customers. A corner saloon became big business. Yet nothing in it really changed, from the service, to the prices, to the character and behavior of the owners.

Then, as now, a pretty good-cross-section of San Francisco was to be found among the customers. There were bankers and hookers, customers' men and columnists, black and white and brown. And keeping the peace was big Harry, the Cop.

It was here I began to make my first friends in the city. I had no letters of introduction, and never would be caught dead with a calling card, but soon there were friendly faces and people who knew me by name.

I knew I had chosen a hard and lonely route when I came to this town. I shall be eternally grateful to it that nobody ever asked me where I came from or what I did. That information, if it was forthcoming, came from me, and unsolicited.

In due time I got a job on a newspaper, where I was set to doing things I had not done since I was a youth—covering Chinese baby beauty contests, burst mains in the Potrero, cheap murders in the Tenderloin, and rewriting handouts that both I and the city editor knew would never see print.

After about a year, I felt at home. For did I not have a job and some friends; and, most important of all, San Francisco?

Of Me I Sing

Somebody back East, who had heard something about a column written by a guy named McCabe, asked a San Francisco friend what it was like.

The friend confessed it wasn't an easy task to say just what it was like. He added he would ask the author himself to try.

I, too, find it is not so easy a task to nail down just what it is I do for a living.

I know it is not quite like what any other newspaperman does for a living; but that can be said of all lads who are allowed, or even encouraged, to write about themselves.

For, in a real sense, God broke the die when he made each of us—which is another of His particular glories.

Writing about yourself is, in one sense, a lazy thing to do In another, it is the toughest and most demanding of disciplines.

Everybody identifies with a person who writes about himself, whether the subject be straight introspection, or the views of the man on levitating rockets to the moon.

The similarities of man to man are arresting. The small differences are fascinating.

It is almost impossible, in fact, to write a dull book or a dull column about yourself, whether it tries to be honest or dishonest.

The honest writer about himself, if he is not afraid to expose his warts and all, will reassure the reader that he is not alone in his crotchets. The truth is that we all belong to the same litter, and always will.

The great honest autobiographer was Michel de Montaigne. His diffidence, his integrity, his skepticism, are reflected in the name he gave to the literary form he invented—the essay, or the trial, or the attempt. Montaigne's whole life was an essay, or trial, or attempt. The life of most really detached men is just that.

The dishonest blokes—Casanova, Benvenuto Cellini, and Frank Harris, to name a few—are interesting simply because of their fraudulence. I have always maintained a man tells more about himself when he lies, than when he tells the truth. Think of this, the next time you real Frank Harris' account of his more improbable sexual forays.

For myself, honest is rather too large a word. I prefer to think that what I strive for is to be undeceived.

Now, this is no easy thing, for the world and its ways are designed to deceive. Its greatest rewards go to those who accept their deception, which is a nice way of saying corruption. The man who gets the Croix de Guerre or the Medal of Honor, his first million at 30, or the Pulitzer Prize, is usually a fellow who believes that war is good, that the accumulation of money is admirable, and that love will land you nowhere, except maybe in alimony jail.

The least deceived people are children. The young, before they bow to the god of pelf, see things much as they are. The middle-aged are desperate but not hopeless. The old are hopeless, but not desperate. (In general terms, of course.)

So the job is to try to keep, or to regain, the clarity of vision you had when a young man; and, occasionally, in brief brilliant poetic flashes, the insights you had as a child, when you knew the real from the brummagem.

Of course, I do not succeed in this earth-moving enterprise. No one with the freight of 20th century life on his back possibly could.

One tries. That is all.

This column grew out of a sports column, which is both a good and bad thing to write. The good thing about sports writing, and the thing which I would like to retain, is the childish values which obtain among the players and the minor orders of employees, mostly former players. (The owners are ruthless and insensitive brutes, for the most part.)

In sports they judge things by the book. You are good or bad by your averages. This is a sure thing. In the complex, confused and deceived world outside, there is no book. People like yours truly try to furnish some sort of a book. This is done, of course, for the reader. Even more so, it is done for my own sadly deceived self.

'Hope for the Worst'

\mathcal{M}y late mother didn't leave me much in the way of her looks or her loot. She did, however, implant into my noggin one bit of wry knowledge that has come in more than handy, more than once.

"Expect the worst," she used to say, "and you'll never be disappointed."

Naturally, this advice would not have taken such firm root had not the soil been previously prepared.

My mother and I were both black Irish, which means that when we were offered the hand of friendship, we saw a knife in it.

Whenever some blessing befalls me, I immediately begin to brood on what life will be like when it is taken away. I hate being told I'm ahead of the game.

The last time I can recall throwing a punch was in a San Diego saloon, a few years ago, when someone said to me, without any malice at all, "You've got it made, pal." The idea of having it made threw me into a fury. You cannot expect the worst and have it made, too.

I hate to know exactly how much I have in the bank. This ignorance will soften the blow when the inevitable day comes and the bank closes (as my heart tells me always it surely will).

I was greatly comforted recently to find that wisest of men, Michel de Montaigne, must have had a mother like mine. He said: "I foster as best as I can the idea: to abandon myself completely to Fortune, expect the worst in everything, and resolve to bear that worst meekly and patiently. It is for that alone that I labor; that is the goal toward which I direct all my reflections."

In the midst of hopeless romantic attachments I have rehearsed the scene as it would be played out when all passion was spent, and the word was "Drop Dead." And seldom was I proved wrong.

For, when you think in this odd way, it is almost a comfort when the blow finally falls. It is the indecision, the worry, the anxiety that precedes the blow, that is the killer.

Montaigne tells the story of a friend. "He married well along in years, having spent his youth in gay company, a great storyteller, a merry lad.

"Remembering how the subject of cuckoldry had given him material for talking and jesting about others, to take cover he married a woman whom he picked up in the place where each man can find one for his money, and made a compact with her that they would use these greetings: 'Good morning, whore.' 'Good morning, cuckold.'

"And there was nothing he talked about more often and openly to visitors at his home than this arrangement of his; by which he checked the secret gossip of mockers, and blunted the point of this reproach."

That is carrying the technique of planned pessimism to extreme lengths, but I can see both the point and comfort of the old gent's maneuver. It took a very important worry from his mind.

Which is all the technique is meant to do, anyhow. You worry a great deal less about losing something when you have prepared for its loss even before you gained it.

The lads who jumped out of the windows in Wall Street after the 1929 crash were the soft-minded ones who thought it was real, and it was there, and it was forever.

The guys who knew it was phony and finite, like Joe Kennedy, played their misanthropic hunch and made millions out of it.

What was good enough for my mother and good enough for Montaigne is good enough for me, especially since I should have felt the same way, I am sure. if I had never met either. "The dread of falling gives me a greater fever than the fall."

2.

Miscellany

*Being comments
wise and otherwise
on a variety
of subjects.*

'Necessary Loneliness'

I cannot think of a worse punishment than to be denied solitude absolutely.

Solitary confinement, to many spirits, would be preferable to enforced gregariousness.

To be condemned to the company of your fellows, unendingly, might make the Chinese water treatment seem like a week at Deauville.

A lady writes, relevant to the business of people owning people, in an intimate relationship: "Not only men, but women as well, have private areas of necessary loneliness which should not be invaded by questions."

This, of course, is true. Everyone has his own private reserve, which must be respected by his companions. There is a part of the self which is never given, or it would not really be a true self anymore.

But there is the other loneliness, which consists in the complete removal of one's self from the presence of those with whom one lives. This should be done from time to time, even if the removal requires a certain resoluteness.

There is great wisdom to be found in being away from the object of one's feelings.

One of the tests of a difference between an immature and mature love relationship is that the immature person often finds it impossible to get away from his love-object, to use the frightful (but in this case accurate) psychiatric term. This person is not in love, he is in the grip of an obsession. In that useful but old-fashioned word, he is infatuated.

Healthy apartness is to the spirit what fasting is to the body. Fasting, by changing one's physical regimen completely, allows the cells to relax, revive and strengthen. "Necessary loneliness" does the same thing to the overburdened spirit.

We do not have to be as tough as old Montaigne, who recommends solitude for almost entirely selfish reasons:

"We should have wife, children, goods and, above all, health, if we can; but we must not so set out hearts upon them that our happiness depends on them.

"We must reserve a back shop wholly our own, entirely free . . . to the end that, when the occasion comes for us to lose them, it may be no new thing to be without them."

Such counsel is a bit too tough-minded for most of us. Most of us do not like even to contemplate the idea of surviving those we love, much less making deliberate plans for the event.

No, the kind of loneliness which I recommend has as its best virtue putting the proper price on our affections once again. At peace, and in healing surroundings, without the daily abrasions that even a loving life compels, we are able to know the extent and depth of our affections. We come back renewed, and fortified.

To be sure, it does not always work that way. Sometimes the opposite occurs. We find that our values have been falsely up, rather than falsely down. We occasionally find that, for our survival, we had better remove ourselves from something or someone that is doing us harm.

It is fear of making this discovery, as a fact, which accounts for the terror immature people (who are mainly interested in sapping, not nursing, affection) have at the thought of separation. They fear it might become permanent.

But whatever discovery is made—whether the affections are strengthened or sundered by separation—I believe in listening to the voice of loneliness. I don't think I have ever regretted a decision I acted on that was made in a decent solitude. (This does not mean, by a long shot, that I acted on all or many of these wise decisions. The better I had.)

When you are alone you are being told something by the deepest part of yourself, the part that is concerned with your preservation.

Of course, solitude and loneliness can be overdone. Solitude, said the humorist Josh Billings, is a nice place to visit but a poor place to stay. And it should be voluntary.

"Necessary loneliness" is but a part of the complete man. But no man can be complete without it.

What's it Like to Be Black?

*I*t is obvious the provoking question above will never really be answered by us pinkish people who are called white by ourselves and those of other coloration.

It is equally obvious that an attempt to answer it, in all good will, is pretty important to everyone at this time, and especially to Americans.

To attempt to do so is to show sympathy—"The act or capacity of entering into or sharing the feelings, interests, etc. of another . . ."

The other day a black man told me: "I venture to say that you as a white man will never feel the frustrations of the black man. The frustration the black man, in all walks of life, faces every day of his existence.

"But perhaps you do have the understanding to imagine what it is like.

"Surely, you have had one of those proverbial days when everything goes wrong.

"Well, try living that type of day *every day* of your life."

That has stayed with me. While I find the utterance a bit on the melodramatic side, it's a useful point of departure if one would like to get within the skin of the black man. Especially the young black man.

Thanks to the magic of television, the black man gets, day in and day out, an astounding education in the life lived by the white man. At the same time, he gets equally stern reminders that he can never fully enter that life.

On the screen he sees incredibly pretty and graceful girls peddling toothpaste. Outside of a fraction of hippie society he cannot hope to have these girls, as friends or as lovers.

He sees those enviable suburban houses, where the mother is just as lithe as her daughter because the whole family eats the same kind of breakfast food. This sort of felicity is denied him

as clearly as membership in the Daughters of the American Revolution.

He sees those splendid, sexy automobiles cruising jauntily along mountain roads. Unless he is a professional or a member of the blue collar elite, these cars are just a promise of continued frustration rather than of possible satisfaction.

It is the curious magic of the telly that it makes the white viewer think that all its extravagant promises can be fulfilled, if he but reaches into his pocket and nips out to the store to buy one magic alchemical ingredient after another.

This does no great harm to the white man, since this kind of salesmanship is but the fulfillment of his dreams.

But this powerful medium is not—and cannot be—attuned to the black man's needs and wants. To him it is a vast cultural strip tease. He is incited. He is seduced. He is made vast promises. At the end, fulfillment is cut off from him.

When I want to get the feel of the black man, I sit before the screen and imagine that I am, indeed, a kid from Harlem, or the slums of Chicago or Hunter's Point.

Soon or late, the hopeless feeling comes over me that I am bound, for the time of my life, to the role of spectator instead of participant, of voyeur rather than stud.

And if you extend what is so immediately and vividly presented in television, you can infer the whole white world is just as much outside the reach of the black man.

In virtually any job he has, he knows he will never reach the same goals as his fellow of a different color, no matter how hard he tries.

So he settles into the black world, whether it be on Sugar Hill or in the worst ghetto. He is condemned to travel pointlessly upon the earth, like the Wandering Jew.

It's a white man's world, and he must live off the crumbs. I remember those drinking fountains in the Canal Zone—gold for whites, the others for blacks. Some of these small, mean discriminations are disappearing; but in the larger world, it's still that way, and in many areas getting worse.

Remember, we "freed" the black man in 1865.

A Note on Mail

*I*t has been noted by someone who studies such arcane matters that at least three out of every five times you lift your phone off its cradle, you wish you hadn't.

On the other end of the line you are apt to find somebody trying to sell you something, or dun you for something already sold. Or you will find some male or female whiner, or one of the troops from Doc Gallup's army of pollsters, or an invite to a party you wouldn't be caught dead at. (Of course, you might be one of those people of whom it is said, "The only party he ever missed was the Donner Party.")

Worst of all, one or more of these odious impositions will occur as you are cosseting your digestion at lunch or dinner.

But if the phone situation is bad, I suggest the mail thing is even worse.

The amount of mail the average person gets which should never have been sent would, over the years, reach from East Pecos to the moon.

I get a fair amount of mail each day. I retain in a jacket pocket the mail I wish to re-read, or cope with, or keep around to remind me of something. The rest goes into file 13.

On a good day, the residue may amount to five per cent of the total. People who have spoken to me about the problem say this is a pretty high yield.

A lot of the mail simply goes unopened. Things like epic pronouncements on national policy by the government of Monaco, or the signaling of a revolutionary new development in the design of bidets, or the news of some extraordinary philanthropy perpetrated by the leading shoe manufacturer of Pasadena.

These communiques are an invasion of privacy. I take as much pleasure in not reading them as press agents apparently take in concocting them. Both sides are enriched in the process, presumably.

But the first-class mail constitutes the real problem. You must open all these letters, for among them may be the one or two which will enrich or change your entire life. Who can say, from the look of a letter, that it is not the offer of 40 grand or so by the Ford or the Rockefeller foundations? Or that something comes from someone desperately in need, and it just happens to be within your power to help? Or a bit of info you had been seeking for years?

Alas, these occasions happen far too infrequently. I seem to get a lot of mailed abuse, and requests for favors which I could not grant if I wished.

The tone of first-class mail needs improving. Happily, through the agency of a friend, I have the way to do it.

My friend suggests that there be an immediate increase of 500 per cent in mail rates. A surface letter would cost 30 cents to move and airmail would be four bits.

What this reform could instigate is staggering in its possibilities.

People might actually ask themselves: "What purpose is this missive serving that I should send it? Is what I am saying worth the price of a stamp, or likely to yield results equal to the price of a stamp?"

I have no doubt that if the cost of posting a letter were made mildly prohibitive, it would result in a raising not only of the content of the ideas expressed, but of the actual composition itself. A man is not likely to spend half a buck on a letter without minding his p's and q's, his commas and his periods. And he is likely to re-read it before sending, to see that it is as clear as his powers can make it.

And if the first-class letter should be raised by 500 per cent, surely that abomination of our time, the junk mail sent out by heartless sales managers everywhere, should go up at least 1000 per cent. This would lessen a lot of burdens, including the postmen's.

Notes on Travel

*S*omeone said to Socrates that a certain man was not improved by his travels.

"I very well believe it," said the wise old Greek, "he took himself along with him."

Like solitude, travel greatly gingers the spirit.

As there is good solitude and bad solitude, there is good travel and bad travel. Socrates put his finger on the distinction: in good travel we put away the mask, abandon the persona that sustains us in our daily and routine life.

We travel, not to get away from Peoria or Palo Alto, but to get away from that outer self which is a continuing strain, simply because it is a mask.

The necessary mask finally becomes an irritant. It is rather like wearing contact lenses too long a time.

When you set foot on the beaches of Ischia or the boulevards of Paris, you must have broken temporarily with the guy who pays taxes, and votes Republican, and worries about his wife's neurosis, and wonders what his son's chances of getting into Exeter are.

If those things are with you, even in part, you are not traveling. You are merely cargo being transported. Your spiritual pores are tightly closed, not open and waiting for the clear flushing action of a fresh rain.

A great many people are just naturally good travelers. They receive change. They do not resist it. They see things in Milan they never see at home, just because the mask is down.

But most Americans, like some delicate wines, simply do not travel well. They take their entire freight with them. The mask remains their specious comfort abroad, as it was at home. It must never be allowed to go one little bit askew.

There are good reasons for this. Most Americans who have the money to travel are among the elite of their home community. They have all the built-in securities of such a

position. Forelocks aren't tugged, but there is that extra-warm greeting at the supermarket, and the extra solicitude from the men working at the gas station, and the protective amenities of the golf club.

Abroad, all these things are gone. You are on your own, as you may not have been on your own since the day you went away to prep school.

There is, too, the question of language, which is more troubling than most tourists will admit. It further increases insecurity to be placed in a world where all nuance is blunted, and frequently meaning itself is missed. This is true even in English-speaking countries like Ireland and England, where the Mother Tongue is used so differently, and with another competence. You are knocking at a door that never really opens.

When you are hit in the old insecurity, the mask is adjusted with a severity even greater than at home. You end up telling jokes about Texas to guys from Michigan in the bar of the Paris Hilton, and eating steak and beans in that wretched Chuck House-style restaurant on the same premises.

Telling the insecure not to be insecure is like telling a worrier not to worry. If anything, it hurts matters.

My advice to those who find themselves lugging themselves along on a holiday is to take all the damned conducted tours you can stomach. Then you see what you see, not what you have come to see, or what you are blinded from seeing.

After a couple of days of this intensive and often rattling exploration you will discover two things: you have been too busy, usually, to worry about the mask; and you will have found several things that you will wish to return to, at leisure and with eyes fully opened.

Gradually, if you have sense, you will drop your Yankee traveling companions. You will discover the rest of the world is as valuable as Santa Rosa, and a good deal more rich and strange. You will begin to find yourself by losing yourself.

And, if you succeed in becoming a good traveler, you will agree with Chesterton that, "The whole object of travel is not to set foot on foreign land; it is at last to set foot on one's own country as foreign land."

Old Nick and the Law

You would think our besotted species would have learned by now that you cannot enforce laws against human nature. By human nature I mean the accepted norms of conduct in the marketplace, in the gym, in the saloon—the places where people are unbuttoned and at ease.

Yet there is some compulsion in Man the Meddler, as distinct from Man the Human Being, to find some way in which to diminish the less respectable pleasures of his fellows. At the same time, of course, keeping in the clear himself.

With this tragic misdirection of effort, we have compelled our police to devote a major part of their effort against something which they cannot imaginably do anything about—i.e. ordinary human nature.

And human nature is everywhere. As Oscar Wilde said: "The more one analyzes people, the more all reasons for analysis disappear. Sooner or later one comes to that dreadful universal thing called human nature."

Society, in granting the police their purview, got two things mixed up: protecting the individual from assault and theft, and enforcing the behavioral prejudices of the ruling class.

In times like this, when there is more assault and theft than can properly be taken care of by our police, it is nothing less than criminal—repeat, criminal—to use the police apparatus against such ultimately unenforceable matters as drug-taking, drunkenness, homosexuality, and prostitution.

In a way, it is worse than criminal. It's foolish.

Most of the disrespect which is leveled against the fuzz these days is because they perform far too vigorously functions which they have no business performing at all.

Instead of concentrating on thieving and violence, cops have been empowered to roust, on general principles, those who are thought to be a threat to the current Establishment.

Someone put it pithily: Society was created because of man's needs; government, because of his wickedness.

Laws arise out of fears. The most fearful people in the world are those who have a fat stake in the system. In late 20th century America, there are more of these people than ever existed before.

Because government increases, and increases, we might be driven to the conclusion that man is becoming wickeder and wickeder. A minute's reflection will remove this notion from our heads.

Men have become more fearful, for the simple reason that they think they have more to lose. They are wrong in this, because they lose more every time they call in the cops than when the old Dow-Jones drops a point or two.

Passing laws to knock the Old Nick out of people is a habit deeply-ingrained, as I have said. It reached the summit of its folly in the English-speaking world in the 18th century—a period of revolutionary social changes.

It got so bad that men and women by the wagon-load were brought daily to Tyburn, in London, to be hanged. At one time during this legal terror there were 223 offenses punishable by hanging—among them thievery in the amount of one shilling.

And crime, of course, continued to increase, until sanity in the person of Sir Robert Peel set in in the 19th century, and the fairest and most sensible police system of the Western World was formed—London's Metropolitan Police, with headquarters at Scotland Yard.

Credit for inspiring Peel has been given to the novelist Henry Fielding, who held the curious view that a police force should exist to maintain the peace—that is, prevent crime rather than punish it after it had occurred.

Our police will be poorly and unprofitably used by us until we remind them forcibly that their most important, and perhaps only, function is to put down thieving and violence against the citizenry.

Thieving and violence. Thieving and violence. That is all. Setting police to chase Old Nick is mostly doing the work of Old Nick for him.

Capital Banishment

We were talking the other night about that foul, inhuman—and, in the end, ineffectual—practice whereby society in cold blood murders people who murdered other people.

Capital punishment, we call it, from the days when it literally meant "off with his head."

We were all in pretty good agreement that the human race hasn't advanced very far over the millenia, but that it has surely advanced beyond the gibbet, the guillotine, the noose, the chair and the gas chamber.

We agreed, too, that guys who murder people *do* present something of a problem to society—whether they are given capital punishment or a life sentence.

No one came up with anything like an answer, however, until the quietest member of the group put his pipe on the table and came forward with an interesting idea.

"I agree with you that capital punishment is archaic," he said, "but is life imprisonment the only alternative?

"Why not bring back banishment?

"It worked fine for England *and* Australia.

"Why not banish our chronic crimesters, three-time losers and murderers who are beyond present rehabilitation methods and send them to, for example, the Aleutian Islands?

"Let them start a new life with the very minimum of aid that would guarantee their survival and perhaps military surveillance. The death penalty would be reserved for only those unwise enough to reappear in this country.

"Loved ones could accompany these prisoners or visit them, but once banished no return for the offender would be permitted.

"Over the years this constant straining out of the worst elements of our society should have some beneficial effects and perhaps something could be salvaged from the lives of those doomed to death or life imprisonment."

And he concluded, "I think it's worth considering."

I must say I found myself in general agreement, although I do not go along with the notion that there is something in the genes of a man that makes him a dangerous criminal. There are few of us who do not have murder in our heart, at one time or another.

Banishment has its merit, chiefly because it changes a situation which is pretty much hopeless to one that is hopeful, to both society and the criminal.

We do know that, when banishment was common practice, many useful societies were founded by criminal elements deported from the Mother Country. Some of those deported were, to be sure, guilty of little more than the crime of being in debt.

Others were really dangerous criminals. In a new country many of them discovered resources in themselves which made of them useful builders and discoverers and artisans.

Capital punishment is an affront to human dignity, and especially to the conscience of those who disapprove of it. Banishment is compatible with human dignity.

Every time a man is killed by society for his crimes, each person within that society, to paraphrase John Donne, is diminished.

When a man like Caryl Chessman, who was certainly not an admirable character, was put to death, who among us can say he felt anything other than a bit befouled?

Who among us? Certainly some did feel some kind of peculiar release or catharsis; but they cannot have been many. These are the people Nietzsche had in mind when he said, "Distrust all men in whom the impulse to punish is powerful."

The core of decent men who make up most of our society do not have this powerful impulse to punish by taking of human life. I dare say nothing will ever be done to restore the institution of banishment; but it is one backward step that might represent an advance.

'Law Enforcement' Myth

Have you ever given much thought to the words "law enforcement?" Or to the words "peace officer?"

I suggest you do so sometime, if you are interested in cops and their activities, and the bad odor which surrounds them in some quarters.

The two phrases used above represent entirely different approaches to police work, although they are often used interchangeably to describe the men who perform it.

The fact that you can use entirely different words to describe the same institution indicates, in itself, that there is some confusion about what the institution's function should be.

That confusion exists in the minds of many American policemen. It does not exist in England, as an instance, where police are peace officers, period.

The law enforcement concept means that the primary function of the cop is to use force to uphold the law, and restrain those who would break it.

My desk dictionary gives the following definitions of enforce: 1. To give force to. 2. To urge with energy. 3. To use force upon, to assail forcibly. 4. To force; compel. 5. To make or gain by force. 6. To put in force; to execute with vigor.

So, law enforcement is the meeting of force with superior force. This is the view the military take of themselves, and the view which the more militant cops in this country (i.e., the majority) take.

It is a view which has brought them into vast discredit in many quarters, and which, if it prevails, will make them even more unpopular with the public.

There are, of course, times when the use of superior force is necessary—as in riots and the control of angry crowds.

But these are minor functions of a police department, though of course important ones. Because of the drama of these encounters with the unruly public, the image of the policeman

is becoming identified with force. In many places the police are called The Force.

We settled this country by law ENFORCEMENT, which is what makes it so easy for us to think in such terms.

When the frontier existed, and men were pushing into unsettled country, justice quite literally existed at the point of a gun. As we know from our Western films, Main street was often literally strewn with bodies before the citizens got around to appointing a sheriff, who was hoped to be honest.

The thinking of those days, and the tradition as embalmed in films and books, has created a powerful bias toward the concept of law enforcement.

Now the frontier is gone; but frontier thinking about enforcement has not. We are a settled country now, but think as if we were still unsettled.

In a settled country, the enforcement aspect of police work should be subordinated to the more humane and useful concept of keeping the peace. And now is the time to do it.

Cops should think of themselves as peace keepers who resort to force only as a last resort, and the public should be encouraged to think of them likewise.

"The only justification in the use of force is to reduce the amount of force necessary to be used," said Alfred North Whitehead.

That is a hard thing to believe, but it is a true thing. The use of unneeded force has brought the police the enmity of multitudes.

The law enforcement concept, I think, is a dead end which has already brought our police more trouble than they can truly handle.

Preservation of the peace is a negative, almost Christian concept, and to many cops doubtless seems sissy as compared with a good manly go-around with the forces of evil. Law enforcement is arresting a gaggle of whores in Pacific Heights on the tip of an anonymous informant. Keeping the peace might have meant forgetting about it until the girls made a public nuisance of themselves.

The San Francisco Peace Department sounds even better than the current name for The Force, and the initials are the same.

On Empty Pockets

English tailors and English ladies agree on one thing: They loathe the bits and pieces that men carry about.

It is their view that the world should see what a man's body really looks like, or at least that current edition of the man's body fabricated by the skill of the tailor.

Influenced by the tailors and the ladies (not the least of whom is his mother), the proper English gent does not tote things about on his person. He wears his clothes, and nothing more, save possibly a thin gold Cartier cigarette case, which may also contain a couple of spanking new ten-pound notes, in case he has to engage in any activity which unexpectedly calls for the vulgar exchange of money.

The result is that the English gent is, and has been for a couple of centuries, the smartest looking of men. It's just him and his clothes. He never carries a package, even a newspaper, in public. If he does carry an umbrella, he goes to every length not to unfurl it. Disturbs the line, you know.

An English lady of my acquaintance married an American (quite literally, for she is a formidable and pushy dame) of mildly Bohemian Hollywood tastes. He customarily wore baggy slacks and a sports jacket sprung at the elbows. He thought he was dressing up when he put on a bow tie.

He carried on him the usual masculine freight: A wallet bulging with credit cards, and the business addresses of lads met in long-forgotten bars; unpaid bills; pieces of paper with little bits of wisdom written thereon; old newspaper clippings; old letters; a pipe and a penknife, etc. etc. etc.

The lady determined to change her man in the image of a Guard's officer. She hauled him to Huntsman's in London, and had a set of suits made. He looked beautiful. He looked beautiful because his wife also had the foresight to go to Mark Cross to have a special little leather satchel constructed for him, which contained all those things he used to put in his pockets. He

walked around Mayfair carrying this elegant little bag stuck under his shoulder blades.

For one reason or another, the marriage did not last. And nobody remembers what happened to that posh little bag.

I was minded of all this recently when I found myself striding along the Rue des Capuchins in Paris. I felt a curious, slightly giddy lightness. I realized, suddenly, that I was not carrying my wallet. There was no reason to. Nobody in France would be panting to see my AAA card, my international driver's license, my Avis credit card, my blank checks on American banks, or the address of that dame I met at a Nob Hill cocktail party.

I did not have that accumulation of silver and copper that inevitably lines our pockets. And I did not have any un-answered mail, because I had not been receiving any mail at all. And I did not have any penciled snippets, which might one day turn into full-grown columns.

The feeling was good. Not merely did my clothes look better on me, I felt a freer person. And I thought, if these things are not needed in France, why should they be needed anywhere?

I reckon on a good day I carry a couple or three pounds of stuff in my clothes which serves no purpose other than to vaguely irritate me. I'm going to try carrying nothing but my driver's license and a few blank checks. Provided I keep my jacket and trousers pressed, I'll be adorable.

The Sense of Wonder

Of the gifts which have been bestowed on me in middle life, the one I reckon highest is a partial recovery of the sense of wonder.

It's almost like buying childhood again, and seeing the world in its newest paint and brightest smile. It only happens once in a while, of course, like falling in love; but it is similarly rewarding. It greases the way through the dust-filled paths of mostly nothing which we call life.

The child has the sense of wonder in the highest degree. Everything is new, but everything is not beyond belief. When you regain the sense of wonder almost everything is new, and beyond belief. The child, when it first takes in the world, is at the same time being taken in by it. The adult, when he experiences his "deja vu" of childhood, literally owns it.

I don't know how this thing happened to me. I suppose it was partly because I became so much detached from other things which had occupied my mind and heart. Or maybe it was a reward for some good thing I did sometime. Anyhow, it's with me, and has made life a harder consideration to part with.

There are mornings when a shaving brush is beautiful to me. I see it, and feel it for the first time. The other day I took a good look at a plate of ham and eggs, and thought I saw in it as much beauty as others see in a Manet.

If this sounds like I'm taking LSD or some other hallucinogen, disabuse yourself. My only hallucinogen is booze, and in fact it inhibits this thing of seeing things as if they had never been there before.

I don't practice at this thing, because I think it a gift. After a lifetime of not seeing really what was about me, or feeling really what was within me, I seem to be catching onto these two fine things.

That very odd Frenchman, Andre Gide, wished in his youth "to have been born in a time when, to celebrate all things, the poet had only to enumerate them."

I'm not sure Gide wasn't born in that time, but may have not been ripe enough. I know people who talk to trees. They were once a joke to me. They no longer are. I don't talk to trees. But I do say tree, over and over again, as I look at one; to find out, I suppose, that the whatness of tree is all tree.

Hemingway had a thing about big words like sacred, and patriotism, and sacrifice. They bugged him. The words that moved him were the names of streets and roads, and fords and streams, and cities and towns where real things had happened to real people.

Until he began to fall apart as a person, he kept this virginal vision. It was his great thing as a stylist. He celebrated things by merely enumerating them. The River Ebro meant more to him, after the battles there, than all the patriotic speeches ever made by man.

What makes things worthy of celebration is passion. And so long as passion lasts can there be a time when, to celebrate all things, one has only to enumerate them? While using the eye and heart.

There is no reason why some of life cannot be a litany, a resounding repetition of things like rock, and tree, and sea, and swift-running brook stream, and all the unvarnished and living and unravished things. The best wish I can give you is that this gift is with you, and will grow.

The Beauties of Boredom

*O*nce in a while even the best among us tires of the sad kindergarten of life. From space ships to swizzle sticks, we begin to wonder if there is any point to our toys. The monastic life begins to look pretty good.

The state is boredom. It has always been one of the great facts of life. A gentleman in the English legal sense is a man who doesn't have to work, and does not. Gentlemen are often bored. Because they have the time, they are compelled to take life straight.

Under the New Leisure, a kind of half-gentleman class is rising in our society. Some of us have more time on our hands than we have resources for its use. As a result we are both physically and spiritually under-employed. This, too, is another part of boredom.

Medieval theologians had a very low view of boredom. They called it acedia, from the Greek word meaning, roughly, "I don't care." It meant lassitude of spirit, denial of life, spiritual sloth.

Boredom is a bed-fellow of mine, as it is of many another Black Irish melancholic. I sometimes sit outside my boredom and look at it. I find it an awful thing to contemplate. It tells me that nothing is worthy of achievement. And I listen.

Yet there is an obverse to the coin. If I were not bored, I literally could not work. It is when I become tired of myself that my mind begins to roam in faintly creative paths, and the typewriter assumes a most seductive dress.

It is when you get tired of straightening papers, paying bills, making puerile telephone calls, thinking about your love life, and having another tall one—it is when you have finished these preliminaries that you enter that wonderful kind of boredom which almost literally forces you into communication with some deeper part of your fellows.

Lord knows, writing these essays is not the most creative thing in the world, but it is a little tougher than hauling water. You have to say something regularly that you are not ashamed of saying, and that you hope you will not be ashamed of having said a year or two from now.

Spiritual sloth it may have been to the abbots whose lives were made pestilential by its presence among the more gifted of the monks. Listlessness of heart it may have been to those superior theologians whose talent lay in defining and dissecting the weaknesses of man.

To me, boredom is quite literally my bread and butter. I have to cultivate and cosset it, in order to achieve that infirmity of spirit which insists I communicate with people.

Making the scene, and especially making the scene with the aid of the grape, is one of the great enemies of boredom. When I have gone on the town for a couple of days, achieving boredom is a tough discipline. It is a process of making yourself sick of yourself.

If I am thinking kindly of boredom at the moment, do not think I always feel that way. There are times I could take boredom and wring its neck.

There are days when I could have lunch with a beautiful woman in the open air, and I deny myself the pleasure. There are times when the kindergarten of life is jumping with joy, and I brood over my black, implacable soul. But, as my mother used to say, what's the use of being Irish if you can't be thick.

Love Those Train Robbers

*A*m I one of a minority in feeling admiration for the skill and courage behind the Great Train Robbery?"

The question was advanced recently by the distinguished novelist and wrestler with moral problems, Mr. Graham Greene. It's a good one.

When one of the robbers, Ronald Biggs, broke out of Wandsworth Prison a Labor M.P., Mr. Tom Driberg, was able to say, "Many law abiders learned with a slight thrill of delight that another train robber had escaped . . ."

And a leading columnist, Mr. Bernard Levin, could observe that he "greeted the news with delighted amusement. I have not so far come across anybody, at any level, who does not share in the hilarity."

I don't think it's any minority Mr. Greene belongs to. As far as I can see, it's a clear majority. I belong to it, too.

Not that I'm particularly proud of it. There are quite a few little facets of my personality that I'm not proud of, but have learned to live with.

Why do we love a thief? Especially a thief on a grand scale? Why is Jesse James a worthier figure in the eyes of many than Rutherford B. Hayes? Why should a sniveling little bum like John Dillinger enter the national Pantheon? Why Ponzi? Why Philip Musica?

The Great Train Robbery was a neat bit of work. In 1963 a gang, of which seven were later caught and sentenced to 30 years for larceny, held up a train near Cheddington, in Buckinghamshire. They got away with over $7 million of used banknotes.

The victims (and this is important in gauging the public reaction to the crime) were such solid, respectable institutions as the General Post Office, the National Provincial, Midland, Barclays, National Commercial, and four other banks—and their insurers, principally Lloyds.

These institutions are inhuman. They almost ask to be sacked. Despite some formidable public relations efforts to change things, people don't love either banks or public buildings. Banks are a citadel made to fall. Bankers are bubbles made to prick. A little fire is lighted in our hearts when J. Worthington Willoughby, prexy of the First National, gets it good.

There is no use for the moral to remind us that it is dangerous to regard these brutal criminals as clever, courageous Robin Hoods, and that such an attitude infuriates the police, handicaps them in their work, and encourages youths to believe that crime really does pay. As it so often does.

We can be reminded time and again that in real life a thief is just a thief; and that if he steals millions instead of bucks he is simply that much greedier and nastier. Cleverness and audacity, we know, are not admirable qualities when directed to squalid and criminal ends.

Somehow, these worthy homilies just won't wash. There is something in our nature which can only be called kleptophilia —we dearly love a clever thief, whether his name be Raffles or Ronald Biggs. The roses and raptures of vice still continue to grab us far more tellingly than the lilies and languors of virtue.

The clever thief does something profoundly satisfying. He acts out our most exalted childish fantasies, like when we gaze glassily at the skies as we loot the Bank of England, or win the Irish Sweepstakes; or, for that matter, ravish Helen of Troy or Cleopatra. It satisfies the truest and most human part of us that somebody did what we merely dreamed of, and sometimes even got away with it.

A thief is pure id. He's a man who just doesn't perceive the distinction between the words yours and mine. Like the omnipotent infant, he wants everything he spies or touches, because it's his.

I agree with you fully that these feelings are immature. But I also claim none of us grows up very much after the age of two. No?

King Lear in Texas

T he young screen writer offered me an oval Turkish cigarette in a thin gold Faberge case given him by his mother, a famous actress. We were in a fancy trap in Park Lane, London, called Les Ambassadeurs, situated in a mansion that once belonged to the banker, Leopold Rothschild. I said No to the cigarette, and we ordered lunch.

He said, "This place is marvelous, really. Nearly everybody who comes here is terribly big in the movie business. In Hollywood and New York they are treated like Cyrus the Great. In London, nobody ever heard of them. They are just bodies, cluttering up the streets and hotels.

"So they come here. Everybody knows the pecking order of Hollywood, down to the last officeboy. Each knows who is going to do something with Marty Ransohoff next, and who is just talking about it. They feel comfortable here. They can cut somebody socially, and he knows he is cut."

We leaned into the smoked salmon, had a long palaver about wine. I decided to be defiant and have some red with the trout. I asked my host, "What you working on now, kid?"

"Ever hear of King Lear?" he asked. "By Shakespeare," he added drily. I said I had taken a couple of cuts at the epic, but it had always defeated me. Those three daughters almost had me barking, especially the King's true love, Cordelia.

Lear, for those of you who have had a full-blooded American education, is a king who gives over his property to two ungrateful daughters, on condition they care for him for the rest of his life. They do not. There are lots of complications with battles and his true daughter, named Cordelia. The old man goes nuts and dies, and so do all the daughters, like in Shakespeare.

My host related how, one rainy night in his mother's country house, he was driven to reading in her library, which ran heavily to the Russians. The only Russian he could stand,

he said, was Turgenev. He pulled down a volume containing a tale called "A Lear of the Steppes," which placed the whole sorry saga in Siberia.

Suddenly, he said, "it came to me that I was reading a marvelous Western. So I tell this to a producer, and he starts making noises about venture capital, by which he means the bankers in New York. Venture capital is only interested in the tried and true. In the movies nowadays, this means a Western with a big name as star."

The producer got an idea. He picked up the phone, and talked to Hollywood. "He said to me, 'I think I can get Duke.'" For the benefit of those who don't know, Duke is John Wayne, the surest thing venture capital ever heard of, the man who could draw $10 million in Gertrude Stein's "Four Saints in Three Acts."

So the producer calls Chase Manhattan in New York, and says he got Duke for a super-Western laid in Texas, which has been very big since President Kennedy got shot there, and it's written by a guy named Shakespeare, so the price is right, which is freebies.

"I'm getting two grand a week for the treatments." said the writer. "And I feel good because I conned the producer, who really doesn't believe it's by Shakespeare. He thinks it is by me. The producer feels good because he has conned both Duke and the Chase Manhattan. And with Shakespeare, it's so what."

I said was he going to get Joan Fontaine for one of the daughters, and he said No, the broads are all turned into young squirts now, and Cliff Robertson has been talked to, though next week they might be all broads again, and Joanie would have a good chance.

The only bad thing about the setup, he continued, is that after a while his invention began to flag, and he has to read the damned play in the original English, and it's uphill work, old boy, on account of now I'm *really* stealing and, after all, I did have a good Christian upbringing.

He picked up the check. "By the way," he remarked, "you ought to read it. Not bad at all."

Remember Servants?

I had a drink in Paris with a lady who is usually described by the gossip and fashion columnists as "a great hostess."

If there is such a thing, I suppose she is. The lady has several venues: A Paris flat, a farm in Vermont, a place in Nassau, a chalet in Gstaad, and an apartment in the best hotel in New York. Chiefly, though, she has a large establishment in Long Island, where she keeps a husband and 14 servants.

"How do you keep your servants?" I asked, as if I did not know, more or less.

Her answer was better than I expected. She said, "It's quite simple. I overpay them and I wait on them."

I suppose one of the things the brave new world of 2100 A.D. will find most difficult to believe about its forbears is that there were things called body servants and household servants in the western world up until about the middle of the 20th century.

Only the very rich bother to have proper servants any more, and the only reason they go to so much trouble to find them and retain them, is to show that they are very rich.

The search for symbols of conspicuous waste goes on continuously among the very rich. This search is beginning to become uphill work, since the man who has everything is increasingly that little squirt next door.

But you are still right up there with the wasters of the past if you employ an English butler who steals more in a year than a captain of detectives or a competent shortstop earns.

I once buddied up with a butler who told me why it was that he refused a month's vacation in the Bahamas, with pay, each winter. "Hell," he said, "I'd lose too much money on the deal."

A butler's life isn't all hell, these days. Where else can you earn 10 grand a year, and steal all the traffic will bear, and at the same time be shiftless, insubordinate, drunk and disorderly?

In the abstract, some successful butlers deserve ten years in the tank for just being their own sweet selves; but, as a practical matter, they will continue to be in demand, and their conduct will never be held against them as long as they remain upright through the main course. Madame can take care of the coffee.

This is all because our egalitarian society tells us it is a bad thing to tug a forelock, and iron out milord's daily copy of The Times, while it is perfectly admirable to give heart, spirit and guts to IBM or the Ford Motor Company for salary and perks.

There are fashions in servility, as there are fashions in everything else. It is part of the cant of our time that there is something wrong about taking care of somebody who is perfectly capable of taking care of himself.

There is little doubt that most gentlemen who have gentlemen's gentlemen taking care of them are more capable of taking care of their gentlemen's gentlemen than he is of taking care of the gent.

All of which misses the point. If a fool and his money are soon parted, that's fine for the fool, who wants it that way, and is doubtless good economic sense, too. If a man feels he needs a valet to engorge his ego so that he can enter White's or the Racquet Club like a man each noonday, what's wrong with that? It's good for him and it's Heaven for the valet.

If I were not particularly attached to my own form of bondage, which is being valet to a lot of damned readers, I think I would enter service. At least, I can steal.

On Being Alive

Really it is a good idea to read your mail to the bitter end. Otherwise, you may miss some rather pointed message.

Like the other day, I was reading a press handout which consisted of a long and rather interesting dissertation on diseases of the respiratory system. (Man is naturally a tropical animal, and as he moves into colder climes mucous develops in the passages as defense, etc., etc.)

Came the last page, and the whole tone of the anonymous author changed. He became visionary, and wrote:

"Man is not concerned with living. He just does not want to die. He expends most of his energy delaying or fighting death, rather than living, as evidenced in his increasing life span and his still greater increasing rate of disease and dissatisfaction.

"Instead of accepting that dying is a process of living, he thinks that living is a process of dying. Thus, man in essence is denying his life by saying 'I don't want to die,' rather than 'I am alive.'"

Now, there's a guy who talks real good.

The idea is held by far too many people that life is essentially a struggle against death, rather than a process constantly to be savored and enjoyed.

The continuous contemplation of death, and combat with it, is of course a bit morbid. It is not merely morbid at the time. Thinking on death constantly can color the personality in a gray and sour way.

Saying that you don't want to die when you know damned well that you are going to die, is not a way to bring out the best aspect of your spiritual nature.

One of the leading illnesses of our time is boredom, which is just another word for denial of life and romancing with death. With the increase of leisure, boredom threatens to become endemic in our society.

77

Boredom is a result of a lack of deep inner spiritual resources.

It is not easy to tell the bored man that life is for the living, and not to be retreated from. This is like telling a man in an anxiety state not to worry. Both know full well the irrational nature of their complaint; but they are helpless before it.

Yet there is no cure for his malady unless the word somehow gets through to the sufferer. He must somehow be persuaded of the vast difference between life and death, and that in his life-style he is serving death, and running away from life. He must make that telling distinction, alluded to by the author above, between "I don't want to die" and "I am alive."

Boredom and life-denial, too, lead to hypochondria, another of the leading ailments of our time.

The number of physical ailments which come from a troubled mind multiply by the day. What is called psycho-somatic medicine burgeons.

And so much of this can be avoided by the simple affirmation that life is better than death, and is here to be enjoyed. That life is a gift and not a burden.

There are times when our resources run so low that we cannot help but look at things through a glass darkly. But the main thrust of our existence, if we can but manage it, is to jump into the full and swelling tide of life.

This is another way of saying we should concern ourselves always with taking things on, rather than sloughing things off. New interests should be sought like paying ore. Everywhere and whenever it can be arranged, the pulse should quicken.

Avoiding death is not merely a rather shameful way of doing things; it also does not profit a man. Death is a matter that we cannot do anything about, in the long run. Living is something we can do, if we are free of the bondage of absorption with death.

The Rest of Your Life

*T*here is rather a nice little motto going the rounds these days. I heard it for the first time at that cultural bazaar, the Buena Vista saloon.

"Remember," a friend told me, "today is the first day of the rest of your life."

This gnomic observation hit me with no small degree of poignancy.

Every once in a while something happens to remind me of life's extraordinary value, and of its transience. For my own good, this doesn't happen often enough.

For those of us who are gazing into the sunset of life rather than living in its bright intense heat, the observation has its special relevance.

It was William Osler, the famous Canadian doctor, who used to urge that one look at life in 24-hour segments. Carpe diem, he said. Just figure, one way or another, how to get through the single day of life and sleep ahead of you—and all will be well. You can cope with the past and the future best, he said, by coping with the day at hand.

While I have always admired the wisdom of the good doc's view, I have never been able to live by it. Not for want of trying.

For me a day is a part of all my days. I'm sorry; but that's the way it is. I know I would be better constituted if I did not think this. But I am not better constituted.

The failures of the past and the fears for the future all color the quality of my day. Past successes and future hopes have something to do with it too, to be sure. But today's Thursday or tomorrow's Friday are indissolubly tied in with the rest of my days, coming and going.

I don't really see how it could be otherwise. Dr. Osler notwithstanding. You are what you've made of yourself, with the grace of God; and, to a smaller degree, what you hope to make of the rest of your life.

This is not to say that one should not try to live for the day. Like a lot of other admirable objectives, it is not really attainable. A great deal of good may come of trying.

To think that today is the first day of the rest of your life, therefore, has its decided usefulness.

But you must *really* think it.

Here it is: There are just so many days between now and the time I face the old Maker, and today is the first of them. You have to repeat simple and good things many times before they come through to you.

Once you have achieved this useful admission, several things are likely to happen.

Perhaps the most useful of all is that you begin to exorcise the past, that weight which makes life so hard to bear for many of us. If you think only of the present and the future, it will matter less that some broad in a red dress ran out on you on a noisy, snowy night, and made life quite a hell for you for a long time.

Nor will the fact that you failed in chemistry in high school be likely to emerge and dampen your day. You may end up more a man of action and less a philosopher, but who is to say that is for the bad?

Like most people, I daresay, I respect most those maxims which are fine-sounding and foreign to my nature. This means, for one thing, that I can have the noble sentiment of appreciation without the hard work of doing anything about it.

But if I honestly believed that I could put the past to bed, even temporarily, it would certainly enhance the vigor with which I would attack the filthy old present.

As of the minute, being mildly crapulent, I do not feel up to taking on any moral exertions. But I am never above sermonizing, which usually makes me feel better and does not necessarily hurt anyone else.

So I say to you, this is good: Act as if today is the first day of the rest of your life. And say a little prayer that I may manage to do the same thing.

The Art of Listening

I am convinced that a good deal which bugs us in our dealings with our fellows would be lost if we listened to each other.

Someone has said that talk was an invention to conceal thought. It might as truly be said that serious conversation, as usually conducted, is an invention to scuttle agreement.

When two people have a point of difference—whether in business, in love, or in games—and enter into a discussion about it, they nearly always emerge with the same equipment they entered with.

That is to say, their defenses. Each man thinks, of course, that he is right, and develops an impressive armory of rationales —some rational and some not—to sustain his conviction.

In "discussion" (which is a polite name for argument) this man is not likely to let his defenses go lightly. Nor is the other man, and for exactly the same reasons.

They end up talking to themselves, not listening to each other. They do not listen until economic pressures, or emotional pressures, or the entry of a third impartial party, compels them to use their ears.

When two sets of defenses flail away at each other we simply have debate, or argument. This is a primitive form of communication. Almost never does anything conclusive emerge from it.

A great enemy to communication is the logical or syllogistic approach. This assumes that feelings between people are rational. They are not. Feelings and rationality are far too often contradictory, by definition.

The rational fellow, when he runs into feelings contrary to his own, tends to explain things. Explanation ignores the existence of feelings. It plows ahead, patiently and with a relentless rationality.

In the end, because he does not understand he is dealing with feelings, he gets nowhere. He irritates himself because

he has failed at explanation. And he downgrades the feeling person, who does not respond because he did not want explanation. He wanted communication.

A great many labor disputes, it has been ascertained, derive not from wages and hours, but from wounds to the amour propre of the worker. The employee feels he is being undervalued as a human being. These feelings are very hard to put into words, especially when talking to the one who has wounded the feelings.

This is where skilled listening comes in.

The good listener must throw away a lot of the rubbish of rationality. He must understand that he is dealing with feelings instead of facts, and that feelings are far more important than facts.

The good listener does not try to get someone to understand him, by the logical techniques of explanation. He tries instead to understand the person, by listening. He allows him to parade his feelings after he has gotten through the facade of "facts" that presumably caused the interview.

Listening brings people together, explaining tears them apart. The good listener allows the speaker to flower, and be accepted as a human being.

If listening to men is important, listening to women is imperative. These charming creatures are almost wholly impervious to the claims of ordered logic. The most lucid lecture in the world, given with the best of intentions, will only make a woman or a little girl back away from you.

Listening is a skill, and have no doubt of it. It is not taught in schools, which still make obeisances before the syllogism.

Unless you are one of the rare persons who was born with the talent, you have to learn it. Learning it is largely unlearning the gospel that every cause has its effect, etc., etc. You will never get very far in dealing with your fellows if you assume that human conduct—yours or theirs—is rooted in reason. If you do not know this is so, just listen.

The Older the Better?

*I*t is my firm belief that the older I get, the better I get. So far.

In the eyes of most people, this is not a prima facie case. I am prepared to defend it at the drop of a gland.

Aging can be more than a decomposition of the faculties. It can be an opening of the eyes. This opening can be physical or spiritual; or, in certain gifted cases, both.

When various passions of dubious value are becalmed, you can sometimes achieve the understanding that passeth all peace. This is a flavorful thing, indeed.

In age, there are less things to be afraid of. In age, there are less things which can hurt you. The thought of death terrifies some, steadies and even exalts others. The best way to think of death is that it is simply a fact of life.

You can be disappointed in love, of course. When you cannot be disappointed in love, you have far too healthy a purchase on death.

But you cannot be destroyed by love—unless you have held onto your childhood throughout your life as a squirrel holds onto a nut.

Among the loveliest gains of all is the fall from the illusions of the competitive life. Proving you are better than the next man (whatever the hell that means) becomes an objective of increasing inconsequence.

When you were young and looking for a niche, you may have wanted to run the hundred in 10 seconds, or write a perfect sonnet in 10 minutes, or seduce that most improbable She in 10 hours. When you have settled into that niche (be it palatial or cavernous) these invidious contests are as irrelevant as the dust on Mars.

You will observe I said "the older I get, the better I get." I did not say wiser because I do not believe it. My judgment was subjective and selfish. I speak now of better as applying to one's own life, and wisdom as applying to the lives of others as well as one's own.

I almost always get an unpleasant turn when an old man is elected to the seats of high or supreme power. Old men become sere and rigid, like good fruit left too long in the sun. Their thinking is done by their pocketbook, by their wives, and by the attitudes which prevailed at the time of their youthful education.

Experience is a wonderful thing, but you should not beat the young of the world about the head with it. Ideally, experience should be fed into the vital juices of the young. The resultant action, taken by a young leader on the advice of one over the hill, would come as close as anything does to political wisdom.

How the world would have been changed if the passionate young Corsican, Napoleon, had taken the advice of the cynical old roue, Tallyrand! Europe and the world would be far different places today. But Tallyrand, for all his wisdom, would have been an even greater disaster than Napoleon, if he had chosen to act with the impulsiveness of the fiery Bonaparte.

Wisdom without virility is as useless to the common weal as virility without wisdom.

The hopelessly unattainable ideal, I suppose, is to get the young to Think Old and the old to Think Young. Wisdom is not growing old, nor is vigor staying young. The well-connected and well-adjusted man, of whatever age, is the lad who sees the point of what he is not.

Respect for the old is preached in most civilizations. Less, perhaps, in ours than in most others. Anyhow, it's a good idea.

More important, perhaps, is to have the old respect the young. This is tough, because it is against all delivered dogma. It is revealed truth, in this view, that the older you get, the smarter you get.

I submit that this proposition remains to be verified.

And so, we aging codgers will cultivate our gardens because, among other reasons, the flowers will not argue with us. They will live, and delight us; or die and sadden us. And that will be that.

Of Those Making It

With a certain justice, I have been called a snob. This is "one who by his conduct makes evident that he sets excessive store by rank, wealth, and social eminence, to the detriment of merit."

I think the definition excessively harsh (and it is much milder than another one, also in Webster), especially in the final phrase. I have found a great deal of merit among the wealthy, the eminent and the ranking. Yet it is true that many of my friends have much more money than I, and are known to Dun and Bradstreet, and Debrett, and the Social Register, and other indices of rank and eminence—if not necessarily of merit.

(In fairness, I should confess that I'm still in Debrett, by virtue of a defunct marriage.)

I even find an enormous seduction, together with a bit of downright nonsense, in the view of a Mexican friend of mine that "all women with money are beautiful, dear boy."

Equally with a certain justice, a great many of my friends are bums, meaning people who "lead an idle, dissolute life." I have more than once been called a bum myself.

To further complicate things, some of the bums I know are snobs, and some of the snobs are bums.

There are, in my acquaintance, scores of barflies, and retired cops, bartenders, indigent longshoremen, butchers who kite checks, and laddies who leave their wives from time to time, and their kiddies even. Etc. etc.

I can identify with the bums and with the ranking. It's the types in between who lose me.

These are variously called the salt of the earth, the great solid middle class, and the boys who carry the hod. I prefer to think of them as Making It.

I do not feel any real hostility to those who are Making It. I just have no sympathy for them, and find it difficult to communicate. I will agree that this is a deplorable thing, and

that the world could not get along without the Makers of It; but that's the way it is, my trinkets, and I do not see how it will ever be otherwise, despite the fact that many Makers of It were once bums and may someday be eminent.

When I go out in the open air those who Make It just aren't there, like Tibet.

What I like about the bums and the rich and ranking is that they are, respectively, below and above Making It. More important, they are not interested in Making It. This gives them a kind of detachment and courage, and acerb humor about the striving middle class, that I find most agreeable.

I remind myself, of course, that nobody is ever *really* above Making It, and that the most secure of San Francisco hostesses will run her rear off to snare him if she finds that Lord Mountbatten is about to lurch into view. What I mean is, relatively . . .

Likewise, there is no bum so detached that he won't roll one of the rich and ranking, if the circs are right . . .

I find it actively embarrassing to contemplate those who shamelessly accumulate the stigmata of success—the right club, the right way to pronounce the names of the right jewelers (Harry Winston excepted), the right prep school, and the right period to be knowledgeable about in furniture and art and bijouterie.

Put it another way and I won't get in a fight with you. Say I reject the values on which our society is based. I will not say you No.

I don't like the inmates. I like the outlaws and the escapees. They may be mad, like the joke goes, and the inmates the only sane folk in the house; but I go along with the mad ones.

The bums do, and the meritorious among the rich do, too; and that is why they are my folk.

The inmates don't need any crying over. They have that infinite capacity for self-delusion which is essential to their state. Money is still rich and strange to them, and enjoyable. When they learn money means nothing, by dropping sharply in the social scale, or rising sharply in same, they will have gained a wry, new wisdom. I'll be the first to buy 'em a drink.

Thanks for Everything

I found myself recently puzzled again by a problem that has bedeviled me slightly most of my adult life.

Earlier, I had been a guest in a pleasant country home, and had enjoyed myself hugely, as always when I go there. From the sheets to the port, everything had been terribly luxe, and I find it somehow easy to fit into such an environment.

The visit ended, memories were pleasant. It had the bonus that comes with some house parties in that I met new people whom I should like to see again—and that does not happen to an aging gent, slipping too easily into the clouds of melancholy.

What remained to complete the cycle of a wholly pleasant occasion?

A thank-you note, of course.

That's where the trouble is. I find it difficult to the point of impossibility to write thank-you notes. The worst part of it is, the more gratitude I feel, the harder it is to express it.

This, as I well understand, is what the savants call an emotional block. Further, I am aware that when a block of this size exists over a matter entirely irrational, it is of some importance to my whole nature. Understanding why the block exists, so the theory goes, brings a purging of spirit, a release of one small devil.

Yet, try as I will, I find it hard to understand this thing. Perhaps I should get the services of a good psychiatrist (English non-Freudians are the best, in my view) and figure it out. This would at least make it easier for me to get along with hostesses.

I do know there is some highly private part of me that I do not wish to share with anyone. Everybody does have this thing, I expect. It is our nature, our essence, that which gives us the right to hold a name.

Perhaps I'm a little bit nuttier on this subject than other people, who seem to hold onto themselves without thinking everyone they like constitutes some kind of raid on their essential quality.

This is selfishness; but not as the word is understood in the ordinary sense. Obviously, the selfish thing is to write thank-you letters of enormous charm, telling madame everything nice you can think of her, and then sloshing on a bit of the whipped cream at the end. You get a lot of damned good meals that way, and a reputation as a divine extra man.

No, the whole trouble is that I feel imprisoned somehow when caught in the grip of gratitude. To owe something to someone means that something of you has been mortgaged to someone else. The more of these charming claims are made on you, according to this thinking (which I know well to be probably irrational) the less you remain yourself. And the more you become something else, which is bound to be inferior, since it is less than yourself.

It's like being in debt, a little. Although I've never had a great deal of money in my life, I have an unholy fear of being in debt, and have managed to avoid it with some degree of success. Being in debt means someone else, or a lot of someone else's, have a claim on you. For a person of my temperament, such a thing is intolerable.

I know all those stories about the carrot in front of the nose, and how you must go headlong in debt, and then work yourself out of it, in order to be a success in this world.

That, to me, is the bargain of Faustus. When you go in debt, you lose your soul, or some large part of it. And a soul is never regained. There are rich who seem to have managed the transaction so that they have bought themselves back; but don't you believe it—listen to them when the wine really hits the brain centers.

There are those who write thank-you letters mechanically, because they were taught to do so, just as I was taught to say mechanically "Thank you" when a small service is rendered me. I envy these people. And I feel sorry for characters like myself who make a production about a small display of good manners. Well, it's my cross, and my hostesses will have to bear it.

The Honesty Cult

All these cats and chicks sit around spilling their ruddy flipping guts at each other about how ugly they are, and what funny private habits they have and when Daddy first lunged, and how Mummy was sleeping with the shortstop, and various other matters, and it's all called honesty.

The meetings, which are said to involve at least 200,000 persons in California alone, are variously called rap sessions, sensitivity training, group therapy or encounter groups.

The thing, which could be called the honesty cult, is sweeping the country. Like Mah Jongg, and Fletcherizing, and swallowing sardines, and how many cats you can fit into a telephone booth.

Apart from the obvious dangers of the cult—such as driving unstable people really up the wall, or leading depressives to suicide—there is this whole question of honesty between people.

Honesty, as between people, is hardly the best policy. It may damned well be the worst.

You show me the man who tells the woman he loves exactly what he thinks of her and I will show you the man who no longer has the woman he loves.

You tell the woman you love what you think of her; but you had better be a gentleman, which means you better have manners, which means that your relationship with her is always a kind of considerate dishonesty.

Beware of the man who says he is honest. He is almost certainly a liar. And almost certainly cruel.

Take this woman. She has qualities which cause you to love her. She also, being human, sometimes smells bad, and is given to using the word fun in unfortunate contexts, and from time to time even reads movie magazines. Such like.

You tell her some of these things, or that she has a fix on her father, and you are surer than hell being honest, and surer

than hell being cruel. Worst, you are acting against your own true interest.

If you are interested in being honest, and I suppose we all are, forget about being honest *with other people.*

It is possible, I think, to be honest with yourself. I've spent a lifetime trying to do it. It has brought me a lot of hell, but a lot of health too.

"To thine own self be true," said our greatest poet. And the corollary is equally true—you shall not be false to any man.

Being honest with other people, whether in an encounter group or in a family situation, is a harmful and impolite form of self-indulgence. It is righteous and cruel, two things which so often seem to go together.

All living with others is an honorable lie.

But with yourself, the utmost severity is in the end the gentlest kindness. You kid yourself, and you are kidding everyone about you.

I was once terribly fond of a woman, and on a hill in France with a bottle of wine, I made the terrible mistake of telling her my version of the truth about herself. I assassinated her love for me. And no man, anywhere or anytime, has the right to do that.

There are people who say, I want it warts and all. They are either deluded, or fools or masochists, or a bit of all three.

The civil man wants from his woman the version of himself he has agreed to show the public. The degree to which he knows about the warts, within himself, determines the face he shows to other people. He does not want to be told about the warts, especially by a person he loves.

Or put it this way. If you are really honest with yourself there is no reason to be honest with anybody else. God put you on this world to take care of yourself, first, and then, when you have mastered this nasty problem, to take care of those you love. "Honesty" with others will get you nowhere, and you better believe it.

Befuddled Anger

Some bright gentleman on the Chron's copy desk was thinking good a few weeks back, when he produced a beautiful headline.

I do not recall what the story was about, for the good reason that I did not read it. The headline was so fascinating. It said: "HE DOESN'T KNOW WHAT'S GOING ON, AND HE DOESN'T LIKE IT."

How well that describes so many of us, these days! There is a kind of pervasive, befuddled anger in the air. It empoisons so much of our relations with others. While we can know it exists, it is so hard to put a finger on its cause.

It's more than Vietnam, and the gap between the ages and the races. It's more than population and pollution. It's more than the rule of the computer.

If I reckon it correctly, it's more like a feeling that something has got out of hand, that we have lost control of our destiny, that no matter what we do, it has a very good chance of turning out badly.

There is plenty of reason for this feeling. In the past man could say, with a feeling of justice, that he was a builder. Nowadays he is beginning to get the dreadful feeling that he destroys more than he builds.

Instead of working from the mud to the stars, too many of us have the feeling that we are participating in the suicide of our species. And that adult-caused suicide, in the case of our children, is something akin to murder.

Whether it's a pesticide gone wrong, or the byproducts of an automobile culture fouling the air, or one of a hundred other wrong moves that started out looking right, things continue to go out of control. The locomotive has lost its brakes.

And there seems to be little or nothing we can do about it. Get rid of the automobile? Power it by electricity? Nothing gets done. Los Angeles continues to strangle itself.

Treat student dissidents with magnanimity and generosity? Treat them like the bright young adults they are, for the most part? Yield to so many of their demands, which make so much sense, in a world of atomic threat and what amounts to a peacetime draft? Nothing much seems to get done.

It's as if a paralysis of the spirit had set in, and set in on some of the best of us. The descendants of the men who built the railroads across the face of this Nation are unable to see that the job of ending pollution of our air and water is more important even, than building railroads was.

Our building talents, which are our great characteristic as a people, are channeled into idiocies like moon travel, and monstrosities like the manufacture of murderous weaponry.

The great social problems of our time seem to merely get worse as every day passes, in spite of the great amount of cerebration that goes on about them in government and in universities—which are increasingly becoming the same thing.

Truly, we don't know what's going on. Truly, we don't like it.

The one follows the other, of course. It's like an emotional sickness, which can only go away with the penetration of understanding. Merely to exist, you had damn well better know.

Knowledge is not easy, but it is possible. Here is where the hope lies.

One of the reasons for this malaise we have been talking about is our increased leisure. We have time to think about our troubles, and to brood over them. An idle mind, we do not have to be reminded, is the devil's workshop.

Most of us puzzled adults are not so badly off that we need a doctor. More, we need a teacher. We are as badly in need of education as are the young. Instead we play golf, and lush it up. We are badly in need of education in one particular field: the enormous harm we have inflicted on ourselves.

Use and Fling

\mathcal{A}mong our other distinctions, we Americans are the world's greatest wastrels.

Waste is as clear an ensign of our culture as pro football, cowboy movies, or the obscene ritual of running for the Presidency.

We debauch our forests to make Dixie cups, which were perhaps the original use-and-fling objects.

We appeal in newspaper ads for funds to feed the starving of the world, and throw away enough food to support several countries.

We trade in automobiles shortly after they have been broken in.

The French still use all of the pig but the squeal. Lord only knows how much of the pig ends up as garbage in this country.

Waste has its roots in laziness and affluence which are euphemistically called "consumer convenience."

Waste and its appeal is creating a tremendous boom in disposable materials. It also promises to create a huge problem in garbage disposal.

Thus do bad things produce further bad things.

The throwaway—or non-woven market—consumes about 217 million pounds of textile fibers a year. The "non-wovens" are fibers held together by chemical or mechanical means. They look very much like paper, and can be produced faster and cheaper than lasting woven or knitted materials.

But their great virtue is waste. You can fling 'em away once they have dirtied.

You can get paper dresses, and paper panties. These latter are becoming very popular, it is said. You can get disposable sheets, and pillow cases, diapers fetchingly called Pampers, swimming trunks, and caps and gowns for graduation. The industry is now working on a throwaway brassiere.

The Chase Manhattan Bank recently published a study saying the industry has sales of about $500 million annually.

This is more than 10 times the size of the market five years ago.

The market is expected to increase greatly in years to come, as the housewife becomes lazier and lazier. Or, as the industry would put it, she is more committed to "freedom from maintenance."

After you wear, or use, your throwaway once, what is going to happen to it?

Looked at pessimistically, as I tend to look on it, it is going to contribute to another of those growing problems which face cities and large towns: the disposal of trash and garbage and refuse.

The consumer can throw away his disposable. Society, when it has to take it over, cannot dispose of it in any effective way yet discovered. Most municipalities simply do not have any place to get rid of their garbage and trash.

The amount of garbage collected in this country, according to the Institute for Solid Wastes of the American Public Works Association, comes to 5.3 pounds per person per day or more than 190 million tons per year.

This, the Institute predicts, will rise to 8 pounds a day or 340 million tons a year by 1980.

Who will pay for the tremendous enterprise of getting rid of all this refuse? Of course, the lazy people who bought the throwaways in the first place—because they were cheap, among other reasons.

The whole idea of replacing the durable with the disposable, which exists in the intellectual as well as in the business world, is too characteristic of the shoddy in our society.

Who can say that we will not turn our moon-going space ships in for new models each year, like our Caddies and Mustangs? Waste is an integral part of our way of life.

We have used with reckless abandon the precious fruits of the good earth, and perhaps are being forced into making funky synthetic products because of our despoliation. Better plastic Dixie cups than paper ones?

But man is a stupid animal. He calls it progress when he throws away his heritage. No throwaway shirt is ever going to be like a silk one. No throwaway house with throwaway furnishings is ever going to be like the honest pleasures of housekeeping. So there.

Is More Better?

One of the persisting delusions of our time, and especially of our place, is that more is better.

At no time is this notion better illustrated than during the holiday season, which is literally a frenzy of activity.

So many of us are evolving into a breed which grows guilty if even an hour is spent in anything quieter than scurrying.

There is a huge social sanction which favors activity simply for activity's sake. The good man is increasingly defined as the chap who, when he has nothing else to do, rushes down to the club to play a game of tennis.

In work, the skillful and sensible man is the fellow who in time works himself out of a job. He is disapproved of.

I am not saying that there is not a case for activity. It surely improves the circulation, which the docs assure is a good thing all around. And it causes you to make lots of new friends and acquaintances, which may or may not be a good thing.

But we must, I think, ask ourselves some serious questions about the *quality* of our activity? Does it do more harm than good, or more good than harm, or is it just neutral and possibly pointless?

These questions are more searching than one might think.

Most persons take it to be gospel that the work they do is a good thing, even if they frequently hate it. They think it is a good thing because it brings them bread. To do what they do at time-and-a-half or double time is very bliss.

Yet many people are in the wrong jobs, and have been in the wrong jobs all their lives. In time they are doing more and more of what is worse and worse for them.

At the base of all this is a confusion between quantity and quality. If ten push-ups are good, a hundred would be far better, and a thousand would be surer. Even if it were impossible, a thousand would be an ideal worth working for.

As a people, many of our attitudes were formed because we always had a frontier.

In frontier life, ceaseless activity was seen to be a clear good, because it was always well-motivated: It was directed at pushing back the frontier. The good man was the man who never stopped.

We don't have any real frontiers any more. We live in a society that is pretty well made. We have worked ourselves into a position where we have enormous leisure; but we will not acknowledge it when we see it.

I sometimes think there is a real fear of leisure among us. We are afraid we do not have the inner resources to cope with it. And the reason we do not have these inner resources, of course, is that we have been so busy worshipping activity for activity's sake that we do not cultivate the garden of our spirit.

Most persons who are honest with themselves are prepared to admit that the average office worker spends something like two or three hours at the task which fits his job description. The rest of the time is just waffling, whiling away time.

The boss knows this as well as the worker, but both prefer to do nothing about it. The system is too dear to them.

I have said we don't have any real frontiers any more. We do have quite a lot of fake frontiers, though, which help expiate the guilt we feel at not hacking our way endlessly through wildernesses.

The great fake frontier of our time is the aero-space industry, and the whole business of getting to the moon. That man is basically a fool is a proposition demonstrable in many ways, but nowhere as easily as in his attempt to "conquer" space. Space isn't going to be conquered, and if it were it would surely be an empty victory. Trying to conquer space is a perfect example of man's relentless pursuit of activity for activity's sake, and of the effort getting out of hand.

World of Worms

The early bird gets the worm, it is said. That's for the birds.
It's not for the worms.

And a great many of us are worms, when it comes to this matter of sleeping in, as they say in the West.

I have a friend, a self-confessed worm, who recently abandoned a long-time habit of fighting the pillow. He got up early one day to accommodate himself to the machinery of the New York Stock Exchange, and dispose of some stocks which interested him to the point where he wanted to deprive himself of them.

He lost $8000. He has gone back to his old lazy habits. He is happy, again.

He goes along with the late Harry Lauder, who used to sing, "O it's nice to get up in the morning, but it's nicer to lie in bed."

It remains to be proved to me that, just because a man is erect and bounding about four or five hours longer each day than his fellows, he partakes of some special virtue.

Usually, to be sure, he gets more things done. But we have to ask: What kind of things? A lot of those jolly ruddy scientists got up very early in the morning when they were playing with that giant Erector set called The Manhattan Project.

If the savants had slept a little bit longer, we might have missed out on the atomic bomb. We would only have to worry about such things as whether S.F. State should admit all black men to its halls of learning, whether they are qualified or not.

It is the besetting American delusion that more is better. If you are a lawyer, it's better to have more clients. If you write, it's better to write more books. If you execute trust agreements, it's better to do more of them.

It may be that in certain isolated activities—like, perhaps, giving away money—more *is* better; but the proposition itself has no intrinsic merit.

97

I'm not even absolutely sure that more sleep is better than less, though I'm strongly gaited to accept the idea.

I used to be a great early riser. When I worked in a newspaper office, there were times when I was walking home, my work fully done, before the first man on the city side arrived for his tasks.

My early rising was largely a matter of guilt. I was brought up to believe that any boy who lay in bed when he was awake, for even as much as a couple of minutes, was a degenerate who would grow up to be something horrible—a Mason, or an inmate in a friendly penitentiary.

So I sprang into action the minute my mind told me I was awake, or the light hit my eyes strongly. I didn't do anything of importance, and I surely did it fumblingly, but I placated the old Popish Superego.

There were times in my life when I even went out for a run before breakfast. I felt insanely virtuous; but I cannot truthfully say I improved the lot of anyone. I was merely able to look myself in the eye in the shaving mirror, a dubious accomplishment.

I have never been quite able to understand this tyranny of eight hours in the sack, and 16 bounding about the planet, doing your thing.

Some people need more than eight, and some need less. I doubt there is a soul on earth who needs a mathematical eight, year in and year out. Yet the old alarm clock is set right there.

I have learned to let my body tell me how much rest it needs. When I am stimulated, this can be as little as four or six. When I am bored it can be ten, and even 12. I lick the daylight by using one of those eyeguards which prolong night indefinitely.

In fine, I am a retired early bird who is becoming slowly metamorphosed into a worm.

And I like it that way, too, thank you. For one thing, I'm convinced I do less harm; which is perhaps another way of saying I do more good.

On Doing Nothing

Sometimes I think I would rather suffer than solve. And then again, I sometimes think a little suffering brings a lot of wise answers.

One of the great human debates is whether that man is wiser who does nothing, or tries to do as little as possible, or that man who continually moves and shakes.

That debate has come home to me recently in a very strong personal way because I have been putting off quite a few decisions that I would have made in an almost headlong way when I was a bit younger. Whether all this is a part of aging, or of wising, or a little of both, I'm not altogether sure.

All I know is it's not easy. As Oscar Wilde put it, ". . . to do nothing at all is the most difficult thing in the world, the most difficult and the most intellectual."

Yet the attractions are great, as Charles Lamb said:

"A man can never have too much time to himself, nor too little to do. Had I a little son, I would christen him 'Nothing-to-do;' he should do nothing. Man, I verily believe, is out of his element as long as he is operative."

Doing nothing is especially difficult in a nation of doers of everything like ours.

For one thing, it produces guilt in great quantities. Among my compeers there are quite a few men who fly their own airplanes; and there is even one who is building one himself somewhere.

When you know people like that it is most difficult to lie abed of a morning reading the novels of Jane Austen, or just gazing at the ceiling.

Take a small example. I think I really hate automobiles. They are ugly and deadly, and they smell bad, and they cost lots of money.

Driving them means Doing Something in its most active and pointless sense. Getting from Point A to Point B without

really knowing, or considering, whether there is any point at all in the exercise.

I never drove a car until I was 35, and found life in a large Eastern city not at all difficult to manage, what with trains and subways and taxis.

Then I came to California, and found myself living on a ranch where you either learned to drive or you burned. I learned to drive, and thereby acquired quite a bad habit, and have been driving ever since, whether it was necessary or not. I have driven when I was too preoccupied to be behind a wheel, and I have driven when I had too much to drink, like a good many of us.

I have never really forgiven myself for learning to drive, nor the automobile for being such a pleasantly indolent way of Doing Something.

Which brings me to my trivial crisis of the moment. For months now I know the machine I drive has not been cared for, that it severely needs its periodic checkup.

I find it so pleasant to do nothing about it. From day to day I allow myself the luxury of not calling a garage to get the job done. And from day to day I get more guilty, for I know I'm being unkind to the machine; and that, in due time, it will become dangerous to people.

So the pendulum keeps swinging between that which I do not wish to do, and rather suspect is unwise to do, and that which I must do, and which I fear it would be dangerous not to do.

The best thing to do with life's little crises, obviously, is to recognize that delicious little second where Doing Nothing ceased to be a luxury and Doing Something becomes a necessity.

One of these days I shall bring the old machine into the shop, and feel guilty about *that*. I guess the only sensible way out of the whole thing would be to dump the car and take up serious chess or serious sex, both of which are admirable ways of Doing Nothing. Ah, pity.

The Future of Work

I have had occasion, in times past, to descant on the menace of leisure and to point out that it takes quite an amount of solid talent to be a bum, and that maybe a lot of us haven't got it.

The days that lie ahead of us carry the promise of a 30, or maybe a 20, or even a 10-hour week. This is going to mean a prodigious re-alignment in the way most of us lead our lives.

We are not going to be able to spend all our free time in fishing for striped bass, or studying the flowering plants of California, or watching our heroes at Candlestick Park, or reading the lives of the saints, or chasing the morsels.

We are going to have to get to work on our idleness, and it may turn out to be harder work than punching the old time clock for Daddy Warbucks.

Aristotle had it all figured out when he said: "Nature requires that we should be able, not only to work well, but to use leisure well. Leisure is the first principle of all action, and so leisure is better than work and is its end.

"As play, and with it rest, are for the sake of work, so work, in turn, is for the sake of leisure."

What the old sage had in mind was that leisure was something more than setting one's self up for a return to the grindstone. It was a period available for, and designed for, the fullest development of the excellences of which man is capable.

Leisure, then, is the time to make yourself into a full man. It is not an interval between work, but an independent challenge.

Yet there is a growing view, in this country at least, that man is going to have a terribly difficult time parting from work, that he is not, as yet, quite up to the contemplative pleasure of true leisure.

It can be argued (and is) that in a country where work has for centuries been glorified, the lad who is firmly tied into the system is a happier person than the man with time on his hands.

Leisure brings with it guilt, in our time and place. Many men develop aches and assorted funny feelings when, for one reason or another, they get off the nine-to-five treadmill.

The problem of retirement is a severe one. Many older men are at a loss to find meaning in their lives when they are deprived of their routine, and its disciplines.

The tense, dedicated man who is married to his job has a sense of purpose in his life that the "carefree" yachtsman and world-traveler and bon vivant too frequently fails to achieve.

I do not know the incidence of suicide as among the care-filled and the carefree; but I would place my money on the intuition that more of the carefree go the suicide route.

So what may happen with the coming of the new leisure, and what many sociologists believe will happen, is that we will have to invent work, in many ingenious forms.

The boondoggle of the 1930s will return, but in another form and for another reason.

Boondoggling, a term popularized if not invented by the late Congressman Maury Maverick, of Texas, was made-work for the recipients of government aid—like planting grass where grass wasn't needed, and breaking shovels so they could be fixed again.

The new boondoggle will arise out of a spiritual rather than an economic need. It will resemble occupational therapy more than work. It will be done willingly, even eagerly, to escape from that most terrible of afflictions—boredom.

Boredom, as the medieval theologians saw it, was the deadliest of the seven deadly sins. It is one of the great curses of modern life. It threatens to be worse as ease and repose increase.

So, in a couple of decades or so, men and women will be occupying themselves with recondite arts and crafts like book-binding, orchid cultivation, glass blowing and the movements of celestial bodies. And all this because, when given the time and space to contemplate himself and his nature, man will not be able to stand what he beholds.

What Is Taste?

*W*hat, indeed, is this arcane thing called taste?

The question, I find, is being asked more often and with increasing interest. This is surely to the good of all of us.

It isn't very hard to define what it is. In fact, the definition is a good index of whether one has taste or not. If you know what the word means you have taste—or had it.

One of the odd properties of good taste is that it can be diluted, or lost, or atrophied. Our taste declines, La Rochefoucauld tells us, when our integrity does.

So there are at least two things about taste. Knowing what it is, and having the integrity to stand by that knowledge. And what is integrity? Ah, another can of worms. I am afraid, and outside our immediate purview.

In initiating these little inquiries about meaning, one must never overlook Webster's New International, Unabridged. A desk dictionary, for abstract words, is usually a bit too little. The 12-volume Oxford, greatest of all English dictionaries, is often too much—so incandescent that it blinds.

Webster's Unabridged, then, defines taste as "the power of discerning and appreciating . . . whatever constitutes excellence."

Among the things that constitute excellence, Webster remarks parenthetically are: ". . . fitness, beauty, order, congruity, proportion, symmetry."

If one is interested in getting to the nitty-gritty of taste, he might trouble himself to find out what Webster has to say about ". . . fitness . . ." etc., etc.

What interests me especially in that constellation of attributes of excellence, is the neatly precise place given beauty. This quality, which we may roughly define as that which is good to look at, is not by any means the be-all and end-all of excellence. Excellence, in fact, sometimes transcends it.

The nonbeautiful qualities are all cousins in meaning: fitness, order, congruity, proportion, symmetry.

Lack of taste is one of two things that most men would rather shrivel than admit to. The other is lack of a sense of humor. Samuel Butler said, and rightly, "People care more about being thought to have taste than about being thought either good, clever or amiable."

If taste is an exercise in the excellent, how are you to recognize that valued quality?

Only, I submit, by exercising the amount of taste that Our Maker ground into your mixture.

If, after due consideration, you find yourselves one of those monsters who was born without taste, it is best to reconcile yourself to the fact and, if possible, be amusing about it.

In a world where there are many fraudulently tasteful, there are more than a few men who can command decent meals and good wines by an honest protestation of their tastelessness.

But if you have taste, as nearly all of us do, it is a crime to vitiate or corrupt it. It is a worse crime not to educate it.

You do not need Burckhardt or Berenson to tell you that Raphael was a great artist, but they help. Great reputations can only be ratified by your honestly seeing eye, used often.

If you are one of those brutes who were born tasteless but witty you might remark, as in fact Lord Melbourne did, that "Raphael was employed to decorate the Vatican not because he was a great painter but because his uncle was architect to the Pope."

Before we leave the subject of taste for the moment, let us remember those words about "the art that conceals the art."

And the apposite words of Beau Brummel, the dandy. Contrary to some current belief, his dress was never ornate or showy. Quite the contrary. He was consistently unostentatious. He wore only the cleanest white linen, and the cleanest black worsted and leather. He said, and don't you ever forget it, "You are not well-dressed if people are struck by your appearance."

Be Your Age

One of the permanently useful injunctions of our language is the phrase "Be Your Age." This is sometimes phrased as "Act Your Age."

There is a powerful lot of wisdom in these simple words.

If you are young, be young; if you are of middle years, so be, and if you are old, be old.

For the truth of it is, unless you are an unusual person, you *are* your age. All the art and guile in the world cannot change this.

This does not prevent people from trying.

The great current gig is for the not-so-young to wish to be younger. This is nothing new under the sun, of course; but there is a slight refinement in the whole idea.

This is "being with it."

There is nothing more melancholy in the world than the middle-aged buck who knows the name of every rock band from here to Salinas, who lights up regularly, who reads Richard Brautigan and Michael McClure, loves paintings of soup can labels, and who wears shiny, pointy Italian clothes.

This sort of character, and his feminine counterpart, are standing, walking, and embarrassing, confessions.

The whole mise-en-scene in which they encase themselves is a confession of their dissatisfaction with themselves, an advertisement of their unhappiness.

Whether he chases the Fountain of Youth, or some goat gland doctor in Switzerland, the man who tries to lick the years of his life is a fool. To so love your own youth as to wish to recapture it is to live in the most dismal of prisons.

Growing older is, among other things, coming to terms with life. There is a certain wry pleasure in this.

There is more pleasure to be had, I suggest, in coming to terms with yourself—which is another way of saying, seeking peace within yourself—than in looking less than your years, and acting like an undergraduate.

That bitter old Dubliner, Dean Swift, said it like it was: "No wise man ever wished to be younger."

Life is a current. To be born is to be borne on it. Nothing can be done to reverse it.

Cosmetic attention can seem to reverse it; but everyone in his heart knows that is a snare and a delusion.

One of the things most wrong with our country at this time is that we have a pretty crumby crowd of middle-agers. They are neither fish nor fowl. The reason is fairly simple: They pay no attention to either the process of growing old, or its considerable pleasures.

Whole industries are based on the desire of men and women of 50 to cut a couple of years or a couple of decades from their physical facade.

More profitably could they be practicing the ancient wisdom of getting ready for their death, and passing along the legacy of their learning to the children of their loins.

One of the reasons for the muteness between the generations is the plain, unadulterated contempt the young feel for those older who spend sizeable amounts of their time and money impersonating the young.

The youth-seekers cannot recognize that they are playing the fool. Some even so deceive themselves as to say they are acting like juveniles "to get close to the kids."

This is poppycock. They are acting like juveniles because they are parties to the greatest of all sucker games: Cheating life.

This is not to say that the middle-aged should not on occasion enjoy the pleasures of the young, if only for their own information as to what the current follies are. Such exploration, however, should be done with a conscious reservation, as when one visits the zoo.

Otherwise, let the years pile up. Resist them not. They are the only real wave of the future. Just try to use the years, rather than be used by them. And leave youth to the kids, who have the stamina to handle this highly volatile commodity.

Smell Like a Man!

*I*t is not easy to say at any given minute whether sex or selling is the more important in the American scheme of things.

But when the two can be combined, tout voila! Then we know that both the American economy and the American soul—which may, indeed, be the same thing—are smashingly in biz.

Take the matter of masculine stink. Not the real thing—Old Locker Room Lavender—but the numerous little commercial lotions that are being peddled across the counters of the specialty shops these days.

That they are sold at all is still rather an eye-popper to us old gaffers brought up on the antiseptic whiff of Lifebuoy soap, as it then was.

There was a time, and it was not so long ago, when it was held—with the severity of tablets handed down from mountains by old men with beards—that any lad who sloshed himself with scent was a security risk, an esthete, or a traveling companion for rich old broads doing a Wanderjahr in the autumn of their lives. In fine, the scented male was held to be as queer as a three-dollar bill.

Real American men smelled of real American man, take it or leave it. In an even earlier day, you took a bath after the crops were in.

But that was before the djinns of the advertising dodge began mixing their little bottles, and mouthing their little incantations.

"We just landed this perfume company as a client," some titan of the racket said one fine day, thumping his Chippendale desk, and puffing at his two buck Partagas panatela. "We gotta convince the American slob he isn't a fag, just because he smells like one." He paused to let that sink in. "Get to work, boys."

Each new slogan had more male candlepower than the last. Dante had "subtle power." British Sterling promised "you will become a legend in your own time."

Tournament was for "the man with drive." Jaguar is addressed, with infinite subtlety, to "the man . . . who plays to win, whatever the game." Match Play says "You'll stage an upset—whatever the game." And Gant, pressing an advantage, says its particular effluvium "gives a man an unfair advantage."

It has been suggested, with some justice, that this after-shave prose is the product of superannuated sports writers. The idea that you can change your sex from mere man to Real He-Man is congenial to the prose style which daily makes heroes of half-wits who can hit good, or throw good, or even stop good.

Maleness as an advertising slogan has proved itself superior to the claims of cancer, when it comes to selling cigarettes. There is no reason to believe that it cannot supervene the ancient hermaphroditic associations of scent.

Yet, adroit as they are, I suggest our ad men have something to learn from certain scent artists who operate in Copenhagen.

These lads put out a scent which is an oil that is added to new shoes to make them smell more leathery. This is thought to be pretty ravishing in the set which equates leather with sex. It is called, simply, "Leather."

But there is an even better one. A man wearing it into a night club or bar in Copenhagen is said to achieve all the animal aura of the late Marilyn Monroe. In some quarters it is known as Instant Sex. It consists of no more or less than what its terse title is: "Sweat."

Unfortunately, these exotic Danish scents are not used by men to attract women, but to attract other men.

It is all too confusing, no?

The Placebo Effect

\mathcal{H}ave you heard of a placebo? Or of the term placebo effect?

If you haven't, and if you have my amateur's interest in what raging loonies we all are, you may find the matter worthy of moot.

I have a crusty friend who says that a drunken plumber could practice the high and crafty estate of medicine if only he knew how to give penicillin shots and prescribe placebos.

The word comes from the first words of the first antiphon of the office, "Placebo Domino," or "I shall please the Lord."

It describes a medicine given to humor or gratify a patient rather than exercise any curative effect. Like, a sugar pill to aid a vague undiagnosed state, possibly nervous in origin.

The funny thing is not how often they don't work, but how often they do.

But in recent years a more surprising thing has been discovered. Real maladies, as well as imaginary ones, can be cured by these fake pills, and with just as much effectiveness as if the latest drugs were used. Like, faith healing exists.

A recent report says, "Experiments have shown that from a third to half of all patients suffering from common disorders like coughs, colds, headaches or nausea can be treated as effectively with a placebo—a dummy pill, as with the latest drugs."

A placebo can satisfactorily relieve even the most agonizing of pains, such as those felt by angina or migraine sufferers, in as many as half the patients treated. And the ones with the worst pain often get the greatest relief.

Dr. S. Bradshaw, in a fascinating book called "The Drugs You Take," says, ". . . if you give a plain sugar tablet to a hundred people complaining of a minor pain, but without telling them what the tablet is, 30 or 40 of them will say that the tablet *has* relieved their pain. And it has—or at any rate the pain has gone. Time may be a great healer, but faith is an even quicker one."

That the mind has a considerable effect on the working of the body is a proposition that even the most devout member of the American Medical Association will agree to. Unfortunately the AMA and its members, and even doctors who don't belong, have long neglected the real therapeutic powers operating inside the placebo tablet.

Doctors are still writing prescriptions in Latin and gobble-degook long after even the Catholic Church has recommended the vernacular for the Mass. The docs, like all priesthoods, are infatuated with mystery, and long to embed themselves in it.

The failure of orthodox medicine to examine seriously, and exploit effectively, the curing power of faith healing is, of course, the factor most largely responsible for the inherently valueless and sometimes harmful junk which is peddled everywhere as patent medicine.

Tender loving care is no joke, as anyone who has under-gone a long recuperation knows. It's quite as important as medicine and medical advice. Its disappearance from the medical scene in the U.S. is a source of genuine regret.

Spiritual healing has for centuries been exploited by quacks. Is it not time that real doctors, and there are plenty of them, move in on this marvelously fruitful territory?

Medicine need not be ashamed of calling on what some people call God, or a gaseous invertebrate, or whatever, if He will do the job. No?

Is Society Sick?

Society, the punditical fellows tell us, is sick. And the pupils of the pundits believe it. And so another cliche is born.

It follows that anything so widely believed, and so-often parroted, is probably a crock. Like the idea that politicians go into the racket because they wish to serve the poor and suffering populace, or that it is sweet and fitting to die for those same politicians calling themselves "our country."

The large event, like recent political assassinations, brings out the doctor in us all, and his ready diagnoses.

The trouble is, we begin to think. Said Mr. Goethe: "If you start to think about your physical or moral condition, you usually find that you are sick."

Mr. Anatole France said: "The mania of thinking renders one unfit for every activity."

I suggest we are no more sick, and no less, than we have been at most times in the past; but we sure do have more time to think about being sick.

I was a kid in the Twenties. If you were to believe the Saturday Evening Post, and those Rockwell covers, and those Scott Fitzgerald stories, you would think our country was an epitome of delights. Some of my contemporaries still think of those times that way.

Actually, sickness was everywhere. The country was in the grip of a bloated and perverse economy, which caught up with it in the crash of 1929. Prohibition had turned my elders into a claque of criminals. It had turned some of my other elders into a posse of gangsters.

But people didn't think too much about it. They had other fish to fry.

As I grew up in the Depression of the Thirties, I was in the midst of a *really* sick society. Men had been deprived of the thing which most entitled them to call themselves men: Their work.

Unless you have seen an expert carpenter spending hours on a park bench reading a tabloid newspaper, you cannot understand the blank sense of futility of those times. It was nobody's fault that this man, and millions like him, were emasculated. It was just the damned general folly of mankind that laid him low.

It is said that the most generally profitable business in Depression days was dry-cleaning. This was because people had to wear clothes, whether they had jobs or no, and they did not have any money to buy new clothes with.

Sartre said life begins "on the other side of despair." And that, too, was true of the Thirties. With all the patent sickness, there was also a kind of health. People learned to know and esteem each other as they had not done before. Sympathy became common. Men were, in a way they had never been before, brothers.

And we were led in those days by a glorious con artist named Roosevelt who was constantly preaching hope and redemption, and we were constantly believing it. He was worth his weight in pieties.

Today, the things which make us think ourselves into sickness, apart from political assassinations, are that rotten war in Vietnam, the crisis of the blacks, and the wave of "crime on the streets" which is a spinoff of the black crisis.

The Asian War will end, as all wars have. The black crisis will abate, as all crises have, though this will take a longer time.

Yet the fact that we have a black crisis can be interpreted as a sign of health, rather than sickness. We have faced up to a long-time evil, and have uncovered some other rather nasty evils in the process.

We do have crime in the streets, but no one can doubt that the condition of the blacks has improved enormously since the Supreme Court desegregation decision of 1954. You don't hear much talk of "uppity niggers" these days. That has to be pure gain.

'Good Lord, Say Something'

I am increasingly impressed—moved is perhaps the better word—by the horror many of my compatriots have for one of the most beautiful things in the world, silence.

It is not so much that noise is blatant everywhere in the U.S. of A. It's a more specific thing. The absence of noise seems to create anxiety in many people.

I recall having lunch at a pleasant restaurant in Ghirardelli Square. I was drinking in the city, the beauty of the bay. I was vaguely thinking of what I might order to drink. I was enjoying myself thoroughly.

It became evident that my guest, an old, old friend, was not having the time of her life. She interrupted my reverie with, "Good Lord, say something!"

An Englishman I know stopped off in a coffee shop in Sausalito for breakfast, and was quietly reading his newspaper. Suddenly the lady manager said, "Gee, it's too quiet in here." She turned on one of radio's noisiest disc jockeys, as a rebuke.

The disc jockeys are a form of noise that is by now endemic. We shall probably never get rid of it, because the jocks have the greatest thing in the world going for them: loneliness, especially feminine loneliness. If they spoke in Swahili, the jocks would still have audiences.

People are afraid of loneliness, for reasons that seem to be sufficient to them, and identify noise as its antidote.

There is the omnipresent Muzak, or other device of music on tape. You hear it in bars, restaurants, hotel lobbies, elevators, aeroplanes, and even swimming pools. Nobody really listens to it. Everyone loves its soft emollient quality.

A child could easily grow up in the United States a quarter-century ago or so, and be lucky if he heard a couple of hundred words a day, outside of school. His could be a world of silence, punctuated only occasionally by speech and other noise.

What child can say this today? He lives in a world of noise,

largely out of the telly box. This is the really unpleasant noise of America—the noise of the circus that came once a year to disturb the peace of the small town.

This noise is a kind of bazaar clatter. It is designed for one purpose alone. That purpose is to move goods, to keep the wheels of the economy oiled, to make the old consumer consume, and consume, and consume.

When the circus came to town, the calliope and the rest were there to take out of the jeans of the farmer the loot he had gained from the last harvest. To the credit of both, the farmer usually thought he got as good as he gave.

But nowadays the conditioning has become so effective that a continuous cacophony is an emotional need. Noise is a part of the environment. The beauties of silence have become identified, rather terrifyingly, with an anxious loneliness.

I had a friend who used to say, "Chatter is the language of courtship; silence is the language of love." I agreed then, and I agree now.

If we would follow the Thoreauvian ideal "to live deep and suck out all the marrow of life" we must bring ourselves back to the days when noise was an interruption of silence, not silence an interruption of noise. To the time when a distant railroad whistle was beautiful, because it was distant and because they were few and far between.

3.

Booze

*Being insights gained
from a lifetime
devoted to study
of the subject.*

How to Fight the Bottle

The French have a certain gelid cast of mind that is often called Gallic logic. This holds, quite sensibly, that it is a kind of lunacy to found a marriage on anything as flimsy as love. They work the deal out with many unlovely considerations, chief of which is cash. French marriages, as a result, tend to last. They are solid as corporations, not gossamer as lyrics.

Gallic logic is now being put to its supreme test. It is being applied to the problem of Gallic boozers, of which there are far too many. A French doctor recently said his nation had the "sad privilege" of outboozing every other people on the planet, including the Italians, who do pretty good with the vino tinto, too.

Part of the problem is that a Frenchman would as soon drink ink or gasoline as water. They don't mind water going out of their system, in one form or another, but they would as soon take it in as they would go to a baseball game. Water is for the perfidious English, and the Yankee. Wine is a natural element, like air. It is imbibed almost as copiously.

The temperance movement in France is an outfit called the Comite National de Defense Contre l'Alcoholisme, and it could be said to be hissing against the wind. But it has its adherents, mostly among suffering wives and industrialists who like to get what is sometimes called an honest day's work out of their serfs.

The problem they face is formidable. It is estimated that about six million French men and about a million women drink at least one and a half liters of wine a day. Two million men and 300,000 women drink two and a half liters.

The CNDCA reasons that the way to attack the problem is to *improve* the quality of French table wine. This will make it more expensive. This, following Gallic logic, will make people drink less of it. At the same time the CNDCA is lobbying for lower prices for non-alcoholic fruit drinks.

The French temperance people point out that the years 1957 and 1958 both had small harvests. Wine prices went up. Drinking went down. There was, they say, a marked decrease in deaths from alcoholism and cirrhosis of the liver.

One is permitted to doubt that increasing the price of something wicked is likely to cut its consumption. In England, these days, a packet of cigarettes costs about 75 cents, and is widely believed to produce lung cancer. Sales continue to soar. Whiskey is more expensive in England than even in America. Sales are far from swooping.

A canny Londoner from the liquor firm of Justerini and Brooks has made a fortune in dollars by the simple gimmick of insisting that his Scotch whisky (J & B, it's called) be sold in swank New York bars at 15 cents higher than any other scotch offered by the premises.

No, I fear Gallic logic ain't gonna work in this case. The trouble is the French aren't real drinkers. Real drinkers drink to get drunk. Frenchmen eat too much with their wine to get the glorious euphoria the true boozer seeks—that life-denying loveliness.

It's not that the Frenchman loves wine so much, but that he hates water so much. I've seen no figures on it, but I reckon that in France more fruit juices, even, are consumed than water.

No matter how much the temperance people succeed in improving the quality of wine, I fear their countrymen will continue to drink it, and in quantities. The frog dearly loves his centime; but he loves that liter and a half daily more. I think.

Of Heroic Boozers

\mathcal{A}mong my varied acquaintances is a lad who is said to have gotten a 502 on a bicycle. This, be it added, is a rare distinction in California.

A 502, for those of you who live in a convent, is a citation for driving a vehicle while sozzled.

I met this worthy recently and asked if the report was true. His answer was a bit circuitous. "A similar incident once happened to me back East," he said.

When he was going to school in Baltimore, he continued, his progress one night was arrested by the fuzz. They asked him all the usual silly questions, and suggested they might allow him the use of their friendly Drunk-o-Meter. Then one of the boys in blue asked him where he got the bicycle.

"What bicycle?" asked my friend.

When I heard this, I silently elevated my friend into the Drunkard's Pantheon, along with such illuminati as W. C. Fields, Brendan Behan, Trevor Howard, Peter O'Toole, Toots Shor, John Huston, and a certain Cambridge don who had better be nameless.

One of the great disadvantages of being sib to the ardent spirits is that some of your finest moments are lost to you completely the next morning, unless you have had the luck to have been accompanied by a Boswell of comparative sobriety. Brilliant sallies and bits of inspired waggery are hard to retrieve in the cold, unlovely light of dawn.

Some of these lapses of memory can be quite extended. The celebrated Bill Fields, as an instance, once started for his New York hotel after a convivial night. (How pleasant "convivial night" sounds, as distinct from, say, "stinking himself out" or "lapping it up.")

The next thing the comedian knew he woke up three days later in a Miami Beach hotel room, having made the journey solo, and non-stop. He knew it was three days later because his agent told him so, and he knew he drove down because his Dusenberg or whatever was parked outside the hotel.

It is a ceaseless wonder to me how much some men can take on, and still function, and how little others can take on, and go all to bits. And my working definition of a true alcoholic is a guy who lets booze interfere with his functioning to the point where he can't any longer do an honest day's work.

I recall a foreign service officer who knocked off two fifths of Scotch a day, yet always remained what he was, a hard-working, invariably polite and always effective public administrator. And the news biz still contains rewrite men who can class up a murder in the Tenderloin while carrying a load sufficient to embalm a man.

We will not talk of the other kind, who take one martini, and suddenly their id is showing. Too depressing.

In fact, one of the trials the career drinker has to bear is to observe the actions of those who can't handle the stuff. You can avoid this, in good part, by only going to good saloons, where incompetence and inexperience in the drinking arts are not tolerated.

There is one night of each year that I become an ardent Prohibitionist. That is New Year's Eve. Truly, I would rather spend a week in jail than an evening in some be-mirrored night spot with a lot of old guys in paper hats determinedly living it up. Hell must be rather like this, to the true toper.

Fatal Glass of Beer

While visiting me recently, my youngest son got drunker than a fiddler's bitch (as people say who have an unreasoning bias against fiddler's bitches).

I think it was his first. His sisters, who know all about him, and are not unwilling to disclose any part of it, claim it was his first. It had, in fact, all the earmarks of his first.

When the great event occurred, he was considerably under the age of consent for these matters. How much under I prefer not to disclose, lest I seem even more tenuous as a parent than I am. He's old enough to steal, but not old enough to enter Harvard.

He met his downfall at a party in Squaw Valley, where there were a lot of people who believed in peace and disarmament, and that kind of thing, and were consequently just the kind to debauch an innocent from Cold Spring Harbor, Long Island.

I have heard a great many reports of what happened, but haven't gone into the matter too closely, for a number of reasons. One report was that he passed out in a hearse, which is a pretty good report. Suffice to say, he took on a pretty good load.

I got the news from the girls in the morning, bright and early. "He got stewed last night, and is moaning in his bed over there, and says he isn't going to get up all day."

The moment had come. I had given a lot of time and thought to this. How does a parent comport himself when one of his boys ties on his heroic first one?

With the Irish, the treatment is tried—and untrue. All his life the kid has been hearing of the evils of the drink, and how his loving mother suffered at the hands of his rotten father because of it. And, at the end of the threnody, "Ah, but it's in the blood, I guess."

The first drunk is a ritual of passage, a defiance of those who have run our life since childhood, a statement of manhood.

It is nearly always a little too thorough, with the Irish.

Then the wrath of God descends. The priest comes into the house. He makes it clear that what you have done is worse than the violation of a vestal virgin. The mother of the house sobs quietly. The old man, craven, orders another beer at the corner saloon. The neighbors, who of course have been informed of your monstrous transgression, lower their voices as you go by. Only the lads on the baseball team, who have just gone through it themselves, or are just about to, have any sympathy.

If a system has been devised to produce a confirmed alcoholic to exceed this one in efficiency, I know it not. It assures the Irish-Catholic that for the rest of his life he will have one sure drinking companion: His guilt.

I had determined that when my time came to play the stern parent, I would enact the role with dignity and maybe even understanding.

That morning I got on the blower with a lady who has had some experience with life, and benefited from it. I told her the situation.

"Ah hell," she said. "Just bring him a triple Coke, with plenty of ice, and shut up."

The advice had the ring of truth. I followed it to the letter. I thought I saw a sad and grateful little smile on the kid's face, in the bed. The last I hear (from his sisters, of course) is that he's on the wagon. "Except for an occasional can."

Fighting the Mirror

The late John McNulty was a professional Irishman. In spite of this, he had great charm. He was high on breeding—in horses, women and whiskey, the things he liked best.

He introduced to me an expression which he said was common in the bars on Third avenue in New York. I am not unknown to Third avenue bars, nor they to me, but I had never heard it. The expression was "fighting the mirror."

The minute I heard it I fell in love with it, for it filled a need. It is the exquisitely clinical description of a certain kind of hangover, known to all who are on more than casual terms with ardent spirits.

You need a bit of the fish that hit you the night before, and you need it quick. The bars on Third avenue all open early, since their trade is heavily Irish, and it is well-known an Irishman likes to get out of the house when he is not sleeping or fighting with his clan.

These bars all have long mirrors, of varying degrees of beauty and cleanliness. You order the first drink, and you take it alone. Everybody respects your solitude when you are fighting the mirror, as you are about to.

The face you see before you makes every temperance shibboleth you ever heard seem true. You see a guy nobody approves of, including yourself.

The night before you were unkind to the person you loved most. It may even be that you slugged a guy smaller than yourself. You were loud and you were naughty and you were wrong about who was the 13th President, and the maiden name of Kitty O'Shea.

You drank your share, and instead of going home, you stopped at another place. Here you further assaulted your liver, and your liver won.

As you gaze at the solitary sinner in front of you, you feel sorry for yourself in that way which is almost a pleasure. No-

body loves you, and to hell with 'em. The business of the world is not getting done, and to hell with that, too. You are locked with your misery. You are loving it.

The barman refills your beer mug, silently. No words are used on this sacramental occasion. You read a litany of hate over the bodies of your girl, your boss, your parents, and all those other malign personages who keep telling you to buck up, and be a man.

And then, soon or late, the water of life begins its magic. Gradually your view of the lad before you rises. You permit yourself a slow, sardonic, secret smile. They had you down there, boy, a little while back. You re-open negotiations with the human race. "Gimme a match, Paddy."

The pride is coming back into you, in great injections. You are still fixed on your image, but the image is friendly. Next thing, you'll be telling jokes to it. The luster of life is replacing the pallor of perdition. You tell yourself, "There's a man I wouldn't be ashamed of being seen with."

You have another. You warm your hands before the glow of your self-approval. You make up speeches to regain the regard of the lady you wounded. You are going to buy a World Almanac. You plan to go to confession soon. You are a broth of a boy, again.

You take the newspaper out of your pocket, and begin to read the sports section. Juan Marichal is having another good year. You have lost all interest in what you look like. You have fought the mirror, and you have won.

Barroom Etiquette

*B*arroom etiquette? Yes, indeed, there is such a thing.

I was reminded forcibly of its existence the other day, while taking a dram or two in a Marin county saloon owned by a gentleman of 80 or so who has (or so legend has established it) consumed a quart of 100 proof bourbon every day for the past 62 years. He still pours, for himself and everyone else, with dash.

On his premises is this bit of distilled wisdom, if I may use the expression:

"Our prices are subject to change, depending on the attitude of the customer."

And that, as I say, is the way it should be. In any good swillery, the boss is a potentate. What he says, goes. In England, the publican is called Governor, and not without reason. By custom and tradition (and often in simple fact) he is the best man in the house.

He sets the tone. Behind every good saloon, you will find a good man. This may be hard for the temperance nuts to swallow, but it is a true fact, mates.

Such a lad is a social leader, whether he is pouring barmy beer or bourbon and ditch.

And the tosspots who consume his product are to no small degree his pupils. By his example and his graces, he teaches manners to the less worldly whom he appears to serve, but actually dominates.

Take this matter of the barroom confessional. It is well-known that there is no finer way to enslave a person than by listening to him. The publican and his bartender gain dominion over their clients in the same way the Freudian analyst does. They simply put on their tin ear, and smile, smile, smile, while the troubles flow. Next thing you know they could order the lout into the valley at Balaklava, and he would charge, with a war whoop on his lips.

The only difference between the publican and the head-candler is the price. Speaking for the analyst, vive la difference.

If, in spite of all the sacerdotal ministrations of the publican, the client does not buck up, and commits sins like loud talking and over-praising of women and bitching about his change, then stringent measures are called for. The old gentleman from Marin would raise the price of a shot. He would be right.

That isn't the way Paddy Kennedy would handle the problem. Paddy runs a London pub called The Star, in Belgrave Mews West. He takes his responsibilities as governor with great seriousness, especially when he is three sheets to the wind.

There was the night he was rubbed the wrong way by a young peer of the realm, who happens also to be royalty. Paddy, exercising his imperial right, decided he was a pansy. There is nothing on God's green earth that infuriates Paddy "like a man going to waste."

He turned to His Lordship and said: "Here now, would you and your friend like to walk down the stairs good and nice, or will I throw you out of the bloody window?" Paddy did not say "bloody."

That, of course, is the way to handle things. Contrariwise, Paddy will carry an unemployed actor on his books for 18 months, and never a word about it. He has enough bad paper to reach from London to Calais. When he goes, he will have one of the biggest funerals in London.

Paddy and the man from Marin do not know each other, but they know their proper function, which is moralist, and their prime duty, which is to bring the customer up to the level of the establishment.

Good Hangover

I had rather a good hangover last week.

By this I do not wish to convey that there is any virtue in a hangover, good or bad. I'm sure you're better off if you do not use the drug called alcohol: but its after-effects can, sometimes, be useful, or thought of as useful.

I woke up late in a San Francisco hotel room, where I was staying for a few days, and felt more than usually crapulent. I had to do my writing stint that day, and I did it; but I realized the times had gotten to me.

I felt depressed. The thought of food repelled me. When this latter happens, I know I am in a poor way.

The phone rang. A woman friend said, "I'm bored to death. Will you feed me?" I never say no to this lady unless it is impossible to say yes.

I met her in the hotel bar. I was fighting the mirror and trying to get down a bottle of Carlsberg. Not much good. She ordered a martini, and I joined her. Not much good. I felt as though I was watching proceedings through a plate-glass window.

"You see before you," I said, "a man who is not well." I had been out with various attractive Italians, and another Irishman, the night before. The occasion was bibulous.

"It always gets better," my friend said.

And she added, "You know, people don't know anything about drinking. They don't know the beauty of getting over it, when you progress from a zombie back to a person, and can notice each small change in you. It's like being reborn."

These words I knew to be true. The metamorphosis had happened to me many times before.

And we gossiped about friends, and talked about books, and soon toddled off to an old-fashioned place around the corner for lunch.

This was the toughest part of all. I knew I had to eat, but could not imagine anything resting on my insides. I chose the

blandest thing on the menu, lasagna, and prayed, if I ate it slowly, it would stick to my ribs.

We had another martini, and some rather rough red wine. Eating was slow and not easy, but the world was coming back into place. I looked around the room and saw several people I knew, and remembered that I liked them.

Meanwhile, a sense that could almost be called well-being was welling up within me. I was grateful for the person I was with, because she knew exactly how I felt, and handled me like a delicate bijou.

"The way I remember it best," she said, "was with those dances I went to as a girl, and we all drank far too much, and spent next day on our backs at the beach, drinking things like Planter's Punches. The whole procedure was slightly like a resurrection."

The lasagna got down, and the wine too. We each had some errands to do downtown, and joined in doing them. We looked in Gump's, and the other stores on that street, and went into Tiffany's and Newbegin's to buy an article or two.

Things were now much better. At the lady's invitation, we went to her flat, where I had some scotch and water, my usual tipple. The lady found some Taittinger with the bubbles still in it.

Now, in the comfort of a big armchair, I knew the full pleasures of revival. You were the more grateful for life, since you had been away from it.

I got on a slight talking jag, and began yakking about my childhood, a thing unusual in me. Everything had become beautiful, in a quite intense way—the sun on the carpet, the paintings on the wall, the young people who wandered in and out of the room. I was on some sort of good trip.

We had a couple more. The euphoria, for me, was complete. The lady's husband arrived, and I had one for the road. I got to my feet, gave thanks all around, which were strongly felt, and left with a grateful feeling that still, for whatever ailed me, there seemed a cure. And that re-birth was a blessed thing.

Ye Parfait Bourbon Drinker

*T*here is much to be said for bourbon whiskey. Though scotch is making its inroads, bourbon remains the standard tipple of the American male.

It has a nice, male image. On the whole, it is a clean drink, taken with either branch water or soda. This despite the fact there are some heretics in the Midwest, and especially around Chicago, who drink it with Coke, thus ruining two good drinks to get one bad one.

The best of it comes in those dandy square bottles, which have given bourbon in some quarters the generic name of squareface.

The drink is so highly favored by some of our legislators that it would not be too much to say it often speeds the wheels of government. In Washington, a dam is not really built or a freeway planned unless there is a bottle of Jim Beam or Jack Daniel's somewhere in sight.

It is altogether a gracious thing, especially in the 100 proof version, and I would not care to see the country deprived of it, although I myself seldom drink it except when in Washington or the South.

But even I can contain my enthusiasm for bourbon and the bourbon drinker with more success than the Bourbon Institute. This outfit is seemingly dedicated to the proposition that anyone who does not partake of this product could be anything from a pansy to a traitor.

Some time back the Institute informed the world about the character, attitudes and worth of the bourbon drinker.

"He's straight-forward, honest and not a snob," the Institute declared. "The bourbon user is an outdoor man who sails his own boat, a sophisticated individualist, intelligent, cultivated, worldly, well-off."

With equal relevance, the same could be said of a heroin user, a gandy dancer, a construction worker, or a minor league shortstop.

The number of bourbon drinkers I have known in my life who have never been on a boat probably exceeds the number who own one.

It might be closer to describe the average bourbon drinker as a guy "about as sophisticated as a Mack truck, who likes barrooms and four letter words and calls dames broads, and who thinks anybody who owns his own boat both effete and rather immoral."

A slightly more plausible press handout has come from an outfit which is introducing a new brand of scotch into this country. This bunch attempts, with slightly more modesty than the Bourbon Institute, a profile of the average scotch drinker.

"Chances are that he or she (American scotch drinkers are about evenly divided between men and women) is under 50, with a better than average education (about 52 per cent have gone to college) and is in the upper or middle class group (72 per cent earn over $8000).

"He or she probably comes from East of the Mississippi. All the top ten scotch states, except Texas and California, are on the sunrise side of the Father of Waters."

You will observe here we have precious little poop about the character of the scotch drinker. We shall never know, from this particular scotch manufacturer, whether the average tippler tends to quote the lyrics of Rainier Maria Rilke to his loved one, or favors conglomerates when he takes a flyer in the market, or has a small interest in an overage tin can.

And this is perhaps as it should be. The character of a boozer, or his lack of it, can reasonably be stated to be his own business. He doesn't have to be told by his wine merchant what sort of chap he is. He knows that only too well. One of the chief reasons he drinks, whether he be a bourbon or a scotch man, is to forget what sort of chap he is.

Of Barmaids

That a saloon, or a pub, or cafe, or a coffee house, or a bierstube is a surrogate home is something quite difficult to grasp for those who are not addicted to these places.

There are almost certainly other reasons why people drink in public places; but it is equally certain that the people who spend the most time in public drinking places are those who are dissatisfied with their home life, for one reason or another.

All this may sound simple to the point of prosiness. I suggest, however, if you think on it you will find out a bit more than you had thought about drinking and the nature (I will not say problem) of the drinker.

I recall one period in my life when my home life was, as I thought, at its happiest. I was living in one of the loveliest places on earth, and was surrounded by people I was fond of, and possibly vice versa.

Yet I spent a great deal of time by myself in the village local, where I read my newspapers and magazines and did the brooding which I regard as essential to my curious trade. One day the lady I was residing with suggested, with a certain acerbity, that I saw as much of Biddy, the village barmaid, as I did of herself.

True, I suddenly thought. And I knew then, as I know now, that I was happier with the barmaid and in the pub than I was at home and with my wife—at least for a considerable portion of the time. The knowledge was stunning. Neither I nor the marriage ever quite recovered from it.

In this case, what I got from the barmaid that I did not get at home was the chance to be alone with my thoughts. My lady, being of a remarkably extroverted personality, could not understand why anyone should wish to be alone. She regarded the desire, in fact, as rather an aberration.

If you had a spoiled family life in your young days, you have a need which can never be fulfilled, and which always must be pursued. It is an *ignus fatuus*. This wispy, and delectable, thing is to be found in bars. The bars, and the barmen and the barmaids, give us a little, but never enough, of the home life we have heard of—which is supposed to rear us, and wean us.

There's precious little weaning to be seen among the men and the women who hunch themselves outside the plank in a lonely fit of rue, or stand and shout and scream in a hysterical attempt at human communication.

These reflections are brought on by the fact that I am in Ireland, one of the places where the barmaid is an institution— especially in the rural areas. Also I am mindful of the fact that the barmaid, who has been illegal in California since 1935, looks to be coming back to the State.

A Los Angeles judge recently struck down a State law banning barmaids on grounds that it discriminates against women on the basis of sex and thus violates the 1966 Federal Civil Rights Act.

When, and if, California has barmaids, the State will un-doubtedly come up with some extraordinary biological sport. I doubt she shall bear much resemblance to the splendid ladies I have known behind the bars in England and Ireland, and who constitute for me one of the chief tourist attractions of these places.

Without getting too confoundedly analytical about it, the maids behind the bar are the mothers we have never gotten away from, just as the bartenders are guys who represent the unfinished business we have had with our fathers.

The barmaids of the British Isles, and the barmen and owners, too, all seem instinctively aware of this, and of the parental responsibility it entails. It is a responsibility they dis-charge well; and, in the case of the bar owners, at a considerable personal profit.

When barmaids are introduced into California, there will be some need of indoctrinating the ladies in their new duties. I'm sure the old Alcoholic Beverage Control people in Sacra-mento are giving ample thought to the problem. They should provide a handbook for the care and feeding of the habitual clientele. I suggest Dr. Spock.

The Old Ale House

That the oldest saloon in America should be the best one is not too strange a thing.

You learn how to run a saloon, like most anything else, simply by doing it. McSorley's Old Ale House, at 15 Seventh street in New York, has been doing it for 115 years.

It was in this place, on a day in 1933, shortly after Prohibition was repealed, that my father treated me to the fatal glass of beer. In this case, ale. It's a lovely memory.

McSorley's is the one place in the city that hasn't changed one single bit from the days I was ear-wet. And it was the same many years before I was born.

When in town I never fail to make a pilgrimage there, and let the old mind and memory float, as I down my share of schooners of ale, and wade my way through The New York Times.

The sawdust is still on the floor, the pot-bellied stove dominates the room, the wooden tables are hard as stone. Atop each table, at precisely noon, a waiter places a beer schooner of hot Colman's mustard.

There has never been a woman served in the place. When one comes inadvertently, or with conscious daring, a captain's bell is rung and every man in the place yells "Out." If the lady doesn't get the message, she is bodily removed.

Neither has there ever been a cash register in the place. The money is carefully thrown into custard cups. When I was young there was a blind bartender who had to ask you the size of the bill you gave him. He was never cheated.

Changeless, too, is the only commandment ever offered the clientele: A sign above the bar saying "Be Good or Be Gone."

The walls are covered with posters, pictures, and programs that mirror a century of the cultural life of this country. There is a picture of Lindbergh, taken just after his flight to Paris,

and there is a framed poster over the bar that offers $100,000 reward for the capture of the murderer of Abraham Lincoln.

It was at 8 a.m. on Feb. 17, 1854 that a former horsecar conductor named John McSorley threw open the doors of this famed oasis. One of the many unofficial historians of the place noted recently:

"John McSorley offered his first customer a 20-ounce pewter mug of ale for five cents, and, if he cared for a snack, cheese, crackers and onions without charge, and, if he had a taste for a smoke, a clay pipe and tobacco all on the house.

"On that five-cent mug of beer, John McSorley made money, sang Irish airs occasionally with customers, bought some trotters that he drove himself, and had little patience with men who couldn't hold their ale."

Even into the '30s I remember the free cheese and onions and crackers. Now a plate costs 50 cents, and you have to have one hell of an appetite to put it all down. This is just about the best lunch you can get in town, when taken with two schooners of ale, which now cost 40 cents.

Sometime in the Depression the McSorley family sold the place to a policeman named Dan O'Connell, who gave his word that the place would never be changed to suit the dictates of either profit or fashion.

It is now owned by his daughter, Mrs. Dorothy Kirwan, who sees to it that the old order changeth not. Since women are still not admitted, she named her husband, Harry Kirwan, on-the-scene owner.

The regular customers, some of whom have been coming into the place for 50 years, know why the place has lasted 115 years, and will last a good many more. They know a man likes a pipe and a glass of ale, away from the women and the children, and a little of the rough talk of men; but most of all just an hour or so of peace and quiet, sitting by the window, nibbling on the world of dreams.

Sober as a What?

I do not know what it is that associates, in the minds of some people, those adroit barristers who become judges, with occasional excessive consumption of that dread stuff, the sauce.

I may add I am one of those "some people."

Since my early days as a newsie I have always regarded the expression "sober as a judge" about as contiguous with reality as the statement that "honesty is the best policy."

Honesty, in other people, is the best policy for the smart thief. Sobriety, in other judges, may well be the best policy for the really smart judges—or, at least, the ones who get to the top of the ladder with greatest readiness.

There was a time, within my memory, when a majority of the highest court in the land had considerable difficulty in handling the old schnapps. Indeed, some of them were the terror of the Washington lion-hunting hostesses.

The improprieties of some of these boys, when they got their noses out of McCulloch vs. Maryland, and that kind of stuff, is not the sort of thing you could put down to be read by pillars of the good, the true and the beautiful.

Things in Washington, in recent years anyhow, do not seem to have changed so much.

One of the ladies who has had her troubles with the tippling habits of the black-robed brigade is Mrs. Aristotle Socrates Onassis, who used to be quite a distinguished Washington hostess.

Mrs. Onassis, when she was Mrs. Kennedy, did not like the aqua vitae to flow too freely in the White House.

It is not clear, from recently unveiled testimony, whether this was because she was a little on the stingy side, or a little on the prudish side, or a little of both.

Her instructions to her housekeeper on the matter were made clear a while back in an historic document.

"No one should ever get drunk in the White House," the

then First Lady said, "so will you see that at staff affairs and official receptions—especially the judiciary—liquor flows much more slowly."

The syntax in that state document could be improved a bit; but we get the message—many of the men who interpret the laws of our land also freely imbibe of its ferments.

I wonder if Mrs. Onassis knew on what sensitive preserve she was treading when she asked that members of our highest courts should be cut off at the elbows, at a cocktail party. I wonder, too, if President Kennedy ever saw that particular memo.

To give out the slow-pour order for a man or men who can cut to ribbons some of the idealistically conceived programs of an idealistic President, is indeed to rush in where less courageous hostesses would fear to tread.

To cut down the Old Grandad supply of a jurist who could murder the always tenuous balance between legislative, executive and judiciary, might be toying with fate in a fashion which would cry out to Heaven for vengeance. None of this bothered Mrs. Onassis.

Which brings us to the heart of the matter: Are the ends of justice served by the generous consumption of booze by distinguished jurists?

I would say that, on the whole, a drunken judge does just about as little harm to our democratic system as one who hasn't had two fingers of bourbon since the day he left his mother's loins.

For what the besotted jurist loses in method, and thoroughness, and ability to pour on the old citations, he perhaps gains by being reminded of his humanity.

Even, one might add, of his guilt. I, for one, would most certainly prefer a guilty judge (guilty about his intemperance, of course) to a pillar of righteousness.

The really splendid drunks I have known among the judiciary have most often been bachelors or widowers. There is something about the healing presence of a wife which holds our scholars of the law to a couple or three. Like, maybe, the old rolling-pin.

Unfinished Bottles

*I*f there is anything to sadden me, it is to see a bottle or carafe of wine left on a table unfinished.

It matters not whether the wine be a product of the lovely gardens of Mouton, or the deft admixture of a Vallejo street merchant of the wines of the Napa valley.

The whole thing of the unfinished bottle seems like a failure of felicity—a bit of hospitality that didn't, somehow, work out.

For a bottle of wine—save perhaps when you are dining alone—is placed on a table to be finished. The French, who have brought the vine and its product to perfection, understand this perfectly. They know just how big to make a bottle. They make it just that big.

The unfinished bottle, as I indicate, is to me a sign of spiritual paucity. For wine is one of the niceties of life. It is the lubrication of the civil. It fulfills that pleasant meeting of souls which a good meal should be.

I do not care, even, if the wine is misused—as it almost always is by Americans.

The way we drink wine resembles cutting one's tongue out before savoring a beautifully prepared beefsteak.

We deliberately emasculate our palates. We drink martinis, or bourbon or scotch, until we have deadened our sensibilities to the point where we would have difficulty discriminating between a good Riesling and some old dishwater.

Nothing in the world is more melancholy than a couple of besotted expense-account types, after a few martinis, ordering "the best wine in the house" at say, 21. They will get it. And they might as well be drinking Squirt. In fact, they would be a damned sight happier with Squirt.

Yet, after that indictment, I still say our friends are better off with wine. There is something about wine which is magical. It draws people together. Anything which draws people together is magical, no?

Perhaps this magic derives from the fact that, over the years, wine has been sold so well as an adjunct to happiness.

Perhaps, simply, because it's good even if you can't properly taste it. What is more life-enriching than a Beaujolais in a decent glass in the sun, soon after noon, in a country of greenery and shining sea?

The late publisher of Time magazine was an abstracted fellow named Harry Luce who used to refer to meal time as "simply a period for fueling." The usage is colorful. A meal without wine, and what flows from its usage, is just fueling.

Wine is a living thing. It comes from vines, which are almost always growing in the most beautiful parts of this planet. Milk comes from cows. It, too, lives. Where in hell does Seven-Up come from?

In defense of the unfinished wine bottle, some people argue that a partially filled wine bottle at the end of the meal is considered in some parts of Europe as a pourboire for Colette or Marie or Celestine, or whatever the cook's name is. This I consider a poor excuse for not finishing that which you have uncorked. If you feel guilty about Colette, raise her wages, or give her a full bottle of Lynch-Bages, 1959.

An unfinished whiskey bottle, on the contrary, is a very good sign all around. An unfinished whiskey bottle is a promise of renewed combat, and maybe victory to come.

The pleasantest times of my life have been those moments spent with an attractive woman, over good food, and polishing off a bottle of red of a good year.

To have left that bottle unfinished would have been as barbaric as to have interrupted an act of love to read U.S. News and World Report. It is just not the sort of thing that is done by civilized people. I promise you.

See Naples and Die?

After the port, and the poker game, the question before the house, was: Where would you like to die, buddy-boy?

Since the group was a fairly bibulous lot, a good deal of the parleying was devoted to the pleasures of drinking one's self to death in congenial and convivial surroundings.

At times, in fact, it seemed that none of my friends had ever traveled anywhere without casing the place as a possible situation for a divine demise in the lap of Demon Rum.

I told of one personage I knew whose greatest desire in life was to retire from his job, take up residence in the Mexican seaport town of Vera Cruz, and lean into the sauce incessantly while listening to the sounds of marimba music on the sidewalk terrace of his hotel. There he would muse upon all the indignities his life in the United States had compelled on him, hate those he felt had done him wrong, and in general feel supremely supported and satisfied.

One of the group favored Virginia City, that little pocket of quiet desperation in the Sierra Nevada, which has seen 'em in all shapes and sizes—from Sam Clemens to Lucius Beebe.

"Some of my best friends," he explained, "went the V.C. route, usually with the aid of 100 proof sourmash whiskey. Some more of my best friends are up there now, or in the neighborhood, doing just the same thing." He added it seemed to him like a perfectly reasonable way to go.

Virginia City, leaving out the indigenes, is a place that attracts rejects—lads and lassies to whom the rat race was meaningless, for reasons that sometimes came from weakness and sometimes from strength.

It is no accident that those who leave the rat race tend to spirituous liquors. Whether the rat race drove them to booze, or whether booze drove them out of the rat race, is something on which you can get a thousand authoritative opinions.

It is also no accident that the places the reject picks for

going Upstairs gracefully are nearly all very beautiful physically. I can think of Cuernavaca, Tunis, Taormina, the Cote d'Azur, Sardinia, New Orleans, and certain small towns in the West Country of England.

It is not so much that the career drinker has great aesthetic qualifications. It's just that there is one word he associates with the rat race, and this is ugliness. It is another interesting coincidence that most of the rat race is conducted in places of, actually, great physical ugliness. The bums who retreat find beautiful places where nobody thinks much to make money (until the parasites arrive who serve badly those who live well).

As I explained to my fellow poker players, when my mind focuses on this morbid subject, there are three places which occur to me. They have this in common: The consumption of booze has as little significance culturally as the consumption of water. If one is going to drink one's self to death, the least one can have is privacy.

The places which haunt me are Oaxaca, a beautiful town with greenish-stone buildings in the south of Mexico. Oaxaca admires the dignified drinker. Peasants who never met him turn out for his funeral.

When I get patriotic, I think of Third and Howard, in San Francisco. Occasionally, you may get rousted and spend a night in the city jail; but on the whole the area is a fine and private place. The cops are likable lads, and only roust when the civic conscience is suffering a bad case of ennui.

But when one has his thinking cap on, it has to be Dublin, preferably in that area from Trinity College up to the Russell Hotel, and chiefly off Grafton street.

Drinking booze is almost sacramental here, though you'd get no good Irishman to say a thing like that. And when a really good one expires amidst the various mists to which Dublin (and S.F.) is heir, you would think Mother Cabrini had gone to her Holy Rest. Following the funeral, there are motions made for his beatification at McDaid's. Believe me.

How to Empty a Saloon

You know the type. He comes in, mounts his stool. A stricken look comes over the bartender's face. Several glasses are hastily emptied. Bodies move toward the street. The barman ruefully looks at the cash register.

A bar-emptier is on the scene.

He is either cold sober, or not so drunk that the man behind the plank can legally refuse to serve him.

The bar-emptier has a compulsive need to act out his hostile impulses in a public place. The booze helps it along, of course; but in most cases our man would be a freak even if drinking Calso.

The bar stool is his confessional and his couch. Most people in saloons seek either companionship, or a long, lovely filthy brood. Our man wants therapy, quick. It matters not a whit to him that one man's therapy is another's tedium.

One of the commonest emptiers is the forensic type. He announces, over his bourbon highball, that the incidence of phlebitis among the inhabitants of the Seychelles is higher than in New Orleans. Or that Mickey Mantle's real name is Murphy.

He insists that he be disagreed with. If no one takes him on, there are likely to be empurpled reflections on the ancestry of everybody in the joint. If somebody does take him on, the results will be just about the same. Petty chaos.

There is, too, the joiner. He kibitzes over the dice game to his right. He tends to be a grabber—pulls and pushes at the sleeves and shoulders of his victims. Whether he wants to be accepted or rejected by his peer group is not always clear. That he wants to be noticed is indisputable.

This type is fairly easy to cope with. You just say, "Get the hell outa here." If you are lucky, he just slinks away. Some obscure need for non-recognition has been slaked. He has now a grievance he can suck on, like a baby's thumb.

Save in rare instances, the male emptier is not violent in a

physical sense. His bravery ends at his teeth. If confronted with a bung-starter, or a pair of willing fists, the gallant fellow lopes towards the door, from where he throws a final thrilling obscenity, before entering the cold, cruel world.

There is, also, the four-letter broad. This one is proper bad news, and the best possible argument for a men's bar. One erudite barman of my acquaintance blames this species on penis envy. He may be right. These dames can be attractive physically, which makes them sadder.

I have known one for years. She comes in, and sits quietly for a while, nursing her drink, and finding the emotional temperature of the place. Suddenly she announces, "Boys, you should see my action." Then, by the Holy, she enumerates and specifies. She is not loved by the hard-core boozers of this town, and less by the bartenders.

The worst lot, though, are the couple, sanctified by marriage or no, who bring their domestic squabbles into the saloon. Fighting at home, somehow, does not satisfy them. They need audience to feel properly the true anguish of their plight. The boite then becomes a court of justice. All one learns from these types is that one domestic fight is about as dreary and footless as another.

A man goes into a saloon to forget that his kind are a sorry lot. He doesn't want confirmation of this melancholy fact, within.

Hangovers

I was shocked, the other evening, in Harry Harrington's Irish boite on Jones street. I sat growling into my beer and listening to a potpourri of hornpipes and jigs from the extraordinary juke box.

This is as close to the old sod as you can get in 'Frisco.

Suddenly, my eye caught some foreign matter above the bar. It was a medicament put out by an enterprising Sausalito pharmacist called "Reprieve." It is what is called a hangover cure.

I reproached the publican, Mr. Harrington. "I never thought I'd see the day when I'd run into an Irish saloon that carried a hangover cure."

Mr. Harrington adopted a mildly hangdog expression; and said it was just one of those things they had for Paddy's Day. On Paddy's Day, March 17, the populace queues up for blocks to get into Harrington's to share the charisma of the Irish drunk. This year the publican had five Irish bands there.

I was not to be placated, however. I am a firm believer that a man should take the consequences of his acts. Whether he gets drunk or performs good deeds, he should be prepared to sweat out the consequences. What with one thing and another, we all come to the same end, which is in the cold, cold ground.

Before that, the fun of it is conducting your affairs with some semblance of dignity and responsibility.

Hangover cures are out.

Actually, there are only two things you can do about a hangover. This depends on how much leisure you have the morning after. You can wear it, as a badge of honor or as an affliction, depending on your temperament. Or you can take a bit of the hair of the animal that bit you. No matter what any sagacious thinker tells you to the contrary, the latter is the best way to cope with the problem.

But if you insist on handling the hangover as if it were a

medical rather than a spiritual problem, there exist palliatives.

The stuff on Harrington's bar works, to be sure, but it works no better than a couple of aspirins. Taken before you go to sleep, two or three aspirin tablets will mitigate the symptoms of the meemies as well as anything. (But be sure you remember something about aspirin that doctors have discovered recently. With all its merits, it sometimes causes internal bleeding.)

With hangovers, it's strictly to each his own. There are people who believe in tomato juice with lashings of spicy stuff, and those who go for oceans of black coffee, and those who walk somewhere briskly and jog, or something.

The most memorable hangover cure I've encountered was used by a Mexican. His cure was well-known. The barman would pour a double shot of Fernet-Branca, a hideously unappetizing concoction of herbs and alcohol. This went into an old-fashioned glass. Atop this went a raw egg.

Manolo would view this with a melancholy eye. Then, a quiver going through his brown body, he would swallow the vile concoction.

If he kept it down, he figured he could get through the day. If he failed to do so, he just went back to bed. He handled the whole problem with superb sense, I thought.

Actually, if you are a Celt, the hangover is part of the drinking process, and is not without its pleasures.

Chief among the pleasures of being Irish is feeling sorry for yourself. There is no better time to do this than during the physical disorientation that follows the ingestion of that famed hallucinogen, booze. And there is no finer cathedral in which to celebrate the occasion than in your friendly, neighborhood tavern.

The world would be a poor place indeed if people did not have to face the consequences of their actions. The learned Viennese psychiatrists say that people can sexualize anything. Maybe. How else to explain how some of us derive pleasure from our guilt?

Me and My Pub Tie

When in England I have two "locals." This is the English equivalent of the family-type corner saloon.

One of my locals, The Plough, in Shalbourne, is strictly for reading. I hunch over an oak table with my morning pint of Bulldog Ale, and read in the dailies about the follies of my fellows in far-off places. Newspapers, I find, take on a special flavor when read in a pub.

The other local, The Sun, in Marlborough, is more for standing up and talking. The governor is a pleasant young lad who used to be a London cop. There is always a blazing fire, and a handful of Wiltshire farmers, all men with decided opinions on everything.

The Sun is unusual in many respects. It dates back to about 1750. The wooden planking shows it. It is also one of the few pubs in England which boasts a yard of ale. It is the only one I know of which has a pub tie.

You get the pub tie for drinking a yard of ale. I qualified a bit back. On festive occasions I sport my smart nylon tie imprinted with a few dozen jolly blazing suns.

A yard is a drinking glass. It is about that long, made of Cambridge glass, and is in the shape of a coaching horn, with a round bulb at the end which carries the ale. Between two and three pints usually fill the bulb.

Drinking a yard, or "flooring the long glass" is a thing easier said than done. In olden times it was one of the ordeals of manhood at Eton. It still sometimes is. There are many who never pass the test.

The object is to apply the yard to the lips and finish the ale without removing the long glass. At the end you are pretty near the floor, over backwards.

I was lucky enough to do it first time around, before an audience of seven veteran tipplers. After the performance, relations between the U.S. and Marlborough were notably hotted-up.

Said the governor, "Drunk like a man."

He then awarded me the pub tie. I paid for it the equivalent of two bucks. I put it on directly. I wore it continuously for four days thereafter.

This was the first time I had ever been awarded a prize for drinking. My feeling for the tie has become immoderately affectionate. In the U.S., in even the most passionately pro-booze circles, I've never known anybody to give, or even to offer, a prize for outsize guzzling.

The governor went back of his shop. He came out with another yard. He ceremoniously filled it with ale. He offered it to an old farmer whose face wore the credentials of a lifetime of conviviality.

The farmer tipped the yard to his head. Back, back, back, he went and down, down went the ale. Half-way in its journey the liquid went berserk. The part undrunk spilled in the face of the farmer.

I thanked one and all for not giving me the trick yard. The governor explained, "Ah, we would have to know you for a good many years before we would give you the trick one." A good thing, too. The humiliation would have been too great. I should have had to forswear The Sun, forever.

I did not tell anyone that I had researched the subject of yard-drinking. There's a secret to it. If you drink on an empty stomach, you will almost certainly fail the test. You will be too fast.

The thing to do is drink a pint slowly before taking the yard. This makes your speed just right. I had done so before my ordeal, shamelessly.

146

Remarkable, this Parrot

The dinner had been dandy. The port and Chateau Yquem were being passed around. The cigars were Cuban. They had been made with loving care in the days before Don Fidel. Our host was one of the noted raconteurs of England. He pushed back his chair and began talking about the late Sir Herbert Beerbohm Tree.

Sir Herbert was the great actor-manager of the turn of the century, and half-brother of the author Max Beerbohm. In 1897, he scored his greatest box-office success as Svengali in Du Maurier's Trilby. With the profits, he built His Majesty's Theater. There he took on all the great character roles— Falstaff, Hamlet, Fagin, Shylock, Malvolio and Micawber.

He had a ringing, marvelous voice and the immense presence of the Shakespearean star of the old school. Like most accomplished monologists, he was a poor listener. It is said he hadn't heard anyone say anything in the last 40 years of his life.

One of the stories Tree dined out on was about one of his sisters-in-law. This lady owned a parrot so remarkable as to be the wonderment of all her friends. The parrot liked port, a taste he shared with his mistress. More, he was so expert in his appreciation that he could identify any port given him, by year and by importer.

"Cockburn, 1870," the parrot would intone, usually after a first delighted sip.

The parrot, who was named Paul, might not answer after the first sip. He would take another taste before pronouncing his judgment that it was "Dow, 1884."

Paul was infallible on the vintage port from the great houses of Oporto like Ferreira, Rebello Valente, Tuke Holdsworth, etc. He was quite good on tawny ports; but rather disdained the ruby kind.

Paul belonged to the school of port fanciers who preferred

147

nuts to cheese with it. He wouldn't pass any judgment at all if there was the slightest smoke from a cigar or cigarette in the room. He would reject any potation from other than the upper reaches of the Druro river and exported over the bar of Oporto.

Or so it was told. As the parrot's fame grew, there were those who just refused to admit he could be all that good. One such lady was a neighbor of Tree's sister-in-law.

She told everyone in the village she would be able to produce a port which Paul would not be able to place. The parrot was game, and so was his mistress. A dinner was arranged. The skeptical lady produced her wine, with all conditions for tasting perfect. Paul was given his tipple. As usual he was quick, decisive and brooked no argument.

"Cockburn, 1878," the parrot said.

The neighbor laughed. "I've won my case," she said. "I bought this port at the grocer's down on the High street, right in the village, this afternoon."

Paul's mistress wouldn't believe her parrot could be so wrong. She went to the grocer and asked for a bottle of the best port. The grocer blanched. He fidgeted. His fingers trembled.

The grocer admitted he had been buying the port from milady's butler, who had been stealing it from her, and that the sample which had been passed on to Paul for tasting was indeed Cockburn, 1878, from her cellar.

Thus Beerbohm Tree's tale.

Our host had heard it when a child. Years later he met Marie Beerbohm, the actor's niece. He asked her if she had ever heard the story.

Marie laughed. "I never heard it told that way," she said. "That's so like Uncle Herbert. He didn't quite listen. He had the story all wrong. It was my mother's *palate*, not her parrot, that was never deceived."

Meet the Brazen Head

I've been looking into the Brazen Head, a far-out pub in Winetavern street, about a half block from Dublin's River Liffey, famed as the heroine of one of Jimmy the Joyce's peculiar novels. The Liffey, that is; not the Brazen Head.

This is an experience I recommend to only the hardiest of travelers and tosspots, or both.

It's the north face of the Eiger, straight up. A truly disreputable dive; but bliss, rather, after the Ritzes and Hiltons of the world. If you come out alive and kicking, you're a good man. If you decide to return after one visit, you're a drunkard cum laude.

A friend was asked why he went there. He gave the answer some wicked Irishman attributed to Prince Philip, when asked why he married the Queen of England: "Because she was there!"

I once sent a Berkeley prof to the Brazen Head, because it was out there, and himself too. The taxi driver told the prof, "I can't let you out in front of this place." The hackie told his fare he would be lucky to come back alive. He let the man in for one drink; but only on the proviso that the taxi waited to take him back to the safety of O'Connell street.

The Brazen Head is that kind of place, and I love it.

It stinks, in the most exact sense. The ancient oak timbers reek of the liquid wastes of another and more noisome century. Robert Emmet slept here. From the bar he directed the waste of his patrimony on pikes and muskets for the abortive plot to seize Dublin castle and kidnap the viceroy.

The patrons (if that is the word) are all voluble, charming, filled with the most recondite info and high oaths, and rather mysterious. One Englishman who dropped the grandest names in Britain like they were ping-pong balls, told me he used to double-date with Jack Kennedy in the golden days of the Stork Club in New York. I felt I must know his name.

149

He looked at me indulgently. "No names, no pack drill," he said. This is British army slang for shove off, old boy.

The best bit of the famed Dublin talk I heard came at the Brazen Head bar just before midnight. In the midst of a political discussion, a black little fellow from Galway numbed us all with:

"The trouble with you damned Irish is that you carry a grievance in your mouth as softly as an old retriever bitch carries an egg without breaking it."

Those who love this trap call it The Death Wish, a glorious name for a pub. One aficionado says, "The atmosphere in The Death Wish about 11 at night feels as though it has been preserved since Robert Emmet. The place is stifling and packed with student drinkers from Trinity college. The only thing you can't buy here is oxygen."

Upstairs, the rooms are occupied by old Irishmen waiting to die. One 19th century lavatory serves the whole place. In it, old copies of The Irish Times serve a useful function. The rooms each have a sagging six-by-five double-bed lighted by a 5-watt bulb suspended indecently from the ceiling. On your way to bed at night, and again in the morning, you run across corpse-like men in the passageway, shaving with straight razors before a cracked mirror, their scapulars around their necks.

If you twitch in bed, you wake the whole place. The Brazen Head is the last place you would go with a lady for fun in bed. I do know one couple, however, who did just that thing.

"If we could make love in the Brazen Head," they reasoned, "it must be the real thing."

4.

Youth

*Being considerations
from the other side
of the celebrated
generation gap.*

Like it Was

The trouble with a lot of parents is they can't remember how it was.

They simply have forgotten what it was like to be young. They have forgotten the uncertainties of their condition, their fear of the great world they had not entered, their fumbling attempts to be men and women before their time.

Most of all, they have forgotten their own revolt against their parents and other forms of authority, a condition which in our species is a necessary prelude to maturity.

One of the things about being young is a constant worry about your place in the world—as it is, and as it will be when you have achieved your niche. In a way, this means knowing just who you are. In our day, this is sometimes rather grandly referred to as the crisis of identity.

This question of who you are, and the uncertainties surrounding it, is one of the great marks of youth.

The other is, of course, the surging of psychic and sexual energies, which is also surrounded with uncertainty and fear. These powerful new impulses, you have been well warned beforehand, are something basically criminal in nature.

They must be "tamed." They must not be allowed to exist in the form which God conferred them; for the God who gave us these impulses was the just and implacable God of the Old Testament, not the loving and merciful God of whom Christ taught.

There is, of course, another side to the coin of youth. The pure joy of existence. The delight in learning. The beauty of relating to people outside your family.

But the real emotional coloring of youth is in that word "uncertainty." The young are at the threshold of life. They are, save for the extraordinarily self-assured or well-weaned or those favored by inherited graces and wealth, scared as hell.

It is from this fear of what is beyond the threshold that most of the patent attitudes of the young spring.

These are defenses, usually defiant ones, against that fear of what is behind the door of life. The young are afraid they may not quite measure up.

The more complex life becomes, or the more complex it is thought to have become, the greater the fear of it is, and the more elaborate and contumacious are the defenses worked out to make the situation bearable.

It is these defenses which bug parents. This is not entirely because they are intended to do so, though this is part of the motivation behind them. Rather more, it is the brave front put up against the unknown, the whistling in the graveyard.

Think of this, if you are over 30, when you are next irritated by the beards, the complicated coiffures, and the frequent physical smell of some of the literally Great Unwashed.

If their clothes and attitudes were more extreme than yours were when you were entering life, maybe it's because their fear is greater. Maybe that's because they have a sight more to fear.

On the other side, the young don't have as much to fear as they think. If they did, it would be indeed a useless world which awaited them, and opting out (all the way up to suicide) would be the way to cope.

I remember seeing a graffito in the men's room of a New York saloon-restaurant down in Greenwich Village. What it said was in its way memorable:

"I want to be what I was when I wanted to be what I am now."

It really isn't all that bad for the young. And there are a lot of us who would give up our so-called hard bought wisdom just to be young and full of folly (and even fear) again. And a lot of us oldsters would be wearing beards, and getting kicks out of the Kama Sutra, and smoking the good Mexican stuff if we could get it and calling cops pigs when we were really thinking of parents—that insensate and secure class.

Youthanasia, How About It?

The fact that there are, or soon will be, more anthropoids of our kind under age 25 than above, is not only something we are are going to have to live with, but a problem we must adjust to.

The young are as numerous as flies around sap these days, and a sight more obtrusive. And, as the young always do, they take the view that unbridled license is their birthright. Anyone who differs from this generous view is square, senile and corrupt to boot.

The young adults of today were conceived during an uneasy period of our national existence, the days during and after World War II.

They have been called The Love Generation, the Now Generation, the Swinging Generation, and a lot of other things. A fairer title, for a large part of them, might be The Unwanted Generation.

The most important fact of life to those of my generation in the '40's was not the war. It was the draft. We had just lived through the worst economic depression in our country's history.

We knew what it was to sit in a darkened movie house, through two showings of a double feature (for 15 cents), because it was warm there, and there was no point in working your rear off looking for a job, since there weren't any jobs.

And then, just as things were beginning to get squared away, around the end of FDR's second term, and jobs were to be had, and life could be planned and thought about, old FDR sprang another one on us—this time the Selective Service Act.

Just out of the servitude of poverty, we were to be thrown into the servitude of the gods of war. And we didn't like it one damned bit.

Most of my tribe had the deepset feeling that we had been used. We were going to see that it didn't happen again, if we could do anything about it.

As it happened, there was something we could do about it. We could take on a wife, which kept General Hershey away from the door for a while. And we could have kids, which kept him away for rather longer.

We could dodge the draft, and still spout patriotic crap in the bars, so long as we were in the business of providing cannon fodder for the wars to come.

It was a good deal for us. Maybe not so good for the issue. Seldom in the history of the world could marriages have been contracted, and children born, for motives more base. We were using our children, even before they were born.

We are reaping the harvest today. The old, I am convinced, are hostile to the young in a way that history has never before seen. The long hair, the pathetic assertion of personality by the defiant use of drugs, the sexual urgency of the music and the dances—all these things bug the old in a way that seems to me unnatural.

I met a clever gent in Ireland recently, who was moaning over the crop of American kids. He worked himself up into a splendid lather:

"We ought to have mercy killings for these miserable creatures," he said. "Youthanasia," he added, with a degree of malevolent, smiling satisfaction.

It's very hard for my generation to make sense about the young because there is so much guilt tied into our feelings. A lot of us didn't want the brutes in the first place, and so we rejected them, and so they became creeps. (Really, of course, we didn't reject them so much as we rejected our own base feelings when we fathered them.)

It's going to be a tough nut to crack, all around.

Down with The Young!

Kids, millions and millions of kids, all wet behind the ears and loaded for bear, are the overwhelming fact about the present and future of the United States.

You may well add, "And may the saints preserve us!"

We are told that in five years half the people in the United States will be under 25 years of age.

This is something to cope with, no? Whether you are a barber, a nun, a newspaperman, a politician or a car thief, this takeover by the young has to be one of the facts of life.

It used to be a joke that most communication in the United States was gaited to the mental level of 14 years. It ain't funny any more, Momma. If you don't somehow penetrate the depths of the impubic mind, you ain't gonna move those tins of spaghetti, or get that ad campaign off the ground or win that war.

What we are living in, increasingly, can only be called a pedocracy, a government by children.

One gets an occasional glimpse into the minds of the young. This can be scary, like one of the remote circles of Dante's Inferno, or the world of Richard Hughes' "High Wind in Jamaica."

I know one young savage from Long Island who is getting a trip to Europe for a high school graduation present this year. He's more than average bright. He knows what he wants. His itinerary has been worked out by himself.

It is brief. "I want to see those cellar clubs in Chelsea, and Liverpool, and all those fabulous clothes shops in Carnaby street. Above all, I want to make it to the Ad Lib." This last is the loudest night place in London, with guys punishing their electric guitars like it was old Ma herself.

I asked him about the Louvre, the Colosseum, the churches of Rome, the fleshpots of Hamburg, the Folies Bergere and Harry's Bar in Paris, and all the other places rich with the

patina of age and long love. "I'll take 'em in if I have the time," he said.

I suppose every generation of the grown feels that the young one coming up is exactly like the Hun, with Attila at the head. There is a good case that we underprivileged adults have more reason than any previous generation for feeling this way.

What is coming up may well be a sub-phylum, a new brand of ignoble savage. Their shibboleth is the Mersey Sound. This week, anyhow. Heaven knows what new cacophony may grip their shady souls by next Thursday.

I have nothing against children, really; but in the past few years I've been looking at them with a growing tepidity.

The reason came clear to me one day recently. I am beginning to hate the brutes for the same reason I hate hypocrites, followers of body-contact sports, people who kiss the posteriors of their superiors, people who wear buttons with their names on them at seaside conventions, and the righteous.

I hate 'em because they are becoming a majority. Any right-thinking man must hate a majority; while bearing in mind Don Marquis' sapient words, "Because the majority is usually wrong, it does not follow that the minority is always right."

In the past I've felt that nearly all majorities were corrupt, just as I felt that too many minority movements, and especially the spokesmen therefore, were phony as a photographer's smile.

Now I have a minority I can really ally myself with, a cause I had damned well better believe in. Submersion, maybe survival, is involved.

This new majority will get my hostility, continued and unremitting. The battles of England may have been won on the playing fields of Eton. Our historic moral and military victories were won behind the woodshed, which is where the young ought to spend an increasing amount of time, conferring with us kindly elders.

The Problem Is People

*L*ong before LSD became something you could sell news-papers with, and build freaky communities around, I knew a prof who experimented with the stuff, and with other hal-lucinogens like mescaline, at a large California university.

Last time I saw this fellow, I asked him this question, knowing I could expect a level answer: "How dangerous is LSD?"

His answer, "As dangerous as the person who uses it."

I was disappointed. I thought the answer was a mite smart-arsed, an evasion of a thing which is something of a problem. But his answer stayed with me. On reflection, I think it is a good answer.

It really doesn't make any sense to blame drugs for the things that people do under their influence. That's putting the cart before the horse.

When a guy gets all tanked-up on Panther Puree, and goes to the family chez and beats the bejabbers out of the old lady, are we to blame the booze, or some deep-seated streak of violence in the guy's nature? And is it not possible that he drinks because of that violent streak, which booze will abate in small quantities, but unloose in large?

The drug problem, too, is a problem of people, more than of chemical substances which are used by some folk who find life wanting and have a need to soup it up.

This is recognized in a 130-page teacher guide and source book called "Drug Abuse" which has been distributed by the State to California schools. It is a document containing much sound sense.

Says the report: "The ultimate solution, if one exists, to the problem of drug abuse rests not in the control of drugs, but in the development of human beings who are resistant to drug abuse.

"In the final analysis, education about drugs may be

159

deemed successful only if it leads the young person to say *no* when he is confronted with the possibility of drug abuse."

And the first step here, of course, is to cure the harm done by parents. Parents have more to do with the conduct of addicts than drugs. Just as they have more to do with the conduct of homosexuals than perversity.

This question of unacknowledged parental guilt is a prime matter. The guilt makes faulted parents impregnable to the appeals of logic, makes them unable to admit that their emotions and their handling of their children, may be the real offender.

The shaken, insecure kid who turns to some form of moral analgesic most often does so not from the wicked fascination of drugs or booze, but because he has been bequeathed a faulted nature by his inheritance and upbringing.

In some cases, parents should doubtless be in favor of drugs, rather than against. They provide a way for weak children to cope, somehow, even if it is weak coping. If some kids weren't turning on with grass, they might be cutting throats.

The hardest of all truths for parents to face is this: If your kid commits murder, you can't blame murder for the crime. You can blame some violent defect in your son's nature. This violent defect is something you could have seen, and could have remedied or mitigated, if you had really been what you always think of yourself as: A good parent.

If your kid is a junkie, don't blame the backstreet pushers, or the Mafia, or the newspapers, or the fuzz, or Timothy Leary, though all of these play a part. The trouble your kid is in, if he's a junkie, is trouble that began at home.

Of Wowsers and Hippies

\mathcal{W}owser is a delicious word. It was a great favorite of H. L. Mencken, who imported it from Australia, and tried his best to give it currency in the United States. For some reason it never caught on. Not that it doesn't fill a need.

Mencken's definition: "A wowser is a wowser. He bears a divine commission to regulate and improve the rest of us. He knows exactly what is best for us. . . . So long as you and I are sinful he can't sleep. So long as we are happy he is after us."

The wowser is, in brief, a killjoy, one of those laddies "too niggardly of joy to allow the other fellow time to do anything but pray." The wowser, to quote Mencken again, "is eternally in the position of a man trying to empty the ocean with a tin dipper."

Right now the wowsers are having a wonderful time with the hippies. The fact that the hirsute, sandaled ones seem to be doing exactly what they want to do, and enjoy doing it, absolutely sends the wowsers round the bend. Their lips are permanently pursed in a prunes and prisms squidge. They tut, and they tut, and they tut some more.

The wowser takes the existence of the hippie as a personal affront. He feels these young brutes were placed on earth to degrade all he stands for, all the values he subscribes to; or, as he would put it, civilization itself.

He discusses the hippies in terms of high moral caricature. They are "a bunch of filthy drug addicts." This despite the fact that they are no more filthy than their square peers, and that the two drugs they most frequently use—LSD and marijuana—are not addictive, no matter what else they may be. Not addictive in the same way as tobacco and booze certainly.

The wowser gets his kicks out of preventing other people from getting their kicks. Disapproval is as important to him as water is to grass. Nothing can make him beat his tambourine with greater fervor than enjoyment, especially if the enjoyment

is found among the young, and most especially if the young are of a sex opposite to the wowser's.

The wowser is like the anxious parent who hears strange noises coming from his kids upstairs, and shouts, "Whatever you're doing up there, stop it right away."

The hippies are a perfect target for these dubious missionaries. They don't work. They take drugs. They make saucy cracks about sacred things, like making it big in the country club. They think their elders are a bunch of jerks and are not too politic about concealing the thought. And they wear the clothes of their choice, not slightly edited versions of what Daddy-o and granddad wore.

They are in fact, outrageous. They think the ancient pieties are a crock. And worst of all, in addition to their opinions and their personal eccentricities, they think they have the right to be left alone.

This is a right the wowser will never accord the target of his choice. Once he has the bit between his teeth, he is a veritable Javert, right out of Les Miserables.

Of course, the wowser really loves the hippie, in his perverse and unconscious way. Only a twisted love could explain the fury of his disapproval.

The hippie, by his mere existence, makes the wowser feel good. That is a service, kinda. As they say, nothing so much resembles a bump as a hollow.

Spare the Rod?

*I*n the days when I was young and green, the Christian Brothers, my preceptors, called it corporal punishment.

This was a sort of refined way of talking about the practice of beating the hell out of pupils for real or fancied derelictions.

We took the system for granted. So did our parents. It was just one of the many burdens of existence.

Since those days there has been in some quarters a reversal of thinking about the place of physical violence in the educational process. Right now, violence is in rather bad odor.

As I think on it, this is not a subject on which I have ever been able to make up my mind. Whether being beaten by my teachers helped me or hurt, I simply do not know. It was just one of those things.

We had our sadists, of course. There was Brother Raymond, and his big blackthorn stick. You went to the front of the class, put your head on a desk, and exposed your behind to his mercies. He enjoyed hurting kids. The pleasure showed clearly in his face. Being hit by Brother Raymond cannot have done much good for any child.

Most of the other teachers used the cane, or in some cases a sturdy yard-long ruler, with reluctance and even diffidence. They hit the kids because it was expected of them.

I daresay the real purpose of beating us was to remind us that we were bad boys, true heirs of original sin, and that the brothers were there to turn us into good men, somehow.

Nowadays the psychiatrists would have us believe that teachers use violence to satisfy the urges of power, anger and sex.

This is not the view of Mr. Stuart Yeatman, of the National Association of British Head Teachers (principals), or of his 15,000 colleagues. The principals recently reaffirmed overwhelmingly the "right" of school officials to use corporal punishment on students.

Mr. Yeatman delighted his colleagues by taking on the psychiatrists. He said only "long-haired wooly-thinking individuals" opposed the use of violence in the classroom.

As for sex, he said that at his age Brigitte Bardot would have difficulty stimulating him.

In England the system of "belt when things get bad" has been in use since the days of Henry VI. The system doesn't seem to have hurt most Englishmen.

A while back the Cardiff City Council banned caning in the schools. A month later it rescinded the ban after the National Union of Teachers protested by citing the high juvenile delinquency rate in that city.

"A good smack on the buttocks is better than all the psychiatrists," said a city councilwoman.

What it all comes down to, I suppose, is how strongly we value discipline as a virtue in our society.

Discipline is unquestionably good, but there can be too much of this good thing. Excessive discipline produces a blindly conforming individual who may be of value to society as a hauler of water, but little more.

Discipline works by the instilling of fear. The fearful man is afraid of nearly everything; but especially is he afraid of being creative, of breaking out of his mold, of doing the odd, the piquant, the unexpected.

The sensible answer would obviously be to use the cane up to that delicate point where the user would know that he is instilling discipline but not killing the creative powers of the pupil.

To know where this point exists would require almost Godlike capacities, and would be impossible for the disturbed teacher, of which a few exist. Yet there is much to be said for the spoilage of children as a result of the sparing of rods. Tell me the real answer, Mummy.

Those Terrible Young

The media are getting to me.

All the caricatures which now move Americans to action, and sometimes to violent action, are beginning to be graven into my mind through the kindly medium of TV.

I used to pay very little attention to the telly. Kind of snobbery, I guess. Recently I lived in England for three years, where I watched the BBC and independent television for a single reason: To learn something about the people I was living among.

In England, the experiment worked. Knowledge, gained through the telly, brought sympathy. It brought some hostility, too, for British television is self-critical and almost implacably honest. In balance, though, what I saw made me like the English more than I might otherwise have.

In a similar spirit, I have taken to watching television in my own country, the better to understand the perplexing people I find all about me.

The experience, to this point, has not been altogether happy.

Take the question of the young, as a single example. When I think of a student now, or even a kid, the stereotype which comes to my mind is increasingly the sweaty, smelly, rock-throwing, long-haired, bearded rebel who has been the most popular character in the dramatis personae of television in recent years, with the possible exception, on occasion, of the drunken black man running out of a store with a stolen television set under his arm.

I know the stereotype of the young is nonsense. The young today are no different from the young of my day. They are worried, but we were worried too. We worried about getting a job. The young nowadays worry about getting shot for their country. We worried because we knew that getting a job was, mostly, out of our hands. The present young worry

because they know that their lives are much out of their hands, and may soon be completely so.

No, it is not the young who have changed. It is their elders who have changed, and changed terribly. The things mature men pursue today are far more evil than the things they pursued when I was a kid—and those things were bad enough.

I was reminded of this forcibly when I recently read some words spoken by the distinguished poet, Mark Van Doren, on the occasion of his 75th birthday and the publication of his 14th volume of poetry. He was speaking of the young:

"They are called destructive but it isn't the young people with beards and long hair who are the destroyers. The destruction that really matters is being done by clean, well-shaven men in business suits who are polluting our atmosphere, strip-mining our countryside, building armaments and conducting a cruel, utterly senseless war in Southeast Asia.

"They are literally tearing our world to pieces."

Words like these, eloquent and true, are what bring me back to sanity. They blur, as it should be blurred, the propaganda image of the young as useless, crypto-criminal monsters.

Words like these remind me of things I used to hear, like "The young are the hope of the world." And indeed they are. The shape of the world to come will be made by them. Indeed, in their haste, they are trying to make it now, without the real power to do so. They will prevail, if the world prevails, simply because they will outlive us.

It is, I fear, too easy to fall into gloom, and conclude that the world, in this country, and late in this century, is uniquely wicked. The evidence, unfortunately, is pointing increasingly in the direction that this is so.

Under the cosmetic lie of affluence and jolly leisure at the bowling alley is a corruption of spirit that is fully visible to the eyes of old poets like Mr. Van Doren, and young militants, like the kid next door. They have found us elder fellows out. For this we cannot forgive them. For this we are beginning to hate them.

Doing His Thing

*I*t was the end of summer, the Sunday before Labor Day. It was nearing the end of the day, too, with flat golden patches of sun showing on the thrusting Pacific.

My host had seen this house we were in when he was living in London more than 20 years ago. It was shown in an ad in Town and Country. He knew this house, next to this magnificent sea, about 12 miles up the coast from San Diego, was what he wanted for life. He bought it, on the evidence of the picture.

As we were sharing his Scotch on the terrace, I thought "Is there anything I've ever had, that I wished to have for life?" Apart from my children, I should say no.

For about a half hour before sitting down, I had been hearing the ghostly strains of a horn. Flitting in and around the rocks I could see a tall young man wearing an orange derby, with his mouth affixed to a saxophone that was golden in the sun.

The music he played came through the trellised wall surrounding part of the pool area. The music had never been heard by man before. It was all in a low, melancholy key, and was the improvisation of a man who knew his instrument.

The sounds were pleasant, and framed nicely the mood of the evening. I gave no particular thought to who the boy was, assuming perhaps he was my host's oldest son. He was tall and angular.

Suddenly, however, the whole thing changed before our eyes. In front of the house there was a spit of rock, triangular in form, and extending perhaps 30 feet into the sea.

Here our musician found himself. He could not have known anybody was watching. He seemed wholly unaware that he had been trespassing on private property.

The wind was right. The sound of his horn came perfectly to our table.

167

The whole scene glowed. This was Pan himself, the god of shepherds and herdsmen, of groves and fields. He had come from the woods and mountains of Arcadia, to play a dialogue with the sea. His notes, melancholy and clear, carried perfectly. In counterpoint were the roar of the waves beating the California shore.

Pan stood on that point of land, writhing and shaking to the sound of the sea and his saxophone. He danced with every part of his body but his feet. The orange derby described circles in the dying sun.

The two men watching him were deploring the fact there wasn't a photographer around. The light, muddy and then brilliant, was perfect. The boy's silhouette, and the golden circling horn, and the surging sea, made a brilliant composition.

For at least a half-hour the sea-and-sax dialogue continued, before Pan moved with his horn slowly up the rocks. He had done his thing. Watching it, there was no room for doubt that he found it deeply satisfying.

It turned out he wasn't my host's son. He was just a guy who had come out on the beach to make some music on a late summer's day.

My host, who is somewhere between straight and groovy, was deeply moved. He wears a beard, but his opinions are mostly conventional.

The concert by the sea, though, had gotten to him. He rose from the table, walked down in the direction of the beach, and spotted the musician as he was packing his horn. He waved at the lad, and clapped his hands.

Returning, he said, "The damnedest things happen near the sea."

At about ten that summer night, as a party was in progress in the house, a young man with an orange derby rang the bell at the front door. When a servant opened the door, the young man handed her a single, long-stemmed red rose.

"For the lady of the house," he said. Then he made a short bow, and went away.

Pacifist or Draft-Dodger?

*A*mong the unfair ethical dilemmas which we have furnished our young is this:

"How do you know whether you are a pacifist or a draft-dodger?"

In recent years, and for the most dubious of reasons, our country has embarked on a crazy kind of course. It has adopted as part of our way of life, what amounts to a peacetime draft.

The effects of this peacetime draft on our life—or, more properly, on the lives of those who are caught up in it—are already immense. They will be felt well into the 21st century.

A young man can be compelled to fight in a war which he totally loathes, while his country is in no visible threat of perishing. Were it in such threat, he might indeed feel that combat was his only honorable course as a human being.

The peacetime draft, which causes thousands of boys to offer their lives in behalf of a senseless adventure in Southeast Asia, is one of the wickedest things of our time. Just think about it, and imagine yourself at age 20, and try to disagree with me!

The worst part of the thing, though, is that a young man cannot honestly be certain whether, when he says he is against war, he is stating a principle deeply felt, or whether he is simply caring for the safety of his own skin.

When I was young, in the time of the 1930s, I was against war, as indeed I am today. There was no ethical confusion in my stand, because there was no possibility that I could foresee wherein either I or my contemporaries would be forced to fight a war we did not believe in.

I could tell myself I hated war, and feel quite principled about the whole thing.

I could not do this today, nor can my two sons, one of whom is of draft age and the other pushing it.

I could, indeed, burn draft cards, march in demonstrations, make strong speeches, quote Thoreau and Gandhi and

Jesus Christ, and in general make all the assertions which are indicated in a man of peace.

I could do all these things; but I could not avoid feeling slightly hollow inside.

I could not be sure whether I was expressing a simple and respected aversion to man's least likeable occupation, or was rationalizing a fear of being drafted into uniform and being killed with the grace and beauty of cattle in a stockyard.

I could not know whether I was being a private kind of hero for opposing something quite degrading and long-favored by my fellows, or whether I was a damned coward because I sensed the breath of the draft board on my neck.

I was against war when it was proper and chic to be against war. When the folly of my elders, American and Japanese, caused the bombing of Pearl Harbor, I knew I was caught up in a predicament which I could not elude. I tried to enlist in the Navy, and was accepted. I was later turned down because the Navy raised its physical requirements and I could not meet them, because of defective sight.

But in each case—my opposition to war, and my later acceptance of its necessity, at a certain time and place—I was expressing my will, or thought I was, which is perhaps the same thing. Until the World War II draft actually appeared it was I, Charlie McCabe, who was making decisions about war and his life.

Nowadays, this cannot be said. When I hear the beefs of the young, about this and that, I am sometimes bored and annoyed at their exigency and lack of taste.

I cannot, however, permit myself to forget the extraordinary fact that, in a country conceived in terms of the democratic ethic, the present young can be compelled to fight in a filthy and irrelevant war, whether they like it or hate it.

I cannot permit myself to forget that the country I now find myself in is not the country I grew up in. I cannot permit myself to forget that when I said I hated war, as a kid in my 20s, I meant what I said and knew what I meant. My elders had not placed me in a bind where I could not be sure that when I said I hated war, I was merely wondering about the safety of my own integument.

Birth of Hate

The other day I was driving south from Marin county. I had just paid my toll, and my driving speed had risen to, say, 35.

Suddenly I was passed, on the right, by a guy who must have been going 60.

I was annoyed, as anyone would be, by the combination of excess speed and careless driving.

I said something to myself like, "That clod," and let it go at that. The incident, if I really thought about it at all, was finished.

But it was not. At the first stop light I caught up with the reckless driver, which of course proved he hadn't made many points by his speeding.

I looked at him. He was about 25. He wore a blue denim shirt, his hair was long, and he had a huge black beard.

Quickly, hatred welled up in me. I hated that guy with a passion. When he turned right on Scott street, and I moved straight ahead, I was glad to be rid of him.

And why?

The beard, of course. To a degree, the fact that he was young entered into it. I wouldn't have hated him so much if he was 50, and was wearing a beard.

I couldn't get the incident out of my mind. I knew my feeling was irrational. The fellow was a careless driver, and perhaps an ass, but he had done me no harm. There was really nothing in him to account for that momentary intensity of feeling.

Then I knew, of course. I was a victim of a contagion.

Lord knows, there is no reason why I should have anything against beards. I wore one myself for seven years. I was on the receiving end of all kinds of charges as to why I wore it—from having a "weak" chin to outright Communism.

I wore a beard for the same reason most people wear beards nowadays, and for the same reason that some people did *not* wear beards in Victorian times—to express my

dissent from the prevailing views of my time. I don't wear a beard anymore; but my dissent is still strong. I happen to be made that way.

I am more in sympathy with the views of people who wear beards than most people of my age, yet here was hate upon me, and hate brought on by a beard.

I do not underestimate beards, nor would you. They are a potent weapon in the fight the young are waging against their elders.

A beard is something uniquely yours. Your parents cannot decide whether you will have a beard or not, because if you are old enough to grow one, you are old enough to make your own decision. A beard is the symbol of independence from the bondage of youth.

Naturally, it bugs the older folk. That's its main reason for being.

I thought I knew these things; but I did not think they applied to me. Now I know otherwise.

The newspapers, and the telly, and the conversation in bars and airplanes, and dinner tables, and the things in magazines finally have gotten to me. A hostility I thought did not exist proved only to have been latent, and to have been brought precious close to the surface by the cultural miasma of our times.

There is a need to hate. The media satisfy it. Nothing, I remembered again, that is common to mankind is foreign to me.

This is humbling knowledge. All you can do about prejudice, once you know you have it, is fight it; but you must fight it from the stance of a cripple, because you have indeed been crippled by the knowledge.

Because a man is a Jew or a black or a self-assured WASP, or wears a beard, is surely an accident of birth which has nothing to do with his humanity—even if he should be a careless driver, or a hard bargainer, or even a crook.

The sad thing is that we should have collective and individual guilts which must be assuaged by hatred of those we feel guilty about.

I am going to be very careful about looking at beards in the future. Perhaps I shall even grow one again, as a penance.

Life on the Beach

There is down there on the beach, no more than 100 yards from me and my beer, a delicious thing from America of 21 years and nine months, who has solved the problem of life. This isn't easy at any age. It's especially uneasy at hers. She has made it with the help of a little old Yankee ingenuity and 25 Yankee dollars.

The hardships that make our squabble from cradle to grave so frequently a drag are unknown to her. At the minute, life is something that never happened. She is almost as distant from its crudities as if she were surfing off the coast of La Jolla.

Her brown body is nude except for a bikini, and a large pair of $25 sun glasses, given by her daddy. The glasses with the transistor radio fitted into the side pieces. Complete with plastic ear plug and volume control.

As she lies there, appropriately basted with Germaine Monteil's Pour le Soleil, there just isn't any way life and its agony can touch her. The difference between my young friend and an eggplant is nominal. She's better looking, but perhaps less involved in the affairs of the planet Earth.

Behind the sun glasses, which excise half the problem of the world about her, she is listening to Herman and His Hermits doing the thing about Mrs. Brown's lovely daughter, which takes care of the other half.

This girl, mark you, is a member of the human race in good standing. She comes from decent, hard-drinking parents, has all her marbles, expects a small inheritance at 25, and is tidily put together. By the merest whistle, she can have everything life can offer a girl of her time and place.

And there she lies, death-warmed-over. Another citizen of Wombsville, U.S.A. Like I always say, if you're gonna be a corpse, be a good one.

It's not that she occasionally puts on her picturesque specs. She seems to live in 'em, in a horizontal position. She

deliberately erases from her nature for several hours a day all those things which give her a claim to humanity.

Were girls always so inert?

It seems to me the ladies of my youth were always on the prowl. They were active in those multiform activities which keep the species going, like trying out dime-store lipsticks, gossiping about the haircuts of their boyfriends, and even figuring out names for their children after they have devised methods of getting their hands on the future hubby's paycheck.

The transistor is now playing "King of the Road." I know, because mine is on too, in the house fronting the beach. The lissome figure continues in its mindless torpor, a knee occasionally raised, and lowered. I cannot tell whether her eyes are open or shut. It hardly matters.

And I thought of that tired old French exquisite, who said: "Live? Our valets can do that for us." And I wondered who was doing for that lovely creature out there the living she had been allotted—somehow, in the scheme of things.

I knew a thing had been lacking all along, and suddenly thought of what it was. All my young friend lacked to be Ye Complete Sunlit Corpse was one of those plastic, transparent coffins that some of our more affluent starlets in Beverly Hills use at poolside. They are rather like a "Whispering Glades" embalmer's sample, or a plastic box you buy a kitchen knife in. They let in the sun's heat, but protect ladies from its rays.

My delicious friend, under one of these, wouldn't get brown, to be sure, but there would be compensations. She would be that much farther from life, that much closer to death. The transistor is now belting out "Fever" as done by Cilla Black.

5.

Personages

*Being accounts of the
author's encounters
with the famous
and infamous.*

Queen at Work

The Queen entered at 11:02 a.m. This was two minutes late unless all the clocks in Buckingham Palace were fast. The crowd in the Investiture Room rose. The band broke from the tinkle of "I'm Forever Blowing Bubbles" to the rousing imperial wheeze of "God Save the Queen."

"Ladies and gentlemen, you may be seated," said the Queen, in her clear girlish voice. Some 300 persons, of whom I was almost certainly the only foreigner, sat down. Stiff at attention behind H. R. H. was her bodyguard, five stony red-coated beefeaters known as the Yeomen of the Guard.

The Queen is a good looking woman, more attractive though less pretty than her younger sister. Everything you have read about her complexion is true. Her hair is bronze. She was wearing a robin's egg blue silk sheath, with a diamond clip at the right shoulder, and black patent leather pumps. She looked like nearly every other woman of her age in the room. Healthy, agreeable, and not-quite-smart.

This was a working day for the Queen. She was rewarding people whom her civil servants valued, about 300 of them. Some were knighted, some got the Order of the British Empire and other lesser-known orders. Nearly all in morning coats, or dress uniforms, these servants of the Queen came from distinguished obscurity to get their reward. They promptly returned to distinguished obscurity.

That is, except Mary Quant, the young dress designer who got an O. B. E. Her reddish-hair cut down to the eyes, the designer wore a cream beret, cream mini-skirt, white mesh stockings and cream Baby Janes. She did not give an inch to tradition, and would have looked perfectly at home on a Saturday morning on the King's Road, in Chelsea.

The Queen had a little natter with each recipient, and then smote him on the shoulder with her sword, or pinned a medal on him. Pinning several hundred medals on men and women must be quite a skill in itself.

As the endless pinning and dubbing went on, the Queen's Own Combo, on a raised balcony, continued with the quiet tintinabulation of Lehar, Romberg, Berlin, Rodgers and Hart, and several Strausses. It was like a tea party in the Orangerie of any Plaza or Ritz in the world, muted and frightfully discreet.

The audience, seated under six Venetian crystal chandeliers suspended from the ceiling of a cream-and-gold room 125 feet long and nearly as high, were relatives—scrubbed kids, goodlooking young matrons in borrowed mink, and a sprinkling of clerics.

After about an hour, the whole thing began to get deliciously soporific. Nobody, happily, had any problem about Nature's Call. The Queen continued to pin and dub and chatter relentlessly. All the while she wore a smile that, miraculously, did not at any time seem false.

There must have been some among the audience, and even recipients, who thought the whole thing silly and childish, but their faces never betrayed such feeling. They were all playing the game.

The tell-tale coughs of boredom nevertheless began. It was about time to quit. The Queen knew it too. All was over by 12:10 p.m. The Queen left, followed by two sepoys who looked like bellhops at the Hong Kong Hilton. The Lord Chamberlain followed.

Last to go were the Yeomen of the Guard. As they strutted out, pounding their maces on the polished floors, the combo rousingly rendered "Whistle While You Work." Must have been some kind of Palace joke.

St. Brendan, the Drunk

\mathcal{D}ublin is the only city I know where the chief tourist attraction is talk. "Come and listen to the great talk in the pubs of Dublin," says the Irish Tourist Office.

I reckon it must be so.

During the jubilee year of the Irish rebellion—which, after all, was pure Dublin talk punctuated at the end by the rattle of gunfire—the man most remembered in this city was not Padraic Pearce, or Joseph Mary Plunkett, or James Connolly, or Roger Casement. It was the late Brendan Behan, a lush and playwright, and jailbird, and great talker, who died in 1964.

In the interval since his death, Brendan has been almost canonized. And since the talk goes with the drink in this town, there are those who call him St. Brendan, the Drunk. Brendan, they say, was a lad who would drink porter out of a policeman's boot.

His death certificate tells the story: "On March 20th, 1964, at the Meath Hospital, Brendan Behan, 5 Anglesea Road, Ballsbridge. Male. Married. 41 years. Writer. Cause of death: Hepatic coma, Fatty degeneration of liver. Signed Peter Sheridan, occupier, Meath Hospital."

Brendan grew up in a world of colorful chatter, where a man could walk into a pub and yell, "Gimme a pint of stout and a bottle by the neck." Where the highest terms of praise were "Your blood's worth bottlin'." And where if one chap met another on the street and urged upon him a physically impossible act, he would meet the dignified reply: "An' yer sister!"

Here are a few of Behan's more notable observations, all of them supposedly uttered under the influence of his beloved "gargle" and all hatched in the low alehouses off Grafton street, and on the Liffey quays, and elsewhere where drink was sold.

Religion: "When I'm in health I'm not at all religious. But when I'm sick I'm very religious. I'm a Catholic after dark."

Some Clerics: "If people want me to behave like Cardinal Spellman or Billy Graham, why don't they pay me the salary those fellows are getting?"

Jails: "I like the English ones when you are young, and the Irish when you are older."

His Conduct: "I think I'm as well behaved as most politicians, owners of television networks, newspaper proprietors. I'm not dead and I don't belong to posterity, yet. How's my health? If I felt better I couldn't stand it."

The English: "They're like the Germans, their first cousins, a very innocent race of people. Gentle when they're taken away from their guns, their queens, their kings."

His Home Town: "In Dublin you have conviviality, but no friendship. And Dublin will give you loneliness, too—but no solitude."

The Gargle: "I can only say that when I was growing up drunkenness was not regarded as a social disgrace. To get enough to eat was regarded as an achievement. To get drunk was a victory."

Soda Water: "A good drink invented in Dublin, but better with whiskey than straight. Whiskey is too good to be sullied with water. Follow it with stout."

On Writing: "Chastity and water is the only formula."

On Politicians: "I'm no politician. I've only got one face."

The Irish Republican Army: "If the big owners like America and Russia are entitled to drop big bombs, surely the I.R.A. is entitled to drop little bombs."

And there are his last words, supposedly uttered to the nun who was caring for him. "Thank you, sister, may you be the mother of a Bishop!" The folk who tell you this story say it probably isn't true. They add that "it could have been."

A Last Lunch with Adlai

*I*t was 12:45 p.m. on a warm sunny afternoon of early May, 1965. The lobby of the Waldorf in New York was crowded. We walked to the last elevator in the bank, shoehorned ourselves into an express going to the top. I said "42" although the car was clearly marked "Lobby to 41." The operator gave me a quick look, and we were off.

The car emptied at 41, where there must be some kind of sight-seeing set-up. We went up the added floor to the governor's suite. He liked to be called governor still, though he was Ambassador to the United Nations from the U.S.

The door opened and we were welcomed warmly by Miss Viola, his housekeeper for many years. The governor would be a bit late, but was already on his way. When he died later, and one thought of sending a wire, oddly the first one who came to mind was Miss Viola. She was closest to him.

We had ten minutes to admire the view, the books, the blue clown of Walt Kuhn near the door, and the black little offbeat Sargent of the Spanish priest seated at a study table. I was reading the Atlantic Monthly when the governor came in to give my wife, an old friend, a fat hug.

He looked fit, and full of fun. "God, what a morning!" were his first words. He had been over at the cool, pacific glass slab called the U.N. building, which we could clearly see from the windows of the Embassy dining room. He had been performing the dirtiest part of the diplomatist's duty: lying on behalf of his country. This time it was the Dominican Republic thing, the bouncing issue of the moment. It was slave labor, and deeply expensive of spirit; but he took it in good part.

No one else came to lunch, a fat bonus. This man, who seemed always to be in large groups, and always somehow alone, enriched small meetings. I never asked the governor the questions a newspaperman might ask. He had enough of that, Lord knows. But I did look out the window at the U.N., as we were having our martinis, and asked: "Is it true that they're

going to turn that thing into a bowling alley one of these days?"

He shook his head ruefully, and said, "More like an armory, I should think."

He talked of England, where we were going, and California, which we had just left. He loved both places, truly. We talked of his grandchildren, of the former Time journalist Tom Matthews, who had been his roommate at Princeton, of his friend, Mrs. Ronnie Tree, and of numerous other ladies who admired him to distraction.

I reminded him of a time we went with him to a Filipino cocktail party at the Plaza, and then down to another cocktail party given by the Afghans, after which he had to go home to get dressed for a proper banquet of some kind, with a speech. This on top of a heavy office day.

"How the hell do you stand it?" I asked. He said something noncommittal about not minding at all. The twinkle went out of his eyes suddenly when he added, "You know, I wouldn't be without it."

The fish was fine, tasting as if it had been caught just off the Narrows a few hours ago, and there was a very cold Riesling, not grown in California. The talk turned to a handsome lady named Margaret Owings, who lives in Big Sur, and is the wife of Nat Owings, the architect, who is the father of Mrs. John Fell Stevenson.

I told him how I had conned Mrs. Owings, who is a superb craftsman with a needle, into making a sampler for me, incorporating a bit of wisdom I once got from Gerald Heard, the English mystic. I said it now hung over the fireplace in the library of our home in England; and that we hoped one day he would come to see it.

The coffee came. The governor had to go back to the oratorical wars. Before he rose, he reached into his coat pocket and pulled out a rumpled paper notebook and from another pocket a stub of pencil.

"What was it you said that Margaret stitched on that sampler?" he asked. I told him: "Success is getting what you want. Happiness is wanting what you get." He copied it down carefully.

"I will surely use that one time," he said. I wonder if he ever got the chance.

Lucius Beebe, a Memory

As a bird of passage through New York recently I nested briefly and devotionally at the long bar of the Artists and Writer's (formerly club) Restaurant. This is a speakeasy (emeritus) on West 40th street. It was a great newspaper hangout, especially for the staff of the now defunct Herald-Tribune. It was run by a man named Jack Bleeck.

In 30 years, the place has hardly changed a whit. There aren't too many places in New York of which this can be said. The bar and the back room are exactly what they were. The chief change was the absence of the free lunch at the bar. This was an opulent collection of cheese and other delicatessen, which sustained many a young reporter in Depression days.

Huge whole cheddars were contributed, from time to time, by Trib publisher Ogden Reid, a regular customer, and columnist Lucius Beebe, another.

It was in Bleeck's (pronounced Blake's) that I first laid eyes on Lucius Beebe. All six feet four of him was covered with white tie and a red-lined opera cape, for he had just been to the Met, down the street. His resounding Beacon Hill voice was raised in full diapason. He was addressing a group of Trib staffers, wearing civvies:

"There are three kinds of people in this world I will never fraternize with," he said. "Jews, Negroes and women."

This was an utterance not likely to be forgotten, especially by a cat looking at a king. It was characteristically Beebeian. He thought Mark Hanna was a liberal. He was a true Bourbon, too, in that he never forgot anything and never learned anything. He thought the rich were beautiful and good. He never ceased thinking so, though this is far from a prima facie case.

He loved to outrage the bourgeoisie, whom he despised and feared, again like a Bourbon. Yet his most rampageous statements, both in writing and conversation, were hard to take offense at. There was in them an element of self-mockery which neutralized the sting.

A typically Beebe column would start out as a slam-bang attack on some institution beloved by the poor. Some thousand words later, fangs removed, it would peter off in an almost friendly farewell.

Lucius was a great excluder. This is perhaps because he was a great lover. He protected himself from ordinary feelings by a passionate dedication to what he considered "the best." He could tell you the best tailor in Vienna, the best chef in Rome, and the finest steelmaker in Sheffield; but he quite literally did not know which league the Dodgers were in.

When a kid, he had had a traumatic experience. Someone very close to him (a younger brother, if I'm not mistaken) had been killed in an airplane, before his eyes. This experience, he once told me, had taught him two things: Avoid being too close to people, since the loss of their love can be so hurting; and keep out of airplanes.

His lifetime fear of airplanes led to a passion for solid, substantial earth-struck conveyances. It made him the leading scholar of the steam locomotive of his time, and led him to one of his more noted vanities: His private railway car, where he buried himself in the womb of the past that was more real to him than the world he lived in.

He was a bundle of fears, which he gallantly transformed into the armor of arrogance. He was more like the rest of us than he thought.

Lucius was a good man, and I miss him. May peace be with his restive soul. He would have made a splendid cardinal.

'Just Bloody Rounders'

The Western Union boy was waiting outside on his bike. I was sitting in a pleasant room, facing a large and lovely garden. My typewriter and paper were in front of me, and 15 feet across the room was the television set.

It was Sunday. Koufax was throwing for the Dodgers. The game was in Yankee Stadium. I was trying to get out a sports column for The Chronicle to be published next morning, wherefore the typewriter and the Western Union boy.

There were, I had found, three ways to cover the World Series. You could go to Yankee Stadium, which was unsatisfactory for many reasons. You could go to a saloon, and watch it on television, which was better, because it had more of the feel of the game.

Or you could sit in a pleasant living room, and watch it on the telly. This was best of all, because it was pure baseball, in spite of the announcers. (How pleasant a baseball game would be on television, with not one word from anybody other than the sounds of the crowd!)

The room I was sitting in was right next to a bar, which was a mistake, as it turned out. The ladies had gone to visit Long Island neighbors. Our host was playing golf. I had the whole place to myself, as I thought.

I was wrong. I reckoned without the British journalist. He was a man of considerable attainments. He was also wedded to the bottle.

He had slept late and needed a drink. He found the bar. He made himself a whiskey and soda. He plopped himself down on the chair near me, and began to watch the baseball game. I was typing notes industriously, about important things like Koufax's windup and Maris's recent impotency at the bat.

It turned out the Englishman had never seen a baseball game. Like a good journalist, he had an inquiring mind and a lot of opinions. He also couldn't take quite seriously a person who wrote about sports for a living.

I knew I was in for a bit of hell.

A beautiful double play was executed. The crowd howled. I made notes on the typewriter, but didn't get very far. My friend was vociferously demanding an explanation. Explaining a double play to an Englishman is like outlining the complexities of original sin to a Melanesian aborigine.

The explanation didn't satisfy him. He continued glued to the tube. "Just bloody rounders," he said. Rounders is the old British game from which baseball is said to be derived.

That was to be the theme of the afternoon. Just bloody rounders. The man would go to the bar, make himself another toddy, return to his seat, demand exegesis of the good old National Pastime, and mutter moodily, "Just bloody rounders."

At about inning seven, wearied of explanations and unable to follow the game with interest, I started to write my column. "I'm going to write now," I said. The news did not affect him in the least, this man who had met hundreds of deadlines, in battlefields, in Parliament, all over the world. The questions and the comment continued. Remorselessly.

Somehow I finished my piece before the game ended. When it was done, I pencilled in the final score, took it out to the Western Union boy, came back into the room to listen to the post-game chatter, and filled my glass with a healthy shot of White Label.

The Englishman was staring into his glass. He had found nothing particularly creditable about the whole performance. It was merely, in his eyes, another bit of nasty Yankee plagiarism. "Just bloody rounders," he said, a final time.

This was Randolph Churchill, son of Winston, a first-rate journalist and rotten politician, a man who loved his father with a touching devotion, a person with all the bad habits of the British aristocracy and few of its good ones—a man too conscious, always, of being a blighted hope. A nice man, inside himself. And a man now, unhappily, dead at 57.

Dorothy

Though her soul never rested in peace for a minute of her her life, she will get plenty of it now.

Death reached Dorothy in a commonplace enough way a short while back in a pretty little pink house on Olivetas street in La Jolla.

She lived there alone, after her mother died, and her sister married and went to Texas, and her brother took a room by himself in San Diego. One day there was a drink or two too much, and the cigarette set fire to the mattress, and when the firemen came there was a dead woman in the bed.

This girl had everything, and used it all rather badly. She was beautiful and bright in the Irish way, and no one who knew her in Dominican Convent could have dreamed her life would not be a brilliant success. She had a husky, sexy, memorable voice, and her whole manner said Don't-Give-A-Damn.

And yet she failed, and calls to mind the words of a great French statesman: "A man's life is interesting primarily when he has failed—I well know. For it's a sign that he tried to surpass himself."

Dorothy was forever trying to surpass herself, not knowing how surpassingly good she was in the first place.

She was a good actress, but lacked the personal discipline the craft requires. She wanted attention and wanted it continuously, but could not do the reciprocal thing of giving her talent continuously.

She was a child to her dying day. She had the bad luck to have a father—a bibulous San Diego judge—who simply adored her and used her as a toy for his enjoyment. She never got that attention and love again, and constantly sought it. She never realized that the first love had crippled her and made it impossible for her ever to find it again.

Because she was a child, children saw through her (as they see through everything) and loved what they saw. She would

walk through the streets of her little town, and every child within blocks would know it, and would join her. She could love children, but had a hard time of it with people of her own age.

At one time she was what we called a starlet, which meant she lived at the Beverly Hills hotel on a kind of expense account, and ate with important movie people at the restaurants which were then considered important, like Chasen's and Mike Romanoff's. She fell in love with just about the worst bad hat in Hollywood, and flew to Texas to marry him, and at the last minute lost her nerve, and dissolved into floods of tears.

She was well and widely read, this from her father. And she was a natural writer. Once she did a society column for the La Jolla paper, and it was the best example of that funny genre that I've ever seen. But when it came to offering it to a newspaper chain, and going into the big time, it was the same old thing again: She lost her nerve.

She could have been a duchess, or run an airline, or written a succession of good books. She could even have been a fine actress.

She did none of these things, because when the chips were down the shattering hand of a father who loved her unwisely and too well, came along to ruin everything.

None of this prevented her from being marvelous company. She was the pluperfect Irish biddy. In her intimate, cozening way she could find the vulnerabilities of any man within five minutes. Then she would describe them, usually to another man, in a style of marvelous bitchiness. This is what made her such a great, if unknown, journalist.

Dorothy had style. Like the Irish peasants, there wasn't an ounce of vulgarity in her. She had by-passed much that the world valued as good in her life, but she had also by-passed much that was bad. I can still see those children following her, an old, unhappy woman who drank too much. And I can see her, younger, when she was one of the hottest properties in Southern California. Yes, she was quite a woman.

W. C.

*T*he picture was published a week or so after the savage murder of actress Sharon Tate, and four other people.

It showed a joyous and beautiful Miss Tate sitting in front of a huge photograph of a man. You could identify the man if you looked closely enough. It was W. C. Fields, with his plug hat and flaring color, as he looked in one of his famed roles.

The picture was an altogether fitting prop in the macabre tale which seems about to become the epic of the late century drug subculture.

The picture is known everywhere, and sells hugely. For the young—drug user or no—the name and notion of W.C. Fields means something.

Just what?

It is hard to say, for the young could hardly have known him personally, and but few of them have bothered to read up on his confused and disorderly life.

They know him through his films, and through his legend. With the last, the young have a strong identification.

The salient thing about Bill Fields, whom I had the pleasure to know slightly when a kid, was his paranoia. He trusted nobody and nothing.

The story is often told of his suspicion of banks. In the belief that one or another was going to fail, he parlayed his money into scores of banks under scores of aliases. And sometimes, under the influence of booze, he could forget both the banks and the aliases. The story tells a lot about Fields.

The screen role he played, over and over again, was the man himself. When he said, "Anybody who hates children and dogs can't be all bad" he was kidding for real.

His phobias extended far beyond children and dogs. They included pretty much everything and everybody, and especially himself. He was a classic example of self-hatred, softened and made somewhat bearable by the gallant use of

self-caricature. Some people call this comedy, and label Fields a comedian; but these words are far off the mark.

He was a man constantly in pain, tortured by the memory of his family in Philadelphia, who used him as a punching bag, forced him to run away from home when he was still in short pants.

His travels around the world as a boy juggler only confirmed the view of the species that he formed when a kid in Philly. They were not to be trusted. Love would be returned with disaster.

In those days he developed his apothegmic form of speech, of which my favorite example is "If you want to know something about juggling, ask a juggler."

To cope with his ever-present pain, Fields took to the use of that great anesthetic and Universal Solvent—alcohol. He took to it with vast and life-lasting enthusiasm.

Typically, he tried to make alcoholism funny, and almost succeeded. He never drank water, he said, "because fish swim in it." His face bore the stigmata of the boozer, and they were worn with great pride, as if drinking was one of the more esoteric arts, practiced with proper skill by only a few of the anointed.

What the present-day kids see in Fields, I think, is that he was the almost totally alienated man—bitter in his opposition to the system, and subsisting in a hostile world almost wholly on his pride.

The pride always came through. The obverse side of paranoia is often a kind of feverish self-reliance. "I can take care of myself" is not far removed from "Nobody likes me." Fields took care of himself, to be sure, but at the cost of how much humanity! He didn't have friends. He had drinking companions, which is another matter.

His picture must say a lot to the young, or it wouldn't be pasted on walls in those countless untidy pads. What he said was sad, and I'm sure the kids dig this. But he was an artist, and turned his suffering into joy for others. I hope the kids dig this, also.

The Angry Man

People knew him by a lot of names in his lifetime.

He was called Bud, and Peg, and Jimmy. His byline, at various times, was James Pegler, James W. Pegler, J. W. Pegler, J. Westbrook Pegler and just plain Westbrook Pegler.

He was always a bit ashamed of that Westbrook; but one-eyed war correspondent Floyd Gibbons talked him out of it in the days both were reporting out of London.

Pegler said Gibbons advised him to drop the by-line he was then using for United Press—J. W. Pegler. The older man told him a "Pullman car" handle like Westbrook would be more easily remembered. Pegler adopted it.

Peg was a great hater. He took to animosity as a fish does to water. Sometimes, as in the case of Mrs. Franklin D. Roosevelt, his feelings were on the pathological side. Sometimes, as in his attacks on crooked labor leaders in the 1940s, it served a useful function.

For many years he wrote sports, for the United Press and the Chicago Tribune. He loathed the freaks who were in the ownership side of sports, and he said so, loud and often.

To this day, Gene Tunney thinks he won his first heavyweight championship fight with Jack Dempsey. Pegler, and a lot of other people, thought Dempsey deliberately lost it, in thankfulness for financial help from a famous Philly gambler of the time, Boo-Hoo Hoff.

Peg wrote the story. Tunney came into the United Press Press office in New York with something close to murder in his heart. It took all the considerable diplomatic talents of Peg's boss, the late W. W. Hawkins, to avert a catastrophe.

Perhaps the most pungent thing ever said about Pegler was from the pen of his colleague, Heywood Broun:

"The trouble with Peg is that, when quite young, he was badly bitten by an income tax."

He hated government of all kinds. It was his luck—it's

hard to say whether good or bad—that he was in the days of his greatness when liberal Democrats like Roosevelt and Truman ran the country. Pegler hated both, and the feeling was reciprocal.

Pegler's first wife was a bright girl reporter for The New York Daily News named Julia Harpman. He proposed to her at a time they both thought she was on her death-bed.

That marriage, which was a good thing for Pegler, lasted until his wife's death in 1955. After that, things did not seem to go too well for him. He fought with his employers, the Hearst organization, until he found himself out of a regular newspaper job for the first time since he was 16.

He even fought with the John Birch Society, whose views he had adopted, because Robert Welch, head of the group, killed one of his columns.

When he left sports in the early '30s, he wrote a daily column for the New York World-Telegram. In his first few efforts, the thing did not seem to be getting off the ground.

Then, in an angry column, he defended the lynching of a white man in San Jose. The flurry raised by that column made him a national figure.

As a writer, Pegler was what the trade calls a bleeder. The stuff came slowly, and with great labor. His office would sometimes be strewn with dozens of rejected leads. He usually spent an entire day on the piece.

When the stuff appeared in print, though, it was technically superb. He was a great phrasemaker, and, at his best, a first-rate entertainer.

In the end, though, this proud and contentious man defeated himself. He became obsessive and rude. In the end, he became a bit of a bore, which was the most unlikely fate that could have been predicted for that lively, funny copy boy called Jimmy Pegler. He made the mistake of taking himself too seriously.

Tallulah

She was funny and nice. That's about all there is to it, in a way.

When she died, a short time back, I felt a sense of loss disproportionate to her importance to me, which was slight. What had happened, I suppose, is that I had bought her legend, and felt deeply grieved when it was snatched from me. She was the daughter of a Congressman, and was named, as I recall, after a place called Tallulah Falls in her natal State of Alabama.

She was very beautiful, and used her beauty poorly. She would rather have evoked a laugh than conquered a man. Maybe she thought the one was harder to do than the other.

She got into the books. Howard Dietz, that devilish clever fellow said, "A day away from Tallulah is like a month in the country."

Fred Allen said, "A parrot around Tallulah must feel as frustrated as a kleptomaniac in a piano store."

And her press agent, Dick Maney, observed, "The screen had just started to talk when Miss Bankhead interrupted in 1930."

My favorite story about the lady concerned a notorious English nobleman and womanizer.

This was in the days when, believe it or no, Tallulah was just about as well known in England as the British sovereign, a dim fellow named George V. The only person who ever approached her in cachet was a fellow American, Duke Ellington, who was far more dukely than most of the species around.

Anyhow, Tallulah was at a cocktail party in Chelsea, when this eminence, who was an old friend, chose to cut her dead.

She is said to have said, "Don't you know me with my clothes on?"

There was another rather bawdy tale about Marlon Brando, but I would have to know you better.

But above all, Tallulah Bankhead was an actress, which is a

pretty funny thing to be in the first place. It may take you a bit of time to learn it, but actresses and actors are something else. Believe me.

Giles Playfair, who knew her quite well, recalls that when she finished a performance, she sought out people the way a sports writer seeks out a guy who had cleaned the bases in the ninth inning.

"Tell me I was marvelous," she invariably said.

She needed the assurance. Years in the theater, as a novice and noted practitioner, had never given her the feeling that she would not fall on her face, of a given evening.

This was, I suppose, a great part of her considerable charm.

She could never relax and take you, and things in general, for granted. Her life was a continuing seduction, and the object of it all was to prove to herself something about which she had the gravest doubts—i.e., that she was marvelous.

She was always late, like most actresses, and many women who are unsure of themselves. But when she met you, if she took the trouble to meet you at all, she was *on*, from the moment of arrival.

Whatever was outrageous in the city she was living in was immediately unveiled to you. She had the most public private life imaginable. She was glad to give you the smallest detail, over and over again.

She was rowdy and at times difficult. There still live men who wanted to throttle her. But she gave more of herself than almost anyone I have known. It was a rich self to have given.

She once did a wicked thing to a friend of mine called Hamish St. Clair Erskine. He was 16, and going to school at Eton. He asked the lady to spend the night with him on the town in the West End of London. Tallulah knew better, but she accepted. The boy came to town against rules. For the infraction, he was sent down for six months.

To this day he says, "It was ruddy well worth it."

Bernardo

I first saw him in the cocktail lounge of the Maria Cristina Hotel in Mexico City. As he entered, accompanied by three of his pistoleros, he took out his own handgun and shot out all six of the bulbs in the beautiful crystal chandelier hanging from the ceiling.

Thus, in typical fashion, did Bernardo Sanchez announce his entry. Bernardo (which is not his name) was one of those swashbuckling lawyers, not uncommon in Mexico in those days, who was a law unto himself. He killed men, and had them killed, the way other men went after pigeons or deer. With Bernardo, there was no season.

He had a square face, heavy beard, and brilliant compelling eyes. His deep hoarse voice had seduced hundreds of juries, and hundreds of women. He grew up in Sonora, in Pancho Villa country, and did not discourage the rumor that he may have been an illegitimate son of that noted bandit.

He had an office, but never seemed to be in it. With his gunmen and his girls he traveled from one bar to another in Mexico City, and Cuernavaca, and Acapulco, talking to friends and clients. He even made out and collected bills in these public places.

One of his clients was a distinguished American oil company. Bernardo was a young man then. Lazaro Cardenas was President of Mexico, and he arranged for the expropriation of large American oil companies in his country.

The companies tried to win their companies back, through due legal process in Mexico. The Yanqui was very unpopular in Mexico in those days, and due legal process was easier asked for than had.

The companies were getting nowhere fast.

Then one of them heard of Bernardo, who was already gaining a reputation as a lad who had a pretty cavalier way with the law.

The problem was explained to the young lawyer: There was a case before the Supreme Court of the state of Veracruz, in Jalapa, which appeared to be going badly against the interest of the Yanqui company. Could something be done about it?

Bernardo, who never lacked confidence, said something could. The Americans did not wish to hear any details. A fee was agreed upon. Hands were shaken.

The following Saturday Bernardo drove down to Jalapa, with a squadron of about ten men—lawyers, gunmen, and servants.

The court, of course, was not in session. The judges and counsel were all in the city of Veracruz for the weekend, enjoying the marimba bands, the lovely girls, and the fine fried fish of that place.

In the courthouse, there was a handful of retainers. As Bernardo and his posse made their way to the office of the bailiff, he passed out hundred peso notes to everybody he saw.

He went into the bailiff's office, placed 2000 pesos on the official's desk, and explained that he was the newly-appointed attorney for the Yanqui oil company. He demanded that all legal documents in the action before the court be turned over to him for inspection.

With some slight reluctance, the bailiff got out the records, great bundles of them.

One of Bernardo's men produced a portable charcoal stove, of a kind commonly seen on the streets of Mexico City. A fire was burning brightly within.

Solemnly, like a bishop conducting a service, Bernardo burned all the papers, a fistful at a time. The bailiff, who knew what was good for him, just looked on helplessly.

So ended this particular bit of litigation, which had been going on for months.

I could tell you how, on the way back to Mexico City, Bernardo killed a man by dropping him into the Great Hole at Ayala, which is so deep that the sound of anything landing is never heard; but that is another story.

'La Vida Es Buena'

The big black Cadillac with the pennant of the Independence Party fluttering from its bonnet would stop in front of my flat late at night. Antonio, the bodyguard, would pound noisily on my door, and announce in his bass baritone, "Chico, Don Luis wants you to get drunk with him."

And I, roused from slumber, would hastily get into a pair of slacks and a huge white guayabera, take a fast look at the state of my eyes, pull a comb through my hair a couple of times, and go down to join Don Luis in the back of the car.

He was a huge, darkling figure. He was hunched in the back of the limousine, wearing a topcoat in the dark tropical night. He was smoking, as always, and the fingers of his right hand were the color of weak sunlight.

He was in a high euphoric mood. "Ola, vate," he said, with a big smile. This was a private joke. Don Luis was a politico, the very best of his kind on the island. His followers called him "El Vate," which translates as something like "The Seer." And he called me the same thing, perhaps to remind me of something.

Antonio got in front with the chauffeur, and soon we were speeding out of the limits of San Juan. Don Luis never told anybody where he was taking them, but as we were heading in a generally easterly direction toward Fajardo, I guessed we would end up at El Yunque. This was a mountain, and also a tropical rain forest, and atop it was a bar which was one of El Vate's favorites.

Every couple of miles or so we would stop at a village cantina, and have a couple of shots of Boca Chica, a local rum, with a little lemon and water on the side, and watch the grace of the dark women and their jibaro husbands and boy friends as they danced to a juke box playing "Cuatro Vidas," or some other favorite of the period.

I would ask a few questions about politics, but Don Luis

was bored with the subject. "Politics is an artifact for children," he said. And he added, "Tonight is for talking about the soul." And he would talk about Pascal, and Don Miguel Unamuno, and whether man was truly responsible for his actions, and what was the best way to capture and hold a woman. "Think of them as forts," he said.

In both English and Spanish, Don Luis was a marvelous conversationalist. Someone once asked him if there was much homosexuality on his island. "There cannot be," he replied, "or my party would have a plank favoring it." He was so completely bilingual that he often made puns in two languages.

We had passed the final cantina, which we called "The Last Chance," and began the ascent of the mountain. The car took the curves easily. The moon was full and brilliant, and was captured in a million lights in the Caribbean below. Don Luis continued to talk about everything but what was usually his obsessive interest, politics.

We were at the peak. The saloon was closed, but Antonio got the owner, and it was opened. We sat on a terrace, and looked down at a whole world, the trees, the sea, the distant roads. We were together, and getting sloshed, and feeling kingly.

Suddenly Don Luis turned his deep spaniel eyes on me, and punched his huge barrel chest, and waved his huge fist at the lovely scene below, and said, "McCabe, la vida es buena." Yes, life was good in those days.

The One that Got Away

For some years, during my visits to Dublin I have been a visitor to a crestfallen little premises off Grafton street called McDaid's.

Mostly men were there, and betimes a couple of broad biddies with tongues that would curl a poker, and sometimes that great woman, Kathleen Behan, would come in looking for her son, Brendan, and stay to sing a score or so of old ballads in her liquid soprano.

But the heart and soul of the place was a man who should have been dead of lung cancer for seven years or so, but didn't have the wit to stiffen, or the resignation to quiet his tongue, which was the most eloquent in Ireland since the death of Yeats in 1939.

This was Paddy Kavanagh, now gathered, but then grunting and groaning and being terribly funny about the middle-classness of the middle class, to the infuriation of that class. He wore two pairs of glasses hanging by cords over his shoulder onto a vest holding the detritus of hundreds of hasty dinners. He was forever on the phone, usually telling the "Irish Times" what he thought of their effort of the morning.

I often thought of writing about Paddy, the finest poet in this country, but one thing or another got in the way of the effort, as it will.

Then one day Jimmy Breslin, the former New York columnist, caught him and the McDaid milieu in a brilliant eyewitness account, which has since been printed many a time in anthologies. It was a grand job. I envied him for it, and excoriated myself ever so slightly. Only later, from my friend Ulick O'Connor, did I learn the story or its writing. Here is Ulick, starting with Breslin's notorious habit of being late for dates:

"In 1964, on five successive occasions in New York he let me down. Each time afterwards he would put his arm around

me with the comforting gesture of a ward-heeling politician, and say:

"'I swear I'll be on the dot next time. God bless yeh.'

"I figured after a while that the 'God bless yeh' was Jimmy's kiss of death. It was as if some inner voice had told him that he was not going to turn up and he was imploring Divine assistance to compensate the stricken person in advance.

"He did turn up once, though. He was in Dublin on a story and he wanted information quickly for a column. He had left it too late to write. Over a meal I gave him a bunch of stories about Dublin poets, painters and characters.

"Later, Jimmy showed me the piece before he dispatched it. He watched me with worried cocker spaniel eyes as I read it. It was brilliant. But he had told *my* stories as if he had met the people himself. I didn't get a word of credit for what I had told him. I was flabbergasted. It must have shown in my face. The arm slipped around my shoulder:

"'I'll fix it upstairs, God bless yeh.'

"This was said with the awful sincerity of a Tammany boss promising a mother a job for her son that he knew in advance he couldn't get. Jimmy shuffled off to his hotel room to send off the story exactly as he had shown it to me.

"A couple of years later I met Jimmy in a coffee house in Lexington avenue, New York. Before he put his arm around me in greeting, I said:

"Jimmy, do me a favor. Leave out the kiss of death. Don't say 'God bless yeh' when I am leaving.

"Bobby Kennedy, he told me, was mad to meet me. He had talked to him about me, and we were just naturals for each other. He'd fix an appointment tomorrow and ring me at six. I said good-by. Jimmy's lips formed in the familiar farewell:

"'God . . .'

"I put a finger to my lips in a gesture of silence. It nearly choked him, but he didn't say it.

"I haven't heard from him since."

I saw it all, and heard it, and didn't either tell it or write it. Ulick saw it and heard it, and told it, but didn't write it. Breslin neither saw it nor heard it, except when recounted, but he wrote it. Which should tell us all something, about something or other.

6.

Women

*Being privileged information
gained from a lifetime
of living with and,
occasionally, without them.*

Are Dames Killing Us Off?

Women are a fact, increasingly. And increasingly, a fact more difficult for the sheath side to digest, and live with.

Us big strong men are scared, Mummy. And just a bit baffled.

Little more than a half century ago (in 1910) there were 106.2 of us to every 100 of the dear things. The ladies' progress upward, in the nose counting department, has been steady and unremitting. In 1960 there were only 97.1 of us to each 100 of them.

And a while back the Census Bureau, in an interim report, reported that in 1965, for every 100 women in the country there were 96.4 men. Over-all, in that year, there were 3.6 million more women in the country than men. Wow! What will the new census show?

The gap in numbers between males and females was greatest in the oldest ages (60 and over), because the increase in life expectancy has been greater for women than for men, and because a generation of immigrants among whom males predominated is passing.

These are remarkable statistics. It is too early to speak of the American male as a vanishing species, like the bison; but if things continue their present course, we are well on our way out. It may well be that, a century from now, there will only be a handful of us around. Presumably for stud purposes, and to play bridge.

Whether the country is better or worse because of the decline of the male is a question I leave to such thinkers as Ashley Montagu, and newspaper circulation managers.

I for one am glad I was born into a world where the male was numerically (and hence actually) in the ascendant, where a man's word was his bond in his business and the law in his home.

Now that dames are the master race (numerically, and

hence actually) I try to assess the situation as honestly as I can, and to face squarely my diminished importance in this brave, new Copernican world.

My conclusion, as of this bright morning, is that the dames are beginning to press their advantage. Just a wee bit.

With increasing adroitness, the female is mastering the arts of leaving her slaving consort with the dirty end of the stick. The more brutish aspects of acquisition are left increasingly to Daddy-o, with the concommitant neurotic and psychotic complications.

More and more these days, when stately society matrons write those little squiggles in their checkbook, as they loot the boutiques, they are spending their husband's ulcer, or his castration complex, or whatever.

Let's face it, men, the dames are killing us off, and doing a spit-and-polish job of it.

If we were as smart as they are, we would be down at the boutiques, and spend hours sweating over hot copies of Vogue under the dryer at Arden's, while the broads would be mounting the barricades, both of industry and war. A female draft could bring much into balance.

But I fear the battle is lost. Behind our backs, a sinister genetic Gresham's law has been in operation, with an inferior stock driving the good stuff out of business. The only males tough enough to cope with the females these days are the dress designers, and decorators, and hair stylists. Good luck to 'em.

Live Alone, and Love It

I think every husband needs to recuperate from marriage once in a while. Marriage, that sweet sickness.

Whether the thing be a heavenly tyranny, or a hellish freedom, or an illusion we all too gladly buy, I know not. My name ain't Dear Abby.

All I know is that an occasional day away from The Sacrament is like a month in the country, to re-word Howard Dietz's crack about Tallulah Bankhead.

It is especially nice if you spend the day in the country, and the lady goes to town. As happens with me from time to time.

Her joyous voice is absent from the manse. Suddenly a deep void is filled within you. To your wonder, you find that, for the first time in months, you are *lonely*. Bliss!

After a severe regimen of "How-do-you-do" and "Thank you," you rediscover the benison of having nobody but the trees to talk to; nobody but the wind to curse, nobody but the moors to marvel at.

Slowly the wounds of sociability disappear.

A fierce serenity begins to grow. As if one were under the influence of one of those dear hallucinating drugs. Some kind of core is being bared.

You are, in fact, finding yourself. And you are making the age-old discovery that, in this great wide hostile world, nobody loves you like yourself, or accepts or approves of you as the felon within your hide does.

You may well be a bastard, and know it; but you are for a period your *own* bastard.

Mark you, I am fond of my wife. Rather. She is the least impossible human being I know.

I am also aware, if but dimly, that in order to keep this lady in my life there are certain idiot conventions that must be observed, like paying the bills, bathing regularly, and pressing

the flesh of countless ladies I would as soon see framed in the guillotine.

Still, there is no point in marrying if you do not at times remind yourself pleasantly of what you married *out of*. That sullen, angry, somehow happy solitary life, which you sold out for a dame.

The bachelor in a thoroughly married man (I confess to that questionable status) sometimes seems as remote from him as the ancient, florid tenets of high-tariff Republicanism.

The truth is different. The bachelor, like the child, dies hard. And for the same reason. He is a child. If a bachelor faced the truth about himself, which is that he is an incomplete man, he would be appalled.

The bachelor is an outlaw. He's in the boat, Jack. The whole point of his life is being able to say "Get lost" to a pile of people and problems which the husband and father must acknowledge; and, hatefully, cope with.

Being married, if it means anything at all, means the end of the outlaw life, if only because there is at least one person in the world, in addition to your delicious self, who must be treated as a person.

Having a decent regard for another human being is just about the hardest task that can be given to a resident of this bawdy planet.

That's why it's so damned pleasant when she's absent. You can become again, if only for a day, a child emperor.

How to Dump a Damsel

Always do it in the daytime because at night your heart takes over. Take her to lunch, to a very chic place, like Le Pavilion or the Colony, where she will see famous people and where it is against all the rules to cry or scream or throw crockery.

"Buy her a big drink, and then tell her that the train has reached Chicago, and you're getting off at Chicago.

"Tell her you're not the marrying kind, but she deserves a home, and kids and candlelight. Tell her she's the most wonderful woman you've ever known. Then buy her a great lunch, and let her absorb the news as she eats. Afterwards, you can walk out into the sunshine a free man. It never fails."

Speaking is Mr. James Aubrey, a former ace mediocrity from the cultural wasteland of television. James is also a sort of Bo Belinsky of broadcasting. He sighs, broads die. He was explaining how he came to be canned as president of CBS-TV, in a magazine article, and mentioned his love life in passing, as gents have a way of doing these days.

On the whole, Mr. Aubrey's technique for disposing of a dame is faultless (especially the part about giving her the jolt while her mouth is full of caviar, shredded onion, and hard-boiled egg). But he does make the male of the species rather unattractive, no?

He is clearly no gentleman, and this is what makes us males hate him so. There are many situations where it is extremely useful to be a cad. One of them is when you are breaking up a brief monogamic relationship, on account the grass on the other side of the hill is getting awfully green.

The gentleman in these tricky situations is often troubled by something called guilt, which inhibits his free functioning, and makes it hard for him to administer that belt to the kisser which is the dolly's clear deserts for having failed him. So he fumbles, and apologizes, and gradually works himself into a tactical cul-de-sac, from which he can only extricate himself by signing his name to a large check.

Yes, the brutal, direct approach is unquestionably best. My high moment came when I pushed an exigent lady of my acquaintance off the Twentieth Century Limited at the depot in New York City. This lady never got to Chicago. But she got the message.

But the most remarkable thing about Mr. Aubrey's approach is what we may fairly call its anthropomorphic nature. He views the situation as one exclusively engineered by the man. We can see that a lad who was known to his intimates as "The Smiler With The Knife" is not the kind of guy who ever could have been the dumpee in such a situation. On the whole, a male who thinks he is irresistible is just that, American damsels being what they are. But not all us males can rise to these heights of fantasy. As a result, we are not all that lucky in our relations with the ladies.

It is my sad conjecture that, when it comes to these squalid little terminations, the spigot is more often turned off by the lady than by the gallant male.

I don't suppose it ever occurred to Mr. Aubrey, or is likely to, that some of those lassies he is forever dropping at the La Salle Street station, don't mind one little bit. That, when the moment of truth arrives, they are quite ready to trade a good, square lunch at the Colony for the beautiful hunk of man in front of them.

I find it a good rule, in the conduct of affairs of the heart, to assume that anything wicked you think you are doing of your own free will has been designed and ordered by the broad. It's lots easier on the old guilt.

Whither Virginity?

Another of those sexologists who make a fast buck by putting far out sentiments on white paper has been stirring up something called the National Council on Family Relations, whatever that is, with his wicked, wicked views.

This one is Dr. Albert Ellis, of New York. In the sex dodge he's almost as big as Kinsey and associates. His specialty is How to Do It, a matter which never much concerned man before the 20th Century, and concerns the birds and bees not at all.

Dr. Ellis calls himself a marriage counsellor, though he doesn't think much of marriage as practiced by squares like me and thee. He has some pretty wiggy ideas on the subject of Doing It Before.

He told a meeting of the NCOFR that "the preservation of virginity before marriage for enlightened and educated people today is an overt display of arrant masochism."

Now, I've heard virginity called a lot of things before, especially by young lads whose impulsiveness has been thwarted by it, but I've never heard it defined so loftily. What he is saying may not be altogether clear to you; but I've made a study of the writing of distinguished sexologists, which is a branch of beautiful letters in a class by itself. If I may have the temerity to translate, I think the doc is saying:

"You have to be nuts to be chaste."

He is saying that every "educated and enlightened" young lady of today, by refusing to give it away until certain solemn vows are pronounced, is engaging in a conspiracy to punch every man who makes a pass at her, or even thinks of it.

For is not masochism, as a psychiatric phenomenon, defined as "the condition in which sexual gratification depends on suffering, physical pain and humiliation"?

So, not only is the tasteless young lady punishing her suitors by giving pre-marital sex a miss, she is even more punishing herself.

And, if you read the doc as closely as I read him, she is getting as many, if not more, kicks from not indulging in sex as if she did.

If all this is pretty hard to swallow, friend, it is simply because you are not with it, Ellis-wise. If you suspect there have been some pretty dandy women in the past, including possibly your mother, who have been virgins until they got married, then you simply show an abysmal lack of knowledge of the dark recesses of the soul, Ellis-wise.

Just because virginity in modern American life is the aberration rather than the norm, is no reason to put the knock on it. Some of my best friends are virgins.

Unlike the cocksure Doctor Ellis, I believe in being fair to minorities, of which unmarried virgins are one of the most conspicuous and oppressed of our time. Just because these ladies are crippled emotionally is all the more reason why we should give them an aiding arm.

Just because what they think is their virtue is really a rather nasty form of sexual gratification is all the more reason why we should, as Mr. Johnson used to say, "sit down and reason together" with them.

For all his big mouth, I wouldn't be so sure that Doc Ellis, confronted with two beautiful women, one a premarital masochistic virgin, and one a swinger who made whole football teams happy, would not take to wife the despised virgin. Oddly enough, so would I.

You Can't Win, Pal

I met a fellow Californian at a cocktail party at the Ritz Hotel the other day, and he gave me the most delicious twitch of nostalgia for what is called The Southland.

This lad had a friend in Pacific Palisades whose wife was here recently. She bought her husband two Dior ties at a smart Rue Rivoli shop. They were no better and no worse than the ties women tend to select for their help-meets—just routine weapons in the war between the sexes.

The first morning after she gets back home to California, she's down in the kitchen, burning the toast and performing other housewifely duties. The old man appears, wearing his best Brooks Brothers basic blue suit, appointed with one of the Dior ties, and a loving expression.

Her eye pierces him like a gimlet. Her first acid words of the day are: "So you hated the other one!"

As the fellow who was relating the story didn't have to tell me, "You can't win, pal. You can't win." The perversity of wives exceeds even that of mechanical objects. I know.

Some time back a young lady of pleasant appearance came to me to report I was a lucky fellow indeed. I was, she added, married to the greatest woman in the world. She found this out after attending a seminar, where three other young girls sat at the feet of my wife, drinking in worldly wisdom.

The subject of the seminar was difficult men. All the young ladies were immersed in relations with difficult men, or recently had been.

My wife gave a laconic description of me, and a more generous description of her forbearance, patience and tact. It was agreed by all that her credentials on the subject of difficult men were impeccable. She had scaled Everest while lesser women were struggling with the Dolomites. How did she do it? How did she handle difficult men?

Her reply was simple, direct and straightforward, for that's the kind of dame she is.

'I build up his ego," she said. "I always take the blame. I never let him feel he is in the wrong. Above all, I yield to him."

As I listened to this description of the felicity of my estate, I could but marvel.

That very morning I had moved an armchair from where it was to where I could read more comfortably. The next time I came into the room, the chair had been moved back to its original spot. There was no scene, no talk. The only further mention my wife made of the matter was to send to Balmain's right here, for a new dress. The price, it was made clear, was a fit penance for my transgression.

I suppose if men ever figured out the way women think, it would be the end of the human race. But that's not something that's likely to happen any day now.

Like. When we were living in San Francisco I asked my mate to put me in the picture, financially. How much money I had, if any. How much we owed, if anything.

I believe in letting the lady of the house handle the dough. This way I always have a grudge; and grudges, I need hardly tell any of you ace husbands, are the cement of marriage.

My simple request was, if anything, overfilled. The lady produced a long document with figures to the left of us, and figures to the right of us. Everything was there, down to the last pound of spaghetti bought at Rossi's, and the last gallon of Sonoma red.

The figures on the left came out in a sum which was the same as the figures on the right. It was beautiful, like something out of Price, Waterhouse and Co.

Next day I realized a few rather large sums had been left out—like airline ticket arrears, the dressmaker and tailor's bills, some bijous from Shreve's and the price of booze. I asked the demon accountant how come, and so forth . . .

She looked at me in total surprise. "I never put in things like that," she said. "Those are our *fun* expenses."

Who Hates Women?

There seems to be a view abroad among the cognoscenti that this here putatively fearless bucko hates women.

There are, in fact, those who put it more bluntly. A stately La Jolla matron said only the other day, "You've been victimizing us all your life."

I hasten to arise and deny the foul charge.

Of course, the fact that I hasten to arise and deny the foul charge means there must be something to it. The guiltless usually remain silent and sweet, when foul imputations are flung in their direction.

For me, the world is composed of women—and more women.

That men exist is for me an interesting datum, but hardly more than that. I have known thousands of men in my life, and save for a handful of friends, I have been unable to relate to them. They are there. Some of them are interesting, and some even extraordinary. Yet if all men were suddenly wiped from the face of the earth, I cannot believe I would miss them.

That men figure sparingly in my emotional life (I am almost uncomfortable in a club) I attribute to my mother, as I attribute most things in my life. Dear Mom was a shrewd, calculating, unscrupulous, bewitching, and above all, embracing human being.

She knew every trick in the trade of enslaving men, whether her sons, her husband, or her admirers. I was her oldest. Day in and day out, for 20-odd years, we did battle.

The emotions, the nuances, I dealt with as a child were always the emotions and nuances of women. Like many kids I learned (or was taught) that there were two kinds of women in the world—saints and whores.

And that, of course, is the trouble. The ones you assign the role of saint to cannot ever fulfill the requirements of this most demanding of roles. They are a constant and continuing

disappointment, after the first fiery flush. They conclude that you hate them, when it's merely that they have disappointed you.

They have disappointed you because they have punctured a dream. The dream has been your fault, though you cannot know it. The dream was planted in your imagination by the dark-haired and inscrupulous woman who produced you.

So, through no fault of your own, you grow wary of saintly dames, and tend to carry on more and more with the ones your imagination (again) assigns to the role of whore.

These dames are blowsy, bibulous, and lean to the venereal side. They are immense fun. They ask nothing of your irony and pity. You relax in their embrace, and you laugh when you lie down. They are a great relief from the saints.

Do I hate women? The question is ridiculous, like do I hate Czechs, Jews, sports cars, or right-wing Republicans. The answer is that there is nothing under the sun which I do not hate, and at the same time love. Ambivalence is all. Hostility and affection are a compost. If we but knew it, we regard all things through this compost.

I both hate and love women, and each individual woman. But more than that, I am one of those men to whom women are important.

I said a world with no men would hardly unnerve me. A world without women would seem to me a world wholly without sense, or reason. A world without women would be one in which I would be a total stranger, and numb. Does this answer your question, dear matron?

Good Woman, Nobly Planned

*I*n speaking of the things I write, a lady observed the other day: "Seventy per cent of the time we are fairly close in opinion. You can change my opinion 8.5 per cent of the time. The rest of the time you can go to hell."

There, I thought, is a good woman, nobly planned.

For what we oldies want of a woman (and maybe the youngies too, if they but knew) is not a glorious collection of curves and rags, or even a fat account with a Montgomery street brokerage house, or even a heavenly disposition. What we want is a human being who reacts to us. This is sometimes called companionship.

But this must be qualified. We do not want one-sided reaction. We do not want a lady who reacts with a scowl or a whimper to anything we do. Unremitting hostility can be a decided drag. A woman can't be all right who thinks you are all wrong. The percentages won't allow it.

Equally, the lollipop who gazes at you from ground level atop a pedestal she has erected in her intricate imaginings. These ladies are forever waiting for you to bump your head so they can rub it gently, and coo. They are on your side when you are clearly in the wrong. A woman can't be all right who thinks you are all right.

And there is the more sinister, and not uncommon type, who combines in one person the worst sides of each of these extreme types. She looks, and acts, and talks as if the sun rose and set in your lordly rump.

When the chips are down, though, you find that behind that jolly exterior she is fighting you all the way down the line. She works both sides of the street—a house devil, and a street angel. The picture of propriety to the world at large, a continually festering sore to the man she bedevils.

None of these three species is human, and that of course is what is wrong with them. No man is right all the time, or

wrong all the time, or with any percentage near total. And no man deserves a mask of affection covering a neurotic hatred.

No. I like the idea of a woman who is with me 70 per cent of the time. That is a right good figure for agreement. It means the number of senseless arguments would be at a minimum. Not eliminated, mark you, for a marriage without senseless arguments would be meaningless. And inhuman.

I don't really believe there is any woman whose opinion on anything I could change 8.5 per cent of the time; but it is a very good thought for the lady to have. It indicates a nice receptiveness. I once persuaded a woman that a good Napa red was better table wine than most of the stuff served in Paris restaurants. I cannot recall any other missionary triumphs in the jungle of the female psyche.

"The rest of the time you can go to hell." The sincerity of those words is quite shaking. You know you may not really be able to change the lady's opinion 8.5 per cent of the time. But you know full well, and in spades, that the rest of the time you can go to hell, and truly.

The heartfelt candor of these words was what finally won me to the percentages as stated. That, and the fact the figures reflect what I feel about most of the spirited women I know.

I would give as good as I got. And I am quite certain that the 20 per cent of the time I could go to hell, and the 20 per cent of the time the lady could go to hell, would be almost certainly over the same subject matter.

Dame Power

*Y*ou would think, wouldn't you, that the distaffs would have learned their lesson?

The lesson: That the greatest fraud the ladies ever perpetrated on themselves was getting passed the 19th Amendment to the U. S. Constitution, which gave them the right to vote, and other horrible consequences.

The couches of the land are awash with female analysands who don't know, anymore, whether they are distaff or sheath. And when they get off the couches their place is taken by an army of gents who suffer from the same confusion.

The 19th Amendment, which became law in 1920, has transformed women from an oppressed minority to an op-ressed majority. As any intelligent broad will admit, the amendment has brought them more suffering than suffrage.

The dames, who are now more than half the population, pretty much run everything—and of course they are not satisfied. There is no such thing, it seems, as a small amount of power, just as Doctor Mahaffy of Trinity College used to say there was no such thing as a large whiskey.

Yet there are still some dames who are far from willing to cry uncle. They are, in fact, trying to get even more power for their team.

The latest horror to threaten the American scene, after our recent and extended bad luck with White Power, and Black Power, and even Lavender Power, is: Dame Power.

Listen to Barbara Likan, of Chicago, one of the neo-suffragettes: "Women are the most enormous untapped force for peace and social change, the last revolutionary force in the world. . . . Talk about Black Power, that would be nothing compared to Woman Power."

And Mrs. Betty Friedan, head of something called NOW, the National Organization for Women. "Women are the next great civil rights issue," she said recently. And she added,

bluffly, "We don't even exclude the possibility of a mass march on Washington. Every group that suffers discrimination has its spokesmen. Why not women?"

The kind of discrimination that bugs Mrs. Friedan is indicated in another of her underprivileged whimpers: "How many women do you find in those smoke-filled rooms where the decisions are really made?"

Perhaps the worst thing about the female revolution of this century is that it has thrown up people of the Friedan type. These dames aren't interested in having the same rights and duties as the male. They want to *be* men, literally.

This disease is a form of emotional transvestitism, and it ain't pretty. The Lord made men and women different, and he made them so for one main purpose: That they could reproduce their kind, and have joy in the act of doing so.

Wanting to get in the smoke-filled rooms with the boys who make the big decisions is not unlike wanting to be admitted to the linament-soaked locker room after a football game with the big lads who make the touchdowns. There are things that belong to the boys and things that belong to the broads, and never the twain should meet.

The desire of women to *be* men is not an aspiration. It is a perversion. No small amount of their existing mass emotional troubles in this country comes from the degree to which women have already yielded to this perverse impulse.

When men are able to conceive children, is perhaps the time when we should talk about dames in the smoke-filled rooms. As of right now, ladies, cool it.

On Filling a Need

With the death of the late California industrialist Henry J. Kaiser we were treated to a good deal of florid prose on mortality and what made Henry J. great. One of the secrets of the late man's success, we were told, was "to find a need and fill it." This motto is painted on the sides of the pink Kaiser cement trucks. It contains, certainly, the essence of the capitalist system at its best.

It is with no irreverence toward the late Mr. Kaiser that I suggest this is exactly what the whores of San Francisco are doing. Whores elsewhere, too.

There are men, and sizeable numbers of them too, and many of them married, who get their jollies from paying money to a woman who hates them, for the almost invariably squalid pleasure of illicit sex.

This is a market. The exploitation of it by women (and, increasingly by male prostitutes in drag) is an industry like any other. The girls who found this dubious need and filled it are industrialists. Further, in my view, they are rather less wicked than some other industrialists I could name.

The femmes du pave are big news these days. One San Francisco Supervisor announced angrily: "If I were Mayor, the girls would be rousted by the police today, tomorrow and every day until the courts were jammed with cases."

And a dreamer from the Poverty Program comes up with the notion that Federal funds can "establish a rapport and try to motivate" the sex-for-sale gals.

I'm not here with a cure today. I'm merely asking that we ask ourselves why we feel the way we do about the ladies of the night.

What drives women to the turf is not depravity, or a need for affection, or loneliness, or exaggerated sexual appetites, or even lesbianism. What drives them to the turf is the boys who

are there, ready, willing, and with money. What drives the boys is another matter, and outside the purview of this little causerie.

Understandably the Wives' Union is up in arms. Their rivals constitute competition in restraint of trade. The wives' choler is wholly understandable; but they have not done anything, apparently, to tighten the market in the Tenderloin. Cynically, perhaps, we might suggest that the ball is in their court.

And whores are a great affront to the Establishment because they sell sex openly and honestly—albeit some clients have been rolled, and the homosexuals in drag certainly offend the great American principle of honest labelling.

It is perfectly all right to stink out the telly with ads which use sex, pruriently, to sell everything from cigarettes to hair rinses. But it is anything but all right to openly exchange a double sawbuck for a brusque bit of amorous exercise.

You are not, under existing rules of the game, supposed to sell sex openly and honestly. Those who do are guilty of that greatest sin against the Establishment: going too far.

Likewise, this biz of arresting the male customers is for the oiseaux. Arresting the sucker because he yielded to temptation makes about as much sense as arresting a bank president because he offered an irresistible lure to a robber.

Hints On Breeding

*W*hatever you do, buddy, don't ever fall in love with a dolly who belongs to the League of Women Voters.

This outfit, if I read it correctly, is a lot of women of faintly bluestocking persuasion, whose aim it is to improve the tone of public life by high thinking, and correct voting. It was founded in 1920.

Despite its formidable purpose, this organization has in it a lot of ladies who are devilishly attractive, corporeally. I know. I've been out with a few in my time.

The world is filled with dangerous women, not only Leaguers. And the boys who tell you who they are are the archimandrites of the John Birch Society, an organization which specializes in handy hints on how to live in the 14th century.

The Birchers are anxious to prevent us from being engulfed by creeping socialism, which means public post offices and all that. To keep America clean, they recommended that bachelors take a good peek at the ladies they are thinking of taking to wife.

American Opinion, the Birch organ, recently urged nubile laddies to avoid like the plague: Leaguers, Vassar grads, hippies, mods and "contemporary revolutionists."

The magazine also warns sternly against dames who enjoy the "wit" of Dwight Macdonald, vodka, the poems of Allen Ginsberg, Twiggy, modern translations of the Bible and canned grasshoppers.

On the whole this advice is good, if one wishes earnestly for the improvement of the breed. But on the whole, I also think it unnecessary. For the most part hippies, the Leaguers, and lovers of Ginsberg's poesy wouldn't be caught dead in the same bed with a Bircher.

I think the point is especially well-taken about broads who eat canned grasshoppers.

I once spent an entire afternoon in Oaxaca eating grasshoppers (not canned) in the marketplace. I was with a lady, and it was her idea, and we had many bottles of Bohemia beer, and these here grasshoppers were fried in oil atop a squished five-gallon gasoline tin, and she wrinkled her nose in a way which was most disturbing, and began reciting to me some of the lustier poems of John Donne.

You know perfectly well that a dame who would go into Goldberg-Bowen's, or Fortnum's, or S. S. Pierce in Boston, and deliberately buy a tin of grasshoppers, is a dame who is deliberately perverse.

She is, in fact, a kind of hippie. She is trying to be different, she is going through a crisis of identity. She is calling attention to herself. She is immature. And, of course, all these things add up to one frightening thing: She's left-wing.

The values which have cemented this great culture of ours are probably as gossamer to her. She probably *believes* in the income tax, and public post offices. She is patently bad news, and would befoul the bloodline of an upstanding Houston or Pasadena stallion.

No, what is required is a wife and mother-to-be who buys Jones sausage and Dubuque bacon and processed bread and recites the Pledge of Allegiance before making love. The road to hell is paved with the bodies (once so beautiful! so seductive!) of dames who harbored a secret passion for canned grasshoppers.

Is Br--d a Bad Word?

I was talking to a well-known judge the other night. He had spent most of his working day doing research into the meaning and intent of the word "broad." He explained why:

"I am working on a murder case. A critical bit of testimony has the suspect saying, 'I shot the broad.' It is important for me to find out just what was in his head when he used these words, and especially if they indicated a hostile frame of mind."

The judge was right and conscientious to deal in nuance. I'm not sure he went to the best authority when he consulted H. L. Mencken, his principal source. Mencken is the recognized chief authority on the American language; but I doubt that gentle fellow ever used the word broad in his life, or knew very many people who did. It wasn't the sort of lingo prevailing about the polite precincts of The Baltimore Sun, and his New York publishing office, where he spent most of his time.

Webster is not too helpful, either. "A woman; sometimes, spec. a prostitute." Use of the word broad to specify a prostitute was sometimes heard in the New York of my youth, but even then it had an archaic sound. Now, I should say, that meaning is merely quaint. There are too many other dandy words for what 70 years ago was called a broad.

Its derivation, like that of most slang words, is murky. There are those who claim it is a corruption of "bawd." But I prefer to think it is merely a description (too often topographical) of the way many women get to look after the first flush of youth.

For a broad is simply a slang term for woman. It carries no more hostile overtone than the word woman itself. I should say that it is used affectionately a deal more often than as a pejorative.

"She's not a bad broad" is virtually an expression of undying affection, from the strong, silent American male, who learns his amative techniques from John Wayne, Jimmy Cagney on the late, late re-runs, and Harpo Marx.

In 1932, Damon Runyon had the word taped. He wrote, "He refers to Miss Perry as a broad, meaning no harm whatever, for this is the way many of the boys speak of the dolls."

There is one dictionary of slang which persists in the belief that the word is used to express dislike, but this is only one of thousands of mistaken beliefs on slang in this particular reference book.

No, when a man contemplates his smoking derringer after having done in his passion of the moment, and says, "I shot the broad," he is being about as hostile as if he had said, "I shot the horse," or, "I shot the pigeon." He is describing a state of affairs, not a condition of mind.

For whatever cause may lead a man to puncture his loved one, what remains when the deed is done is anything but hostility, in most cases. All passion is spent, in that orgasm of gunfire. And the gent (or lady, for that matter) who tells the cops and reporters, "I did it because I loved her (or him)" simply isn't kidding. The murder of a mistress or loved wife is perhaps the supreme male sexual act. After that, satiety is all.

For my money, when that suspect said broad, he was a drained man. Neither love nor hate was on his lips. He was simply mumbling about an enigma he had failed to solve: Woman.

Maids and Martinis

There was a learned little seminar one evening, enlivened by the use of certain of the alcohols, and productive of that splendid flow of wit and persiflage which we associate with ourselves and our friends when taken in drink.

At various times in the evening certain flat and unqualified statements were made, like certain politicians were either bad hat or good grief. The one that struck me as the most pontifical was:

"Martinis make dames mean."

No qualification. Delphi had uttered. No use to continue the discussion. The matter was as closed as the last sentence of a sermon.

In fact, it worked out this way. Other flat statements had received short shrift from our group of eight logicians. No one objected to this statement, not even the women.

Brows were immediately wreathed in bands of memory. We were all thinking of this dame or that whose veneer totally peeled off under the influence of four or five ounces of juniper-flavored spirits, and a certain amount of ice, and maybe a little vermouth.

(Vermouth in gin these days is either passe, or emergent, depending on whether you are terribly out or terribly in, in alcoholic circles. Certain smart New Yorkers are going full circle: Back to the ancient formula for a martini, wherein the vermouth exceeded the gin by two to one. Cold enough, this is not a bad tipple.)

The sistern who crumbled under the corrosive effects of iced gin, we all seemed to recall, were often the most attractive morsels we had known, pillars of the kitchen, and supporters of all the right political causes, such as not killing people you're not mad at, in the sport called war.

Paul Claudel once said that the cocktail was to a glass of wine "as rape is to love."

225

And it has been said that truth lies at the bottom of the bottle, and that in wine there is verity, and so forth.

Following this line, the martini produces in some women a kind of cataclysmic, uncontrollable revelation.

Insights closed to the rest of us are opened to Miss Martini. And these are usually insights which transcend all such considerations as truth. They are just *there*.

When caught in this torrent of wisdom, you are likely to be accused of anything. Your own crapulent 4 a.m. versions of your imperfections (and these can be scary) are as nothing to the blackness that comes out of the lady's inflamed imagination.

Like, you learn that you have been sleeping, for years, with one of the girls who runs the lift in one of the doctors' office buildings downtown. Or you have been cooking the books in the office, and talking about it in your sleep. Or that you lie about your age.

One of our group told about a couple in Texas. The husband sued for divorce, using an ungallant simile about Mrs. Jekyll and Doctor Hyde.

A lawyer friend isolated gin as a possible source of the trouble. The couple reunited temporarily, with gin out of the wifely diet. Twelve years later, both are getting on famously, and getting sloshed nightly—but not with gin.

I am not suggesting that men do not also get mean under the tutelage of the martini, or that all women are wicked at all times under the same circumstances, or that even martini-prone women do not have their lucid intervals, when they can handle two or three and retain all their sober charm.

No, I am just suggesting that when you contract with a woman to provide her with a martini, you are dealing with an extremely volatile product in its most volatile form. More bluntly, you asked for it.

It can be argued that martini-induced meanness may have a certain therapeutic value for the lady and, in the long run, for the man too. This, however, is hard for you to believe when you are being assured by the gentlest and most beautiful woman in the world that you have been queer since you were in the fourth grade, you bastard.

What's Attractive?

One of the most attractive women I know asked me the other evening, "What is an attractive woman, in your view?"

I answered, both gallantly and correctly, "The kind who are like you."

Of course, one doesn't let such a pregnant question go that lightly answered, especially if one writes a column for a newspaper. One thinks about it, and puts it down on paper.

To start with, the lady I was talking to. She happens to be good-looking; but she could be a sight less good-looking and remain quite as attractive, in my eyes.

She has vivacity, which is *the* great quality. This means she is interested in life, and the savoring thereof. Unless a woman is interested in life, she cannot be interested in anyone. That includes you. This means the ball game is over before it has started.

This particular lady is interested in the Giants, the Warriors, the writings of St. John of the Cross, the doings of most of the cretins who are running for office at the moment, Elizabeth Arden's little beauty factories, and avant-garde cinema. She doesn't care for bookkeepers, or lawyers, or sermons—from the pulpit or otherwise.

Her vivacity, of course, takes years off her life. She's around 50, and looks 15 years younger.

She has another great quality, which is present in most attractive women—she does not blame the men in her life for her troubles.

She understands, as so many ladies fail to, that her particular troubles existed long before you entered her life. In fact, they existed before she knew most of the men in her life, with the possible exception of her father and a couple of brothers.

One of the prices you pay for falling in love with a woman is too frequently that you become the cause for her spasms, her vapors, all her womanly agonies. This, again, is far

227

too frequently too high a price to pay. It was paid by the last laddie who fell in love with her, and it will be paid by the next.

Closely related to this is a tendency some women have to pay off scores on you, scores usually incurred in some emotional combat which happened long before you got on the scene. The attractive woman may feel this same ignoble impulse, but somehow she manages to keep it under control. Which is another way of saying that she values your friendship more than her ancient hurts.

In addition to her many other interests, the attractive woman is genuinely interested in you. She is also genuinely interested in a lot of other men, too, which can make it a bit rough on you; but you have to take the vinegar with the sugar, old boy.

And we come to the final, and perhaps most important thing of all:

The attractive woman does not confuse love with ownership.

It is most difficult for some women not to confuse the love and friendship they have won from a man with conquest. In fact, a lot of them use that precise word to describe what they have won from a man.

When a man gets the feeling he is considered owned, a lot of things (and some of them very nice) go wrong. No man is an island, but no man is a chattel, either.

There is a small, private area that no man yields to any other human being. If he did yield this personal enclave he would be a man no longer. It is, among other things, his masculine insignia.

The truly attractive woman, then, is something like that headmaster of Choate school, who used to tell his pupils, including the late John Kennedy, that what was important was not what your country could do for you, but what you could do for your country. The attractive woman does not think so much of what a man can do for her, as what she can do for a man.

As for attractive men. If the shoe fits, wear it, buddy.

Marriage as a Renewable Contract?

I think it was Lady Mary Wortley Montagu, the 18th century bluestocking and wit, who first spoke of the advantages of a law which would make of marriage a renewable contract.

It was the lady's idea that a bill should be passed by Parliament providing that after each seventh year the consenting parties would agree whether they wished to stay together for another seven years. With nothing lost if they didn't.

Other people have provided for three-year options. And recently a psychiatric social worker at the Esalen Institute at Big Sur went for five.

Mrs. Virginia Satir pointed out that marriage "is the only human contract in the western Christian world that has no time length, no opportunity for review and no socially acceptable means of termination."

She added that picking the right partner for life is to ask people "to be wiser than they possibly can be."

As one who has had some participation in the institution of marriage, both as participant and observer, I can only agree that these ladies, and others who agree with them, have a lot going.

The idea that man is naturally monogamous is a sweet and proper one, and perhaps needed for the best functioning of a Christian society. Whether it is true is another matter.

Too many marriages are prisons because neither party can admit the other could use a little company outside the sacred union. Man, especially, has this need. What is more, he usually manages to satisfy it. But the satisfaction is illicit. This poisons everything, including the marriage.

They say there is a lot of truth cemented into old sayings. Such a one is still heard in the west of England, which suggests that the best state of life might be five wives for each man: "A Frenchwoman in a dance, a Dutchwoman in the kitchen, an Italian in a window, an Englishwoman at board, and a Spanish a-bed."

And with each of these five wives, the aphorism of Stendahl might be remembered: "There are four kinds of love, seven stages of it, and ten ways for its ending."

A contractual review each five or seven years might do much to ease such fantastic marital complications as the one I heard of not too long ago. Here it is:

An English nobleman obtained a divorce from his wife, on grounds of adultery.

The divorced wife soon tired of her lover. Her conscience worried her about leaving her late husband alone, since he was hopelessly incapable of taking care of himself and his home.

She offered to become his housekeeper. The husband accepted the offer, since the house was going to pot, and he could not keep any servants, because he had a foul temper.

Soon proximity and the housewife's kindness began to revive in the man the feelings he had for the lady in the first place. He proposed a second marriage (or a marriage for the second time) and was accepted.

Before the marriage there was another blow-up. The master changed his mind.

The housewife and fiancee was enraged. She sued her fiance and former husband for breach of promise and asked for substantial damages. The court upheld her.

When last heard of they were living under the same roof— as master and housekeeper—as if nothing untoward had ever happened.

Somebody, there, needed a housekeeper more than he needed a wife.

But many of us feel, with St. Paul, that it is wiser "to marry than to burn." And with Dr. Johnson, who said: "Marriage has many pains, but celibacy no pleasures."

Don't Ever Tell a Dame

Women baffle and confound me. This I suppose, just makes me one of the boys.

The dames, it seems to me, act always as if the moon were full.

I have racked my brains to please one or another of the species, and have found such occupation a form of Russian roulette. I have planned and plotted to get the perfect gift for some pneumatic dolly, only to have her burst into tears.

Six months later you find out the tears were because the gift reminded her of Charlie Schwartz, who went and married that terrible Alice Hemingway, and who is now doing awfully well as an investment banker, and always sends a Christmas card, and My God, Darling, why don't you go to a manicurist's more often . . . ?

I shall never give up in my attempts to pluck the heart out of the mystery of the ladies. Somehow, a voice keeps telling me, a lot depends on it. Like, what are you going to do when you get tired of stud poker?

Wherefore I pay great attention to the women's pages in newspapers, and to such women's magazines as come my way. I do this for two reasons: (a) these media are a treasure trove of unintended humor, at least to a male, and (b) I hope to find some clue that will finally bring me to paydirt in the Comstock of womankind.

I came close the other day, I think, when I read an interview with Mr. Lee Stockford of Cal Tech's Industrial Relations Center. Mr. Stockford has a quarter century of experience in the relationship of management and women in industry.

He insists women are different. You can counsel them on what to do but you must never, never *tell* them.

When I read that, the penny dropped, as the English say. Or the nail was hit on the head, as we say.

It is a principle of negotiation that if you wish to get any-

thing from an insecure or frightened person, you must first convince that person that what you want is *his* idea. This is sometimes called counseling—"mutual advising; deliberation together." Of course, it's nothing of the sort. It's pure con. It works.

The modus, then, is to think of the dollies as a collection of sleek and shapely gulls, lined up in front of the snake-oil sales booth. You are the salesman, she is the sucker. You can get *anything* you want from her, if you can but convince her that she thought of it first.

Thus all inter-sexual relations are taken forthwith out of the realm of reality. You must never lapse into naturalness or rationality. Women instinctively recognize these things as signs of weakness.

Don't tell. Sell.

Of course there was a time you could tell a dame, and she heeded. But that was before the damned 19th Amendment, which emancipated and ruined women.

Women had it good once, before the French Revolution. Hear Duff Cooper about women in those days: "The years that have since elapsed have witnessed what is called the enfranchisement of woman, but neither from the polling booth nor from her seat in Parliament has she as yet succeeded in exercising the same control over the lives of men and the fate of nations as was hers while she remained merely the center of a select circle in her own drawing room."

How to Keep a Man

*I*n my occasional capacity as guru-at-large I have been asked how one pleases the brutish male of the species, and keeps him pleased.

I know the answer, of course.

It can be phrased in many ways. The answer I usually give is the answer given me by a famous English-French cocotte who had the reputation of being wildly pleasing to men, albeit she also had the reputation of getting a new one with each full moon.

Her advice was short and simple. "Dear boy," she replied, "just keep them thinking the sun shines out of their derriere."

I suggest no woman can go wrong with any man if she follows this advice to the letter. If she should find the spiritual cost of sustaining her gent on that pedestal too great, perhaps she should find another line of work.

Another lady of fabled potentialities as a pleaser was Miss Peggy Hopkins Joyce, a charmer of the 1920s and '30s.

A friend of mine had often wondered about the lady's secret. With his wife, he found himself at the same hotel as Miss Joyce in St. Moritz. They arranged to be seated near her table for dinner, to observe her in action.

Miss Joyce was with a young, handsome, titled Englishman. From the pate to the Grand Marnier, which took about four hours, my friend observed the couple. Miss Joyce just looked blonde and pretty; her friend was babbling and having the time of his life.

Nothing unusual here, my friend thought. There was nothing in the date he had been spying on to distinguish it from any other meeting of two young and attractive people.

As they were leaving the dining-room, his wife said: "Do you know her secret now?"

He allowed he didn't.

His wife said: "Didn't you notice that no matter what she

was eating or drinking or saying, she never for a second took her eyes off his face."

That sort of conduct, ladies, will get you everywhere.

Perhaps the best guide to conduct for ladies who wish to be good at their job comes from the wife of Richard Burton—the explorer, not the actor.

Before she married that complex and twisted man, Isabel Arundell retired to her Victorian study and drew up a most remarkable document entitled: Rules for My Guidance as a Wife. There were 17 in all. Some of them suggested the lady knew exactly the way her head was screwed on. Among the rules:

"Let him find in the wife what he and many other men fancy is only to be found in a mistress . . .

"Keep pace with the time, that he may not weary of you . . . Hide his faults from *every one* . . .

"Never permit anyone to speak disrespectfully of him before you . . . Never answer when he finds fault; and never reproach him when he is in the wrong, *especially when he tells you of it* . . .

"Never ask him *not* to do anything . . . Do not bother him with religious talk . . . cultivate your own good health, spirits and nerves, to counteract his naturally melancholy turn . . ."

Mrs. Burton was a woman not without her difficult side, as the married life of the couple was to prove, and her widowhood to certify; but when she was about to enter the union, she was clear-headed to a fault.

The good marriage or the good love affair must be based on pretense, for the simple reason that no man is as good as he would wish his woman to believe. Most of us don't even want them really to believe that the sun shines out of our derriere. We just want them to say it. And to act it, always.

Of course, for a woman to keep up a lifetime of this pretense she would actually have to be as talented as she would daily have to profess her husband to be. Dames have their problems too, I guess.

On Belting

Whether a woman should be struck regularly like a gong, as Mr. Noel Coward once suggested, is plainly a proposition that has more than one side to it.

I suppose there are men who go through life without ever slapping a dame, or even giving her the old one-two; but they are not among the lads of my acquaintance.

"I had to belt her to shut her up," is a line I have heard many times during my serried lifetime.

The reason men hit women is not because the men are ruddy sadists or fascists, or because they have some deep-rooted hostility to the other sex (though these guys indisputably exist), or that they wish to keep their beloved in a state of emotional peonage.

No, the reason is usually as simple as this: To shut them up.

For ladies have agile tongues. Agile and, too frequently, uncontrollable. To a very high proportion, they also possess that instinct for the jugular which is essential for a hittee.

It may be that this capacity for verbal infelicity is in some degree a natural compensation for the tiny and tender physical endowment of the sex.

In any case, I am convinced there is some element in the feminine nature that requires and solicits a belt in the chops from time to time.

The ladies set up the situation themselves. They will create a magically inflammable word: like maybe Elaine, or Mary, or Esther. Whether the lady exists or not hardly matters. The response is all that matters, and the response is one of increasing annoyance—as it is intended to be.

Or the word may be "scotch" or "the boys down at the bar" or "the locker room." The essence of the accusation is that it is some activity, pleasurable to you, which gets you out of the sight of the guardian at the gate for a short while. This the guardian at the gate cannot stand.

In due time, and without fail, the inflammable word is used once too often, or the inflammable situation is enacted once too often. Whammmmmm!

What got me thinking along these morbid lines were some remarks made on the subject of belting by actor Terence Stamp, described as "leader of the London jet set" and "lady killer in chief." Said Mr. Stamp:

"Most beautiful birds have been getting away with murder for years. They try it on men because they secretly hope the guy will turn around and thump them.

"Physical control of a woman is vital and there is nothing like a good right-hander to bring them sharply into line.

"An elegant beating, not brutal but . . . memorable."

I won't say I've had many elegant or memorable beatings to my credit; but the ones I remember have nearly always produced more good than harm.

Ladies have taught me many lessons, and one of them is the need to occasionally resort to violence in order to achieve what ought to be the birthright of a man in his relations with a woman: a little damned peace and quiet. I'm certain there are men who have murdered, just to acquire a little peace and quiet.

I'm just talking about ordinary women, the kind described by themselves and everybody else as normal. I'm not alluding to the freaks who have a real need for constant punishment, to assuage some obscure guilt of their own.

These babes are real poison. They should be avoided like tambourine-thumping, colored cocktails, tennis over 40, and other follies.

No, I'm speaking of real, ordinary Dear Old Mom. The lady for whom, with blueberry pie, we fight wars. She is the one who, all too often, creates the situation where you are labeled a hopeless monster, because you give her a well-deserved whack.

And if you don't whack her, when her conduct so rightly deserves it, you get an ulcer or an anxiety neurosis. You lose either way, as in most negotiations with the fair sex. Ah, me!

236

Handle, or Fondle?

Too many women think they can handle men.

Better they should fondle them!

I hasten to add that I'm certain all this works the other way 'round, that women have equally the same complaint about too many men; but at the minute I'm talking about the matter from the male viewpoint because, on the whole, I find it more congenial.

I have had more than my share of handling in my time. I am grateful that I've had a bit of fondling too.

Men are at fault, to be sure, for getting into this whole fondle/handle pattern.

This is because we are slobs. We tend to take the easiest way out. There is nothing easier than getting back into our most comfy role: the babe in the arms of his loving mum; or, even farther back, the mannikin in the amniotic fluid.

We all love to be babied. We throw ourselves into the role. There are among us, to be sure, the stern and upright Joes who will not allow their feelings to be touched by anyone other than maybe a true buddy in a duck blind. These waifs usually get as little love as they give.

For the most of us, who love to be babied (loved, that is, in the most demanding and undemanding sense) we throw ourselves on the horn of a most unappetizing dilemma.

We allow our need to be loved to be interpreted, all too often, as a willingness to be owned.

The ladies who are willing to own, it may be hastily added, are only too quick to fall into this misapprehension.

This is where the rot begins. This is where the woman ceases to fondle her man, and begins to handle him. This is where the man, in his woman's eyes, becomes a property.

The literature of property is filled with elegaic lines; but none of them have ever persuaded anyone—especially a woman—caught in the grip of this curious lust.

Women cannot realize that, for all our need to be treated as children, we draw the line at being treated as chattels. In the process of growing up, most men have found in themselves something useful, and private, and not to be relinquished. This is our ensign, the thing that makes us ourselves.

It is the most important thing we have. Therefore, it is most prized by those women who come to think of people in terms of things, of entities that can be conquered, absorbed, and stacked up like old phonograph records.

Men are not the most sensitive of emotional barometers; but there is none among us so insensitive that he does not know when he is no longer a person to be fondled, but a thing to be handled. The man may never be able to put it into words, but he knows what has happened. The relationship has changed from a human one to a subhuman or sometimes anti-human one. He is something like a fly in amber, but much less valuable.

When this happens, mostly, it's Endsville.

There are said to be some adroit souls among our species who can recognize what has occurred, and can handle the ladies in such a way as to bring them back to reality.

It would be nice to think this, I'm sure. I find myself with a very strong suspension of belief. It seems to be that once a woman has experienced the perverse joys of handling a man, she is spoiled, forever. Spoiled for fondling, that is. Fondling, which is the proper function of a woman.

What we want in a lady, in short, is a housekeeper, no matter how we call it, or how vociferously we deny the word itself. We want somebody who will take care of a) our dear selves, b) the house and c) the children and pets and whatever else may be in the house.

There is no doubt that, being a woman, the lady will move toward ownership of one or all three of these matters in due time. You will know, with implacable certainty, that this has happened. It will be like ice thrown in your bed.

You can do three things. Resign yourself to a life of misery. Leave the broad. Go fishing. If you can get away with it, the last is recommended. If you can't, leave the broad!

The Mates Men Choose

*I*t can come as no surprise to any student of the subject that women like to get married.

Nor will anyone be greatly puzzled to be told that they like even more to be removed from the institution.

There is a serious question in the minds of some lads as to whether a woman prefers a divorce to a marriage ceremony.

Recently Mr. George Gallup applied his talents to some of these questions and found that one out of every four American wives would pick another husband if they were starting out again.

However, only one in every ten husbands says he would have proposed to another girl if he had known as much as about his wife as he does now.

How to account for this relative inconstancy of the female? And the really surprising basic fidelity of the husband?

There is, of course, the fact that a man has his work. This increases his inner security. At the same time, it plays hell with the inner security of his wife.

Most women hate their husband's work. I am also prepared to believe they would hate him a lot more if he were permanently unemployed, with a life centered around a bottle of beer, and the tube, and those interminable sporting contests.

For, let us face it, marriage is a most improbable arrangement, even at its best. Dr. Johnson put it well, in a classic formulation:

"Sir, it is so far from being natural for a man and woman to live in a state of marriage, that we find all the motives which they have for remaining in that connection, and the restraints which civilized society imposes to prevent separation, are hardly sufficient to keep them together."

The exceptions exist, of course; but mostly the bonds of matrimony are being constantly strained against, when they are not actually broken.

No matter how happily a woman may be married, someone said, it always pleases her to find a nice man who wishes she were not.

In the Gallup poll alluded to, man fared more poorly than wife as a social partner, close companion and parent. Women were also more critical of their husband's devotion, personal appearance and mental growth.

A large factor in woman's unhappiness within the bonds is surely her emphasis on romance, with a capital R.

Before she gets married, in order to satisfy some inner aspiration of her own, she endows her loved one with an unbelievable series of qualities.

She makes him a combination of an astronaut, a Knight of the Round Table, a Provencal troubadour, and an English country gentleman of the 19th century—or whatever other little impossibilities her perfervid imagination sets upon.

It is not long before she finds out he is merely James Francis McTaggart, or whatever, and a steamfitter, and a guy who prefers The Sporting Green to the poesy of Dante Gabriel Rossetti.

Perhaps the most satisfied of wives are those who take to heart the advice of Lord Chesterfield on the subject. Perhaps, to avoid dissatisfaction with husbands, more young ladies should heed the following wise words:

"There are but two objects in marriage, love or money.

"If you marry for love, you will certainly have some very happy days, and probably many very uneasy ones; if for money, you will have no happy days and probably no uneasy ones."

The sensible woman should marry some dull dog who puts together conglomerates, has two large candlelit dinners a week, and a child every three years. She should leave the blue-eyed, raven-haired ravishers to the more weak-minded of her sisters.

Fashion as Therapy

At a local party recently the guest of honor was Mr. John, the distinguished maker and seller of ladies' hats. I was favored to be among those present.

Following dinner we went for a drink to the home of friends. The lady of the house was an old customer of Mr. John, who was *very* big in fashion circles a couple of decades ago. He is quite as big still, in a quieter, more dignified way.

The hatter turned out to be an amusing man, and quite mad enough for a hatter. He looks like a dissipated Botticelli cherub, with his long hair. He is saucy, extremely well-informed, and has views on everything. He would make a dandy columnist.

When things had warmed up, I asked him the crucial question: "Just what is it like, selling a woman a hat?" I could have added selling a woman a hat whose husband earns in excess of $40,000 a year; but we both understood that.

His answer was a model of precision and candor:

"The client comes in looking a bit furtive, as if she was visiting some kind of back-street lover. She is visibly uncomfortable.

"She may start out by telling you that her nose is too long, or that she has an emotional problem about being an Irish-Catholic on Park avenue. She may tell you absolutely hairy stories about her husband's sexual aberrations, real or imagined, or that when she was a child at Newport she never could screw up enough courage to go to parties she was invited to. She tells you things she wouldn't tell her pastor, and perhaps wouldn't tell an analyst.

"Several have confided in me that they didn't have the courage to come right out and be Lesbians."

I asked him, "What do you do?"

He said, "Dear boy, I listen."

I asked further, "And then."

He said, "I sell a hat, or two, or more."

"Ah ha," said I, 'then the whole damned thing is therapy." The hatter nodded happily.

And, of course, the more you think of it, the more it is so. Buying hats, and other items of attire, are a woman's way of proving that she is worthy; but it seems a needed part of the process for her to prove that she is unworthy, and put upon, and generally visited with affliction, before she can part with several hundred bucks of the old boy's well-earned.

For all this the fashion industry is grateful. It knows that fashion is by definition transient, whereas the ailments of women are pretty much always the same, and pretty much always worse with the passage of time.

When a thing is fashionable, it is absolutely certain that in a brief period of time it will be unfashionable. And when it becomes unfashionable, the woman who wears it is unfashionable, in addition to being badly put upon.

No doubt Mr. John exaggerated the case, as I am doing now. Yet I am certain he is close to the kernel of truth.

There are doubtless women, both rich and not so, who are interested in the high couture as such, and can talk knowledgeably about Mr. Worth of Victorian times, and know just what Chanel does best, and the deeply secret details of the personal life of Senor Balenciaga.

But most fashionable ladies I have known are that because they have the time and money to be insecure and unhappy. They find that buying a new dress or a great hat is a glorious, if temporary, nostrum for their small neuroses.

Being fashionable is a more refined and polite way of caring for a mild case of the whim-whams, or even the plain whims, than going to one of those nasty little chaps who want to know when first you went off the breast, and first you went onto the potty.

Chasing the goddess of fashion keeps a good many worthy women off the streets. And, for all men know, those bills from Balmain may be cheaper than some others they might get.

Fashion, like some other self-conscious industries, tends to overestimate its fraudulence. Buying a new hat—from Mr. John, please—may be a better thing for society all around, than sitting on several worthy hospital boards, or alleviating the spread of poverty by giving black-tie suppers.

The Eternal Quadrangle

*I*t is becoming one of the commonplaces of modern psychiatry that a marriage, that most intimate of relationships, is composed of four people.

These are the husband and the wife, and the child who was father to the man, and the child who was mother to the wife.

None of us ever gets rid of that encapsulated child. He is with us in all our relationships: work, friends, even in our political attitudes.

Some of us master the child. These are called mature, or grown people. Some of us, especially in times of crisis, are always mastered by that powerful infant. These are called immature people.

Mostly, when people become besotted with each other, in that intricate ballet we call love, there is almost nothing on earth that can prevent them from trying marriage.

At this stage of the game, the two children involved in the romance know almost nothing about each other, though indeed their needs are probably what is being satisfied.

A little knowledge of these two children, by both parties, might be anything but a dangerous thing.

For almost as certainly as the sun will rise, the marriage of two adults who were unhappy children will fail. If one party was a happy child, and the other not, the odds for success rise considerably.

When both parties were happy kids, the odds are high indeed for success; but here too, failure is possible, usually because of the unforseen buffetings of life.

There is considerably more sophistication about this matter nowadays than when I was first nubile.

More and more kids are falling in love, and living openly together, without any thought of marriage. A lot of these are doing it to spite their respectable parents, to be sure; but a lot are also doing it because they have considerable psychological insight into their childhood.

243

They know, some of them, that their sexual hang-ups derive from their childhood conditioning. The wisest of them make a firm assessment of their own childhood, and try to guess at the childhood of their mate, and if they guess that marriage would not work, who of us is to say that they are not wiser to go on as they are?

To ask that they separate is to fight human nature. Besides, it is a decision for the pair alone to make.

Even though divorce is looked upon lightly these days, the prevention of bad marriages should have a high priority on society's list of things-to-do.

We compel a physical test before granting a marriage license. Would a test for emotional well-being be out of the question?

Ah! you will say: Here's old Fearless, who is against making laws which affect human behavior, and who looks upon certain aspects of society, and the power of psychiatrists over other people, with a certain dimness—advocating yet another law and yet another test.

Yet, I do think it's an idea worth considering.

The unhappiness brought on by bad marriages exceeds, I think, any other unhappiness that can come to man, with the possible exception of ruinous health. The sight of two people destroying themselves in the name of love is the most melancholy on earth.

And, of course, most of them do not know what is causing the havoc. They do not associate the kids they were with the adults they have become—a catastrophic mistake.

A little State-supported psychiatry for premarital counseling might very well be a good thing. It won't really work, of course, unless a law is passed.

I admit there are drawbacks to the plan, and to what plan are there not? But I submit the ultimate advantage to society of letting the four people involved in a marriage get to know themselves better before it occurs outweighs whatever disadvantages the plan possesses.

View from the Topless

============

\mathcal{W}hat man has the savoir-faire to gaze into a girl's lovely eyes when she's wearing a topless?"

So inquires that distinguished prober into the human psyche, Dr. Joyce Brothers, a psychologist who got her start on one of those quiz shows on The Other Eye.

In answer to her question, here's her man, right underneath the derby hat.

And it's got nothing whatever to do with savoir-faire. ⅄ just happen to find big breasts rather obscene.

I thought Jayne Mansfield was a funny girl, and had lunch with her a couple of times, but getting my eyes below her tonsils was a chore I gave up shortly after knowing her.

In a beautiful woman, all proportions are just and meet Most beautiful women, like most women, are small. Small, well-formed breasts are one of the loveliest adornments of the human body, female division.

When breasts are big in proportion to the body of the owner, and are attractive to gentlemen who observe them, we are dealing with two forms of aberration: ugly women, and men who would be better off in a psychiatrist's office than having their Eggs Benedict served them at lunch by a lady whose breastworks would survive the siege of Cannae.

I need hardly point out to you intelligent and worldly readers that this is because most American men were never quite gotten off the teat early enough by their loving mothers and as a result regard anything which produces milk, including superannuated jerseys, as sex symbols.

I went over to the Condor one night and took in the routine of Carol Doda.

As I sat there, watching the spotlights playing over the lady as she worked like an ante-bellum slave to make her living, I thought, not without compassion, of what one of the first topless girls, Kim Satana, of Los Angeles, said about the ardors of her profession.

"It's awfully hard on your breasts. I mean bouncing around that way. It breaks the muscles down. That's why I wear a thin support strap under each one. I'm only 21, and I don't want to lose my shape by the time I'm 25."

If you wonder why young ladies choose to make a living in this fashion (apart from the loot) I can scarce do better than refer you to that seeress who started us out, Doc Joyce Brothers.

It's all hatred of men. "As a psychologist I can't believe that a woman who really liked men would go topless in public. If she's married it's an insult to her husband; if she's not married it's still a way of making the men who see her uncomfortable and ill-poised."

But, on the other hand, it's also hatred of women. "American females are pathetically selfconscious of their bosoms. In a topless outfit, camouflage is out. Girls who can wear topless costumes successfully are: (1) beautifully bosomed and (2) eager to humiliate other women by showing what they've got."

I love this kind of portmanteau answer. The Doc also pulls defeminization, narcissism, exhibitionism and boredom out of the hat, with appropriate exegeses.

Fact is, middle-aged American men like to be hit on the head, or close to it, by a young girl's mammary as she hands them their Dover sole after the fifth martini. The real reason for this is far too morbid for me, or Doc Brothers, even seriously to think about.

Mother Ireland

There have been several letters from time to time," a correspondent of the Irish Press wrote recently, "about girls leaving the country and going to Dublin, instead of staying at home and marrying a farmer. These letters tell only half the story.

"I have been married to a farmer for over a year and this time has been made thoroughly miserable by his mother.

"These women hate the idea of another woman coming into the house and continue to treat their sons as children.

"Many friends of my own would willingly marry a farmer if it weren't for his mother."

These words, from Reader, County Kerry, are well and truly spoken, and if you can use the word tragedy as applying to Ireland, this could nibble at something the earnest might call a National Tragedy.

The mothers never let go in that country. Big Mamma is Boss in the Old Country. Never believe a word you hear about the priests. The priests are all secretly married to Big Mamma. They are denied the pleasures of sexual congress by Big Ma, which places them in the same position as most of the husbands of Ireland; but they are indulged for pursuing the vices which are execrated in the husband.

When the padre takes a bit too much paddy of an evening, it is somehow ingratiating in the eyes of Big Mamma. "Ah, he needs it," she says, "after all he has to go through." All he has to go through is, usually, the attention of all the other Big Mammas of the parish.

There was a case to be made for the woman who wrote the Irish Press. She made it admirably. But how about her husband? It is my view that he is more miserable in the marital situation she describes than she is; but it is not a thing that is often mentioned.

The wife is tyrannized by the mother. But she recognizes

the enemy. She knows where to direct her hostility. The poor brute who is the mother's son knows the truth as well as his wife, but he is torn to impotency by a complication of allegiances.

He loves, or at least recognizes the importance of, both his mother and his wife. Likewise he loves, or at least recognizes the importance of, those two other great factors in the life of the Irishman: his bottle and his priest.

And it is the tension among these four factors which makes a spiritual eunuch of that splendid physical specimen: the Irishman before he has fallen apart.

He gets away from his mother by going to his wife. He gets away from the wife by going to the priest. He gets away from the priest by having a seance with the bottle.

Any way you look at it, it's all flight.

He wonders, in due time, if life is worth all that running away, and where it went wrong in the first place.

And, if he is a wise and a tough man, he comes back, in the endless argument, to the old lovely brute who gave him his life, his mother.

The Irish mother regards the pangs of birth as the price she pays for the possession, forever and in fee simple, of the body, soul and gaiety of her children.

So great is the Irish mother's devotion to this Simple Spiritual Truth that most of her children are relieved when she is dead.

7.

Love

*Being divers
definitions concerned
with what it is —
and what it isn't.*

Love and the French

It's like they change the seventh-innings stretch to the bottom of the third. Or doctors don't play golf on Wednesday afternoon. Or Herr Gunther Sachs goes into a monastery.

That is, the bad news from France. That the hours of love-making (as distinct from the hours of marriage and family life) are being moved back from the traditional cinq a sept—five to seven p.m.—to from two to four in the afternoon.

The news comes from Mlle. Francoise Sagan, who announced in her latest novel, "In Paris no one makes love in the evening any more; everyone is too tired."

Now you don't have to believe every word said by Mlle. Sagan, the poetess of the Paris jet set, to be alarmed by her words. But if even a few of the French jet set are setting up these obscene new hours for the old amour, we may have to re-examine some of our dearest assumptions about the Gallic temper.

The lady blames it all on Paris traffic jams.

The ardent French chaser finds he cannot score with his mistress between five and seven and still get home in time for dinner with the wife and kiddies in the suburbs.

We are asked to believe this, by Time magazine: ". . . the ardent lover grabs a quick sandwich and a bottle of refreshing Vichy water, then dashes off to see his mistress from two to four."

This, I fear, is where I must restrain my credulity. We must view the remarks of the young lady novelist as though they were somewhere short of Holy Writ, or even the Gallup poll.

I do not doubt there are some sex maniacs at large in the Republic who would drop their chief pleasure in life, which is the huge two-hour lunch around which the Frenchman's life centers, for the distinctly minor kick of a triumphant romp in the hay.

I do not doubt, as I say, that some such queer lads exist, but I cannot believe they could be respected in France.

From the pate to the camembert and the dregs of the second wine bottle, the Frenchman's lunch is his life. Greed and not lechery is the characteristic sin of this deeply civilized people. Offered a choice between a steady diet of Brigitte Bardot and regular meals at a two-star restaurant, the Frenchman who chooses l'amour would be a laughing-stock among his fellows.

The last time I saw Paris, the old cinq a sept was still a roaring concern. The great beauties of the town were swept off the streets, as if by a snow-plow, when the sacred hour of five arrived. If you wanted to see them for a drink, the hour was eight or nine, after the Homeric encounters had been filed away.

It is perfectly marvelous the way the Frenchman has sold himself as top banana in what the actress Stella Campbell once called "the hurly-burly of the chaise-longue." Americans, particularly, believe that all a frog has to do to obtain permanent possession of any woman alive is to wink and twitch his mouth and wicked moustache a couple of times.

If there is any secret to the Frenchman's success it is that he is a trier. Every woman who comes across his path is an Everest, to be conquered simply because she is there.

The primacy of the Frenchman's affection will always go to that enormous lunch, of which both he and the chef are so proud. After that, a quick hour of cheating the clients and customers. And then, from five to seven, l'amour. It will be like this when the Seventh Republic rolls around, and Mlle. Sagan is a scholarly footnote.

Love and the Hippies

I've just emerged from a couple of days reading the hippie underground press. To say I have, as a result, a smashing case of the bends would be to state it lightly.

I'm all mixed up about this four-letter word the undergrounds keep using: love.

I've come to the conclusion that these young folk don't know even vaguely what they mean when they use this word. They are wildly in favor of love, and they use it as a shibboleth, but there is no preciseness, no agreed value to the monosyllable.

In this the hippies are not unlike the rest of us. I've been using the word all my life, in one context or another, and as I think on it I have no very clear definition of what it is.

That the hippies have got me hung-up on love, and that they are doing the same thing for a lot of other people, is a measure of the impact they are making in some quarters. To talk about love in public, for a grown man, is something like weeping in public. (But let us remember that weeping in public was once a fashionable thing to do.)

What, then, is love? Let us address ourselves to this modest inquiry.

Webster's Third International defines love as "The attraction, desire or affection felt for a person who arouses delight or admiration or elicits tenderness, sympathetic interest, or benevolence."

This admirable collection of words doesn't get us very far, I feel. This definition could embrace "like" quite as easily as love. It could comprise one's feeling toward Minnesota Fats, or Mona Lisa, or Seabiscuit. Or one's feeling for one's self. This is not the love the hippies are talking about, or thinking about.

Nearer, doubtless, is the classic Christian formulation of love: The Golden Rule, which states that one should do to others as he would have others do to him.

Here we have a clear statement that love involves others, and this is the beginning of wisdom on the subject. For much of what is called love never advances beyond the stage of self-love, which is baby love. On this millions of mature relationships have foundered. Self-love is not love. It is a need for love, another matter altogether.

When we are children it is of immense importance to be loved. Love is nearly as important as food. Life depends on it.

Many of us never grow out of this need. There is not enough love in the world to satisfy us. That is why all love-objects, in the end, fail people who have never advanced beyond the need to be loved.

The need to be loved is almost the opposite of the capacity to love. The capacity to love is an adult accomplishment, gained through a good deal of suffering and conflict.

Says one student of the subject: "In adult life one can be strong enough to diminish the need to be loved, and to develop the enjoyment of loving others. This capacity to enjoy giving interest and love becomes the basic attitude towards other people."

"Being in love" and "falling in love" are all too frequently the expression of unsatisfied infantile needs. The prognosis for this kind of love is negative, and bleak.

This kind of relationship is simply reciprocal self-love. This is what La Rochefoucauld was talking about when he noted, "The reason why lovers and their mistresses never tire of being together is that they are always talking of themselves."

Hippies and Love (2)

I am trying to figure out, in public, what love is.

What brought on this amative frenzy in me is the fact that the hippies have a hang-up on love. Their hang-up is making many people, including myself, give a little thought to what this respectable four-letter word really is about.

In the course of my quest I spent some time in that most delightful of San Francisco refuges, the Mechanic's Institute Library on Post street. I was trying to verify a quotation that lay in the back of my mind for years. I thought it was the best definition of love I had ever read.

This definition had been evolved by an American psychiatrist, and I went through perhaps 30 or 40 books of heavy or moderate Freudian orientation.

In virtually none of these books was "love" even entered in the index. After my early surprise, I figured that "love" is not part of the Freudian canon. Love is treated, when at all, as perhaps a subordinate manifestation of something of vastly greater significance, in the Viennese world—hostility.

I found my definition. It is the work of Harry Stack Sullivan, and it seems to me useful.

"When the satisfaction or security of another person becomes as significant to one as is one's own, then a state of love exists. So far as I know, under no other circumstances is a state of love present, regardless of popular usage."

This definition, to me, is like a freshly minted coin. It is not too far from the Christian ideal of the Golden Rule, but it differs in two ways: it is more precise (it can be used as a convenient guide rule in any situation or relationship), and it is unhackneyed. Most definitions of love are tarnished by careless and portmanteau usage.

The only thing I find wrong with Dr. Sullivan's guideline is that it is a counsel of perfection. I would prefer to have the word "almost" judiciously inserted somewhere.

Yet, to "almost" feel the satisfaction and security (solid, fresh words, those) as being as significant as one's own, is a rare and enriching thing. It is love itself. One has thrown away the vestments of self when one can feel this thing. One has embraced the world. One has allowed someone, or many people, to penetrate the crusty integument of the ego.

It goes without saying that, in order to love anybody else, you must have achieved that sometimes difficult thing, the full approval of yourself. This is distinct from the self-love of which we have spoken earlier, which is a form of onanism.

Unless the hippies are more unusual, and more gifted, and more disciplined than I think, they can hardly have gotten beyond the stage of onanism. Their love and their flowers seem to me less an achievement than an aching *need*. For all their talk of sharing, the alienated cannot give.

I think the gift of love is the greatest thing in life. I have too little of it myself. I envy deeply those, young and old, who have been well-favored by this gift. And I offer the most beautiful definition of love I have heard, that of the poet Rainer Maria Rilke:

"Love consists in this, that two solitudes protect and touch and greet each other."

Hippies and Love (3)

We have been talking about love and the hippies. For purposes of clarity we have looked at the two faces of love, which are: the need for love, and the gift of love.

The first is childish, the second mature. The first is taking, the second giving. Although the two are all mixed in our nature, one or the other always predominates. Yet we must remember that the most adult of us still has large chunks of childhood in his composition.

Now it requires no great depth of perception to figure out that when the hippies talk of love, they are talking of their childish need for same. There is nothing wrong with this need. It has a kind of pathos.

These kids are mendicants. They are begging for love, which is why they talk so much about it.

The wonderful thing is that the need for love *can* grow into the gift of love. This is sometimes called growing up. Merely to think about love, and to get others thinking about it, is a strong and healthy sign.

What can the over 40's (and even the over 30's) do to help, to assuage this need, to contribute to this growth? Maybe there is more than a little merit in a suggestion passed on to me by a school teacher.

"The over 40's should do this: Go down among the kids, straight clothes and all, or maybe work clothes, the kind you wear to wash the Pontiac, Toronado or GTO on Saturday morning.

"Give something away. Half dollars are good. Just get a handful and pass them out. If you don't have any, anything will do. Flowers, cookies, sticks of incense—or pass a big bag of potato chips.

"Think, while doing this: 'You are our children and we love you.' Don't get caught at this. You will be accused of building your ego, trying to atone for your sins in a cheap way

and encouraging immorality. Also you will be accused of being barking mad. Worse, you might be thought to be imitating Jesus, and that is a bad bust."

I am not going to commit myself by saying I have followed this provocative suggestion, or that I may in future follow it. I do say that giving something away is far, far better thing than carping about long hair and freaky clothes.

There is nothing wrong with the Christian ideal, and there never has been, despite mutterings by people like Nietzsche that the last Christian died on the Cross.

We live in a culture where it is fashionable, almost obligatory, to be on the take. Acquisition followed by affluence is the national ideal. We give, mostly, when we are forced to by social pressures and company goals, and we damned well have in mind whether the gift is tax deductible.

Yet most of us know there is something wrong with our way of life. The hippies look at their family, and see a mother with a neurosis and a father with an ulcer, and they ask, Who needs it?

The hippies exist because there has been a failure of love in their lives. They are coping, quite gallantly I think, with this failure and the giant need that is unsatisfied.

Anything we elders can do to change these kids' need for love into the gift it should rightfully be, is performing a deeply Christian act.

Love Can Be Cured

*I*f your bedazzlement at the wondrous workings of science has been on the glimmer a bit, consider the case of those two Shrewsbury doctors who have found a way to turn love on and off like a 150-watt Mazda lamp.

They discovered that love can be cured by (appropriately enough) aversion treatment.

Aversion treatment has long been used in treating alcoholics. The docs give you a pill and a bottle of Old Grand Dad. You get drunk and you puke at the same time. The puking is worse than the drinking. If you keep taking the pills, they will not hurt you until you take a drink.

The English docs reported in a medical journal that they treated an unfaithful husband for his infidelity by aversion treatment in the form of mild and continued electric shocks.

The docs (psychiatrists, naturally) said they had showed the errant hubby colored pictures of his wife and mistress alternately on a screen in a darkened room for 30 minutes each day for six consecutive days.

When the mistress' picture was flashed on the screen the unfaithful husband received a 70-volt electric shock on the wrist. When his wife showed, a tape recording admonished him for the harm caused by his horsing around.

Husband and wife, after the treatment, were reported happier than ever before, the mistress was virtuously shorn, and you could chalk up another one for Science.

Am I a mite peculiar in feeling a strong sense of distaste at this whole caper, from the contributions of the psychiatrists to the willingness of the married couple to avail themselves of same?

If a person is willing to do so, I see no reason why he should not submit to aversion treatment to break himself of the habits of drinking, smoking and gambling, or whatever.

But it's another matter, I think, to diddle around with an emotion as mysterious and as sensitive as human love.

Unless the word is used loosely, love for another person can only mean a regard for that person at least as high as is held by the lover for himself. Love never seeks her own, The Bible tells us, "for wheresoever a man seeketh his own, there he falleth from love."

Human love is not something you kill mechanically, by aversion treatment, or in any other way, because it is inconvenient, or unpleasant, or a bit of a bore. How you cope with unwanted love is a matter between you and your character. It is not a matter to be solved by head candlers armed with electric batteries.

And don't forget, when you submit to the thesis that love can be cured, the notion can work in all kinds of ways, many not so admirable as joining up a marriage that has been going on the rocks through infidelty.

After all, the Shrewsbury patient could have arranged to get the shocks while he was looking at his wife, and the beneficial moral lecture while studying the image of his mistress.

Any happily married stinker, of either sex, could erase from his heart every trace of affection he has for his mate, by a simple succession of jolly jolts, and proceed with a clear conscience to marry a widow or widower who was loaded.

Until we know more about human love than we now do (and I truly doubt that day will ever come) we had best let it wind its own silly course to its own silly ends.

As for scientists who persist in monkeying about with the affections, "Father, forgive them; for they know not what they do."

Divorce, California Style

The breakup of a marriage is, among other things, a deep ignominy.

It is a confession of a failure of love, just about the worst thing that can happen to two persons—and their issue.

If a marriage has failed, it really does not matter what the reasons for the failure were—whether real or fraudulent, honest or dishonest, petulant or principled.

What matters is the failure.

Only those who have gone through the whole rotten process of failing in marriage, and then retreating with one's wounds, know the real meaning of this failure, and how it can blight one's life.

When all the temporal nastiness is out of the way—the property settlements, the nastiness of lawyers, the squabbling over custody, the gossip of friends, the embarrassments of being in the same social milieu—there remains this sense of failure.

It is the last thing to go. It stays with a person for years. It makes it very nearly impossible for him to view another human being, with any relish, as a new partner in his life.

I talk glibly of "the failure of love." And what do I mean by love? I have often, with imperfect success, tried to define this elusive thing.

The other day I looked it up in the 12-volume Oxford Dictionary. The savants who put it together do not seem half-off.

Love, according to the big dictionary, is "That disposition or state of feeling with regard to a person which (arising from recognition of attractive qualities from instincts of natural relationship) manifests itself in solicitude for the welfare of the object, and usually also delight in his presence and desire for his approval . . ."

Perhaps it's that simple. When you no longer feel solicitude

for the welfare of the object, when you no longer delight in his presence, when you no longer desire his approval, the thing is dead, dundee. No use flogging a deceased horse.

The failure is, in itself, one of the most wounding things that can happen to a man or a woman. Society, not content with this, has surrounded the institution of divorce with a paraphernalia of claptrap. The whole tawdry business is transformed, by the lawyers and judges, into a titantic struggle between the Forces of Darkness and the Forces of Light.

This usually reads as Man and Woman, in that order.

It is perhaps natural that reform of our ancient notions of divorce procedure should be changed first in California, where the abuses have been greatest. Reforms need the soil of abuse.

Divorce in California, for the woman who cared to exploit the idiocies of its laws, was a hard-nosed career, requiring skills and toughness a longshoreman would envy. There are plenty of dames who not only qualified, but practiced —and not merely once, but often.

Now, California has a law which makes divorce a matter of unadorned justice, instead of a sumptuary law weighted hopelessly in favor of the woman.

The new law eliminated the word "divorce." The new notion, "the dissolution of marriage," ended the concept that one partner was mainly responsible for the dissolution. The new law eliminated as grounds "extreme cruelty"—the grounds for 90 per cent of California divorces. Substituted were "irreconcilable differences" between husband and wife, or incurable insanity.

Alimony is rationalized. Punitive money damages are out. Community property is divided "substantially equally."

This is an admirable measure. It does not shred the dignity of the parties. It merely judges their differences of courtroom brannigans, one of the wretchedest parts of the whole wretched business, is done with.

In the Assembly, the measure was voted against by three members who have something in common. They are women, the only ones in that body.

Honesty, Ugh!

*H*onesty has ruined more marriages and love affairs than infidelity.

At least, that's what I think.

What is called honesty between lovers is far too often only sanctimonious hostility.

Beware of the man or woman who starts off a little speech with, "Honey, I'm going to level with you." Rather than leveling with you, he is likely to level you, like one of those great steel balls razing a brick building.

Honesty may be the best policy in most things, but it certainly is not in affairs of the heart.

People who make a thing about their honesty are often people who inwardly doubt their honesty, just as people with a thing about their virility, or a thing about their virtue, etc., etc.

Those who have a good thing usually do not talk about it, much less boast about it—usually because they are unaware they possess it, or do not place any great value on it.

The "honest" man or woman is almost as bad as the candid friend, and can wreak as much emotional havoc. Honesty, for him, is often a form of therapy. And, for the person he practices it on, a form of torture.

I know. In my younger days—and still indeed, to some extent today—I was a great one for using honesty in a lacerating fashion.

It did not occur to me that when I was talking honestly to someone, I was simply using my version of honesty.

I seldom got outright honest unless I was hurt. Then, as I now see, I used honest talk as a weapon to get back at the person who hurt me, although the hurt was often inadequate. It simply grazed against one of my sensitive bones.

Honesty, in intimate relations can be crushing. "Now, my dear, we must face the fact honestly: You're not as young as you used to be." Or, "Let's face it, your father ended up

in the bin." Or, "Why try to hide from people the fact that you are growing bald."

If honesty is not the best policy in close relations, what, pray, is? The answer is simple:

Good manners.

Like all injunctions of perfection, this is easier said than done. But merely to *attempt* to have good manners rather than ruthless honesty, is bound to influence for the better the quality of the relationship.

A very wise woman named Daily Fellowes used to say of marriage, and of love affairs:

"Never say anything to the other person when you are together that you would not say if there were guests in the room."

Apart from love-making, of course.

A love affair, or a marriage, is not an excuse for the raw ego to have a field day. The conscience and the amenities should be observed, insofar as possible.

If you want to keep the affair or the marriage going, you must rise above revenge and retaliation. Never allow your mate to get to first base. When she throws you a nasty curve, what you say is:

"Look, darling, you're hurting me. Please stop."

Sometimes this works. Sometimes it doesn't. But you can be sure that, even if it doesn't work, and a scene is played out by your love, the whole thing will not be so hurtful as if you had fought back in the first place.

"Honesty" from one of a couple is bad enough, but it is not the disaster of two honesties caterwauling at each other for hours and days, like desperate regiments.

If the relationship gets so bad that real honesty is required to repair or maintain it, get a third person into the act. A minister, a priest, a psychiatrist—somebody neutral. You have less desire to be fake-honest in the presence of a person with whom you are not involved.

Believe me, "honesty" between lovers, and even friends, can be a pathology of the feelings. Beware.

Eyes and Ears

There's this chap I know who lives in Santa Barbara. He sells land and the buildings thereon, which makes him a realtor, or something.

He is a handsome duck, and has given no small amount of thought to the subject of the ladies, and of love-making in general. He has distilled all his wisdom into a theory which is known in some quarters as Bromfield's Law. It goes like so:

"Men make love with their eyes; women with their ears."

When first I heard this, I regarded it as a pretty facile formulation, and gave no more thought to the matter. But I found it was one of those things that would not go away.

What the law states, in other words, is that when the chase is on a man never hears anything, and a woman never sees anything.

Perhaps these are two necessary deceptions, as the whole process of courtship is a necessary deception.

In my brief and inconclusive experience in these matters, I think it incontrovertible that the lady cares far less about how you look, than what you tell her about how she looks, and how heavenly she is in other matters.

You tell her that the sun, the moon and the stars revolve about her pretty little head, and no matter who she is or where she is, you're in like Flynn. It is only when you stop making these pretty little asseverations that you're in trouble.

Blarney is the greatest aphrodisiac in the world.

With a woman, you can talk your way into anything. Talking yourself out is another matter, and not nearly so interesting or so easy.

One of the most successful lovers in English history was also one of the ugliest men of his time, the great political agitator of the 18th century, John Wilkes. Johnny Boy used to say:

"Give me a half hour, and I will overcome the handsomest face in Europe."

And he proved it, over and over again, with the most beautiful women of his time. You can make a woman forget a wooden leg, or a most sinister aspect by a few thousand well-chosen words on the wonders of her character, and the distinction of her mind.

You emphasize her character and mind, of course, if she has a beautiful body. If she doesn't, emphasize her beautiful body.

Man, conversely, gobbles up the lady's looks, doubtless for the sound biological reason that he wishes to improve the species, and that his wonderful looks compounded with those of the lady he is serenading at the moment, will result in a race of supermen.

He is obsessed by her ankles, by the way she crosses a room, by the way she wrinkles her nose, the way she sits into and rises from a chair, by the way her breast heaves when he has delivered a particularly successful period. He is obsessed, in fact, by every physical nuance of the woman he has chosen as his divine prey.

He never hears a word she says, which too often leads to small bits of trouble. It leads, for one thing, to the dangerous illusion that a beautiful woman is something like a beautiful horse—just a beautiful animal. This is a mistake. Horses don't go to lawyers.

That's the tragedy of it all. Women have wiles. And men, at some time or other, have to do something other than praise the beauties of the beloved. Like go to work. Then some other eloquent and idle lad is apt to come around, and make the same speeches he made in an older day, with exactly the same results. It has been known to happen.

I am convinced that Bromfield's Law reaches deeply into the nature of things. If you want to achieve the favors of a woman in the shortest possible period of time, think of her as the House of Commons, or the U.S. Congress. Address her as you would address a legislative body if you passionately wanted a new bridge or freeway in your district. You will prevail, if you keep your voice down.

Quarrels and Love

Quarreling is all too often the bad side of the coin of love.

You must love in order to quarrel. The person or ideas you quarrel with must matter mightily to you, in order to put up with this most wasteful form of human activity.

As it takes two to tango, it takes two to tangle. A quarrel is rapidly settled when one person withdraws from it. That this does not happen more frequently is further proof of the deep, essential attraction the quarrelers have for each other.

I once knew a lady for whom I had the highest esteem. I would have done, so I thought, anything to please her. But after a while our friendship got to a point where every meeting seemed to degenerate into a quarrel.

I found myself saying things that I really did not even allow myself to think. She did the same. These verbal Donnybrooks exhausted each of us; but there seemed no cure for them.

I finally concluded that the cause of these unseemly squabbles was that I wanted something from the lady that she was incapable of giving me; and that it worked the same way on her side.

I tried to tell this to the lady in a hundred ways, and got into another hundred quarrels.

For the serious, sustained quarrel is the ultimate breakdown in communications. It is the collision of two indomitable egos. Something has to give. It is usually both parties.

I had a lot of training in quarreling, for I came from a quarrelsome mother. When she was not quarreling, she sometimes said, "It's better to quarrel than to be lonely."

The old lady really loved a good quarrel. She almost literally rolled up her sleeves and had at it. There was almost nothing she wouldn't say, or provoke others into saying, when she was at full tilt.

The reason for these quarrels was the usual one between

mothers and sons, and possibly between men and women. I wanted to be free and enter the great world, or thought I did, and my mother, for reasons of her own, wished to keep me captive.

Or maybe the real truth is that she didn't wish to be lonely, or had gotten so used to the quarrels that she would miss them desperately. I never learned.

When these passages were over, and they would usually end precipitately and even with a laugh, she was her old funny self again.

Though I would never let it show, for reasons of pride, the discord tore me apart.

And the reason was a simple one. She had made me doubt her love for me. Emotional consistency was not her high suit. As a result, she has a son abroad in the world who has both a great need of, and a great fear of, deep emotional entanglements. He does not want to have love withdrawn from him. It hurts him very much when this is done.

I wish I knew how to avoid this kind of thing; but I suppose, being my mother's son, I shall always to some degree associate love with discord. I wish it were otherwise; but it seems to be a burden I bear.

I find the best way to avoid quarrels is to find a woman who likes them even less than I do. There are such about. It's remarkable how hard it is to quarrel with someone who won't quarrel with you. I've known my share of such women in my life, and to them I attribute a large part of such sanity as I still possess.

And I sometimes console myself with the little aphorism of Logan Pearsall Smith, "For souls in growth, great quarrels are great emancipations." If this is true, maybe I haven't done so badly, and maybe I will do better in future.

Sex and the Heart

\mathcal{T}he man holding the scotch and water was a distinguished heart man, world-famous in fact. Addressing him in a cluster of people was a good-looking society matron. Like many good-looking ladies at social occasions, she wasn't above asking for a free medical opinion from susceptible docs.

"Tell me, doctor," she said, "is sex bad for the heart in a man around fifty?"

The doctor looked a little puzzled, and mumbled something about differing circumstances making different cases.

The lady continued. She allowed that some months ago her mate had had a mild heart attack. Since then, she added, he had rather husbanded his amativeness. She was worried

The doctor replied: "Sex," he said, "is rather like tennis. Or bicycle riding, or other strenuous sports. It can, under happy circumstances, be continued into the 80's—*provided*, that it is practiced regularly."

With these strenuous sports, he continued, you must not lay off for long periods, and then resume, for then you might risk heart damage. You are safe, though, if you just continue whacking away at whatever it is you have been doing most of your lifetime.

This rather assured me. I am a creature of routine. And I believe in the comforts of routine.

I am not a tennis player or a bike rider. I am, in fact, far too sedentary for my own good, though a brisk walk does not disturb me.

Certain small things are important to me. For many years now, after doing my stint of writing in the morning, I like to read the newspapers.

I do this in a special way. I go to a pub, usually a place where nobody will talk to me, either because they do not know me or because they are too polite.

Over several bottles of ale (never more than four) I

read the latest bulls of President Hayakawa, the views of one and all on Ted Williams as manager, the latest absurdity of the take-charge students—in fact, the whole jocose-tragic parade of mortality.

So ingrained in this routine that I find I cannot read newspapers anywhere other than at a bar. If for any good reason—sickness, an important appointment—this routine is changed, I get the whips and jangles. All day long I feel a sense of inner discomfort.

Yet if this interruption of routine continues long enough, some little machine inside me says, "The hell with it." I funk what I consider my duty, and feel no discomfort about it at all.

So I can see what the doctor says about sex. In a way.

Yet I have this reservation—sex is *not*, really, like tennis or bike riding.

It is not a therapeutic duty, intended to be done a certain number of times a day or a week, like push-ups.

Making love after a certain age is a creative thing, like putting together a sonnet, or making a beautiful room, or writing a song.

When the flesh is young and the juices are fervent, love-making is almost a necessity, a necessity for which the human race may thank God.

But when the bones have set, and you accept the folly of your friends, love is neither a necessity nor something to be done on schedule, unless you're some kind of a monster.

It is still a pleasure, perhaps a greater pleasure than ever before. But it has to be felt, and felt until it is ripe to be uttered, like any other creative act. It has to grow, in short. It cannot any longer be blurted. It cannot march to any sort of inner goose step.

It cannot be regimented, not even for the sake of the heart. Better take a few risks of heart damage from slight desuetude than turn love-making into something to be done on prescription. If the lady is to hand, and if love is present, and if nothing is forced, the old engine will go until it runs out of gas. I kid you not.

8.

The English

*Being first-hand observations
of the foibles and
fascinations of life
in the sceptred isle.*

Note on the Four-Letter Word

When I read about some kids who were sentenced for their devotion to a four-letter word which is such a blessing in private and such a damned nuisance in public (for reasons best known to the Anglo-Saxon conscience), my mind kept going back to an Englishman well-known in the days before World War I, Horace de Vere Cole.

Cole once got away with this controversial monosyllable in a leading West End theater. He did the whole thing with such grace and charm that it is still being talked about, often with admiration. Cole was a lifelong joker, a man of wealth and ingenuity. Somebody called his jokes "battles in his self-declared war against pomposity."

Many of his jokes have been credited to others, including an American named Hugh Troy. With some friends dressed as workmen, Horace set up shop early one morning in the middle of Piccadilly Circus, the busiest place in London.

The "workmen" roped off a large section of the street, lighted a charcoal brazier, put up a red lamp to divert traffic, and proceeded to dig a huge hole in the middle of the pavement. The police moved traffic out of the way. The pneumatic drill was deafening. Nobody asked any questions.

The workmen went away in a few hours. Still, for days, no questions. Finally someone dared to ask what had happened, and who had authorized the work. The news leaked out it had been a joke. All London laughed. The authorities feared to prosecute, believing it would bring ridicule on themselves.

Cole's greatest coup was directed against the Royal Navy in 1910. The flagship HMS Dreadnaught was resting in Weymouth Harbor, and aboard was Admiral William May, Commander, Home Fleet. Cole sent a telegram, allegedly from the Permanent Undersecretary of State for Foreign Affairs. The telegram warned the navy of the arrival later that day of the Emperor of Abyssinia and his full entourage. He was to be given full naval honors.

Cole and a party of friends were made up in blackface by Willie Clarkson, the theatrical make-up man. There was a German interpreter, Adrian Stephen. His sister, who was garbed as a dark princess, was later to become Virginia Woolf, the novelist. Cole came in frock hat and silk coat as Herbert Cholmondelay of the Foreign Office.

The party arrived from Paddington Station on a special train. A naval guard of honor awaited them. They were taken out to the Admiral's flagship by a motorboat, to the music of the Royal Marine band (playing, mistakenly, the national anthem of Zanzibar), and the flying of every scrap of bunting the navy could lay hands on at short notice.

The Emperor, played by Anthony Buxton, had a vocabulary of two words, "Bunga, bunga!" He uttered them as each miracle of British naval expertise was shown him.

The Hoax was a complete success. The party got back to Paddington with make-up intact after the long day. Cole let the cat out of the bag, and "Bunga, bunga!" became a national shibboleth, to make miserable the life of Admiral May whenever he set foot ashore. The jape cost Cole about $20,000. He always said it was worth it.

His most exquisite joke was unveiled a few years later, when he bought up all the seats in the stalls and pits of a West End theater then running a popular play with Mrs. Pat Campbell as star.

Cole sent out all the invitations himself to a picked list of guests. Among them were a carefully selected number of bald-headed gentlemen. The order of seating these bald-headed gentlemen was so arranged that, when viewed from above in the dress circle, the circle and the gallery their bald shining pates formed a distinct pattern when they took off their opera hats.

The pattern so carefully wrought by Horace de Vere Cole was that Word. Itself.

Love Life of the English

The love life of the English is no more remarkable than that of Americans or Swiss or Eskimos, except in one respect: the love-object tends to be an animal rather than a person.

The English have a sex life, and a full and varied one it is too. That is another matter. It has far less to do with love than the island people's full-blooded longing for anything with more than two feet.

But just because the limeys of both sexes love animals, you are not to jump to wild Viennese conclusions that the furry and winged creatures get the repressed affection the Englishman denies to his mate. It has been well-observed that the animal doesn't exist who cannot be adored by an entire English family, whether it be a hamster, an owl, a budgie, a terrapin, a goldfish, or a baby alligator.

I heard the other day of a splendid old dowager who each day wheels a twin perambulator across Piccadilly, in the heart of London, and onto the lawns at Green Park, just under the Ritz Hotel. Kind strangers walk up to the pram, expecting to smile and cluck the twin children under the chin. Instead there are two pekes. The old lady lets them out. They run for miles. She then places them back in the pram and solemnly walks them home.

During the war it was often the family cat or dog who got the major part of the scanty meat ration the housewife waited in line for hours to get. When ladies of a certain age turn up for the four-day peace demonstrations of the Committee for Nuclear Disarmament, you may be almost certain that what is on their mind is more likely their pet than the younger and yet unborn generations of mankind.

The provincial newspapers are filled with advertisements like the following: "Will anyone with a garden or ground floor give me a good home? I'm a female puppy, offered free. Dad is an Alsatian and Mum a Chow-Alsatian and I look the

cutest teddybear Alsatian. I'm two months old, and already I'm a watchdog."

Recently the town clerk of Brentwood and Chiswick, alarmed by the droppings of pigeons and starlings, sent a carefully worded letter to house owners and local tenants:

"While the feelings of bird lovers can be appreciated," he said, "it should be borne in mind that, apart from the disfigurement and damage they do to property, pigeons are in numbers a distinct danger to public health both from the point of view of hygiene and the fact that they are recognized carriers of infection.

"If therefore you are in the habit of feeding these birds I would ask in the interest both of the public and your immediate neighbors, that you cease to do so and discourage any members of your family similarly inclined."

The letter, predictably, enraged the citizenry, even those whose own roofs were most disfigured. The feeding increased in richness and volume. In time Chiswick became the favorite supping place for the pigeons in southwest England.

Most popular of all books sold in England are those about animals. A large proportion of the national dailies is filled with any kind of news item than can be hung on a canary, a swallow, a squirrel, or a bat. The surest way for a rich parvenu to break into high society is to give a fat check to the London Zoo.

You may imagine the consternation caused in the letters column of the Sunday Times when a practical joker decided to put on the animal-cult, with the following missive:

"I am emboldened to denounce a growing urban menace, the taking of dogs into taverns. In London especially a restful and restorative lunchtime drink is becoming impossible because of the presence in the cosier bars of groups of loutish animals leering and lurching about, not infrequently sampling one's tankard. If the large men or women by whom these gauche beasts are invariably accompanied cannot be persuaded to leave them at home, I view the future with foreboding."

Where Did You Leave Your Mind?

*L*ord David Cecil is an absent-minded professor. Goldsmith Professor of English Literature at Oxford, to be exact. He is 63, wears blue jeans, and comes from a family that has ruled England since the days of the first Elizabeth. His grandfather, was Lord Salisbury, Prime Minister for Queen Victoria.

Lord David comes by his forgetfulness by inheritance, perhaps. His uncle William was Bishop of Exeter. "He was very absent-minded," said Lord David recently. "He lost his railway ticket once, but the ticket inspector said it was all right. They knew who he was, so he hadn't to worry.

"'But I am worried,' said my uncle. 'I can't remember where I'm going.'"

The English professor once didn't turn up for a dinner date. A few days later he met his host in the street. The host asked what had happened. "When was the dinner?" asked Lord David. "Last Tuesday," said his host.

"Right," said Lord David. "See you then."

When asked about that incident, the professor said he couldn't remember it. "It sounds more like the thing Doctor Spooner used to say," he pointed out. "After the war Spooner said to one of his students who had returned, "Tell me, was it you or your brother who was killed?"

Lord David added that he had not said that, alas; but "I can quite see the mental process behind it."

The Rev. William A. Spooner (1844–1930) was another Oxford man, the warden of New College. He was the most famous absent-minded professor of all, and the one who made the type a world-wide joke. He had a weakness of speech which is called in rhetoric metathesis, which consists of transposing the first sounds of words so as to form some other intelligible combination. If the combination is funny, it is called a Spoonerism.

He said things like, "We all know what it is to have a half

warmed fish within us" (for "half-formed wish"). And he told a congregation once, "Yes, indeed; the Lord *is* a shoving leopard."

His most famous Spoonerism came when he announced the hymn, "Conquering Kings Their Titles Take", early in 1879.

It came out "Kinkering Kongs Their Titles Take."

A joke which has entered American folklore came from Doctor Spooner, according to Spoonerologists at Oxford. "I remember your name perfectly, but I just can't think of your face."

The most complicated of all the metatheses attributed to Doctor Spooner was a speech made to a student he was told to send down, which is Oxford slang for expel.

"Sir," he said, "you have tasted two whole worms. You have hissed all my mystery lectures. You have been caught fighting a liar in the quad. You will leave Oxford by the next town drain."

Of even more questionable provenance are a couple of well-known Spoonerisms which have almost too much the mark of the Yankee. "One swell foop," is a frequently heard one. And it is also said the good doctor officiated at a wedding reception. He noticed that the groom had overlooked an important part of the ceremony.

"Son," Dr. Spooner said, "It is kisstomery to cuss the bride."

I have not been above committing a Spoonerism or two in my time. It wasn't too long ago that I told someone, in a moment of high dignity, "I'm not so think as you drunk I am."

The Solid Gold Potty

I am not the first financial genius you will meet, nor will I be the last, who acknowledges that he does not really understand the grip of gold on mankind in general, and the financial community in particular.

I know gold is almost twice as heavy as silver, that its pursuit has discovered most of the known Western world (for what that is worth) and that it persuaded a lot of 19th century hippies to come out West and start up San Francisco on the remains of Yerba Buena.

I know it does not tarnish. It is used to back national currencies. It can, however, be dissolved by aqua regia, a mixture of acids.

But why it is so reverenced by the rich, and brooded over by the Gnomes of Zurich, is quite beyond me. Why not tin, or beer, or Maiden-Form bras?

A thing has intrinsic value, apparently, because a lot of dudes decide it has intrinsic value. There is no changing this, or these dudes.

My understanding of gold was not heightened by the announcement that the Bank of England recently "cut off Godley's flow."

Why Godley, or his flow, should so occupy the attention of the Bank of England may puzzle you. It puzzled me. If you listen carefully, you will get the drill.

David Godley, a smith from Leicester, England, makes solid gold potties. He recently, with the loving care of a Cellini, crafted several dozen nine-inch-diameter, 22-carat gold models. His work was not altogether for love of art. It had a bit to do with making a spot of loot.

All perfectly legal, in the British Isles. In this country, possession of gold, and sale thereof, is akin to the rape of virgins—again for reasons I imperfectly understand. In England you can buy gold tax free if you make of it something called "a functional item."

A potty, even if gold, presumably qualifies.

Instantly he put his functional thing on the market, he was inundated with hundreds of offers for it. The applicants, base chaps that they are, were less interested in the functional side of the gold potty, than in the gold side. There is still a healthy world market for gold, even if it is shaped into a convenience. Conveniences can be melted.

This is when the Bank of England moved in on Godley's little gesture towards the improvement of Britain's economy. No dice, said B of E. They were fearful of any kind of strain on the gold market, or maybe a dirty letter from the U.S., which thinks gold is so important that it must repose either in your teeth or Fort Knox.

"The Bank," said Godley, "requested, it did not order me to do this. It said golden potties would harm the economy, and being an upright, flag-waving type, the last thing I'd want to do is harm the economy.

"But," he added, with a certain determination, "I bloody well will not melt down the potties. They will not be sold in Britain. Maybe I can use them for export."

As I say, gold and its complications perplex me utterly. But I think it would be jolly if some enterprising American or other bought one or two of these delicious products, and somehow managed to bring them into this country.

Somehow, they would blend with our culture.

That it would be mildly illegal is beside the point. Smuggling is a national industry, although not what it might be if prosecuted with more efficiency and skill.

All you would have to do is haul up a big box and tell the customs inspector at Kennedy or S.F. International Airport:

"I've got a solid gold potty in here."

You would be waved by with the genial smile which greets busty airline stewardesses, and members of the cabinet, and returning baseball teams.

In Praise of Comfort

I can endure quite a lot of comfort.

At various periods in my life, and for one reason or another, I have been a guest in some mighty Stately Homes. As a result, my moral fiber may have disintegrated somewhat; but I had a hell of a good time getting there. Half the fun is that, according to the ads.

There are still houses in England which are conducted as if Edward VII were still alive. Rising above taxes and death duties and the decline of manners, the owners bravely face life, luxe style.

Though I don't ask you to believe it, there are still places where the valet, as his first duty of the day, irons the wrinkles out of The Times before placing it on milord's breakfast table. Milord, when he finally gets around to reading the paper, grows empurpled and calls its owner, Lord Thomson, a filthy Communist. A filthy Communist, in these exalted circles, is one who believes in the graduated income tax.

There are houses, still, where they draw your bath. It's always a little cold, but the thought is there. There are other houses which go to a step further: The tooth paste is laid flat out on the brush for you by the valet.

A piece of soap, once used, is never seen again. It is replaced by another piece, from Floris on Jermyn street. One wonders where all those once-used cakes of soap go. Presumably to a home for the Worthy and Indigent Aged.

There is one hostess, an American lady living in France, who won my heart by a beautiful gesture. Beside my bed was not the usual collection of lightweight best sellers. There was a veritable small library of titles that made my mouth water. Before her guests arrive, this savvy lady calls up a Curzon street bookseller named Haywood Hill (everybody buys books from Haywood Hill) and determines their taste and bent of mind.

This serves the useful purpose of enlivening the conversation, under her skilled direction. The lady, moreover, makes it clear that when you leave you may take any or all of the books. It's kinda hard to refuse.

I like percale sheets. I like having all my things pressed and laid out by a man who knows how. I have even learned to like breakfast in bed.

And the worst thing is that I am coming to like these things without guilt. When I first encountered la vie luxe I was torn between ancient revolutionary allegiances, amusement, and just plain enjoyment.

A bit later I got sufficiently used to great luxury to forget to be amused. Later still, I wasn't even guilty. I just leaned into my good fortune. It's amazing how habit sanctifies things.

Part of the pleasure comes from the archaic grandeur of the thing. This is a way of life on the way out. At the dinner tables and over the port there is an ominous ground bass sounding: The death rattle of a way of life. Live it up, baby, for tomorrow we're off to the knackers.

Presiding over all these moribund pleasures is the English gent, likewise a vanishing thing. He may believe The Times is a filthy rag. He may say you shouldn't give coal to the poor because they will only store it in the bathtub. He may be stupid, and short-sighted, and an anachronism.

But you can't take this away from him. Because he has the time and money, he makes a career of his own comfort. And part of his comfort, as he sees it, is the comfort of his friends, and his friends' friends.

London Winters

If you have ever been through a winter in London, you are not likely to forget it.

Today, however, according to some poop I got recently from the sceptered isle, you would be hard put to remember it. London winters aren't what they used to be.

We all of us know the winters of Sherlock Holmes and the characters in Limehouse Nights, and the world of Sax Rohmer. Sinister folk jostling against each other in the fog, everybody intent on his own little bit of nastiness.

Shivs stuck suddenly in backs. Bodies plopping mysteriously into the Thames. Scurrying figures escaping in the bleak damp night.

Well, the fog is virtually gone now.

The London City Council a few years back decreed that the city was to be a smokeless area.

Like most well-intentioned reform measures, the smokeless ruling has had its desired effect, and some side effects not quite so desirable.

People can breathe again, which is surely a good thing. The level of respiratory infections is down, which is another clearly good thing, and people don't bump into each other on the streets at night.

But a great London institution has disappeared, and for good—the blazing, bright red coal and wood fires which have burned since just about the beginning of English history.

Now the very rich have central heating, which lacks the poetry of burning coal. The poorer have gas fires, which have a spectral and unhappy look.

In between, there is a melancholy electric fire into which the London Electricity Board has built a revolving flicker that is supposed to look like flames.

Most old-fashioned fireplaces are being boarded up. Some people keep their fireplaces and use a form of smokeless coal,

which is very expensive. This is probably the best substitute for the ancient roaring fire.

One of the last places I knew that had two roaring fires going all the time was the Victoria, a pub in the Paddington district. It bears quite a resemblance to San Francisco's Buena Vista (apart from its Victorian decor) in that the premises are furnished body-to-body.

I don't know how the Vic got away with its fires. When inquiries were made, they were always met with smiling silence. I wonder if those fires are still going? They surely made one winter for me all that less miserable.

But even without its fires the Vic would be warm, with the warmth of people enjoying themselves.

That seems to be what is happening in London. Folk are going to the public house around the corner to keep warm. (In the rural districts, of course, they still have wood and coal fires.)

The pubs all over England are more crowded than they have ever been, despite harsh drunk-driving measures.

This is not necessarily because the English are drinking more Scotch and bitter and pink gin. There are just less pubs, 30,000 fewer, than before the war. And more women, of course, are going into them these days.

Figures recently released show only 75,000 pubs available for 55 million Britons—one for every 733 persons.

But if the fog has gone and the warm pubs are going, there is one thing that hasn't changed about London for an American.

That's those crazy Eskimo hours in winter time. It's dark when you get up in the morning and it's dark in the middle of the afternoon.

One of my most vivid recollections of London is going to lunch at Buck's Club in Cork street during that brief patch of light the English call daytime. The lunch was fine, as were the wines.

When I reached the street it was, of course, dark. As I found my way to Bond street, I spotted at its end an unforgettable sight, a full moon. It was 3 p.m. They don't hardly have sights like that in San Francisco.

'Aging Roué with Taste'

*T*he advertisement appeared recently in the personals column of The Times of London:

"Aging roué with a penchant for kippers with white wine over the crossword puzzles for Sunday brunch, seeks lady with similar tastes. Object matrimony."

There is an engaging lad, I wish him well in his quest.

And I also wish to thank him for reminding me of three British institutions with which I was once quite familiar, and which I sorely miss.

These are the classified ads in The Times, the aging roué, and the Sunday brunch.

The Times classified ads are printed in agate type. They used to be on the front page, until Lord Thomson took the sheet over a couple of years ago. They are universally called the agony column. I think this is because, in the 19th century, they were largely turned over to notices of severe illnesses and obituaries.

Now they can be about anything. You can offer a palace for sale, or report that the aspidistra are doing well in Falmouth, or that you gave a party for the Marquis of Lansdowne.

The ads are censored by some invisible and mighty personage. His standards are inexplicable. You can put in a perfectly proper ad asking for a landscape gardener to come to the country to do some work for you, and it will be refused. Equally, you can advertise for ladies to make dirty movies for you, and it could very well be accepted.

Actually, there are two newspapers in The Times. There is the usual journal of news and comment. There is also the agony column and the letters to the editor.

You can forget the newspaper entirely, if what you are interested in is less news than a reflection of that curious character, the Englishman. If you want to know what makes John Bull tick, and it's worth knowing, it's the letters and the classified ads.

The aging roué? It seems to me that most of my male English friends fitted into this category.

He was an old boy from a public school. He had been an officer in World War II, and still wore his smartly fitting GI camel's hair overcoat. He could wear it because he kept his figure.

His complexion was usually ruddy, from leaning into the port after dinner. Like as not, he figures as the protype of one of the characters in an early Evelyn Waugh novel. Quite frequently, he would fail to finish a sentence, just letting it trail off elegantly.

He tended to be down on his luck, waiting for some rich relative to die and leave him a modest 50 quid or so. He might live in rather squalid premises in Chelsea.

He never dared leave his room before noon. It was between 10 and 12 o'clock when the invites came, if they came at all. The rich ladies who needed aging roués to fill out tables on the weekend, and who remembered vaguely that Ronnie was good at croquet, were the difference between hell and earth for the aging roué.

The Sunday brunch in the country? These were endless affairs composed of fish and other food and a huge supply of Sunday newspapers.

The newspapers were a problem. Nobody cared much for the news, but they cared *passionately* for the crossword puzzle and the book reviews.

You would think if you had ten people, it would do to have ten copies of The Times, The Observer, The Sunday Telegraph, with the occasional News of The World for the racist member of the group. But that wouldn't do at all.

The guests tended to divide themselves into Cyril Connolly people (he reviewed books for The Times), and Philip Toynbee people (the Observer) and Anthony Burgess people (The Telegraph.) You could never remember who was madly Connolly, and who was bitterly anti-Toynbee.

The crossword puzzle was equally difficult. So, in the end, you put a great pile of newspapers on the kitchen table of a Sunday morning with the notice to one and all that first come, first served. You knew there was going to be bad blood over this, but that was part of the charm of life in the English countryside.

'Steer British'

We were talking the other day about the sublime conviction the English have that their way is the right way. Many things, including the British Empire, have melted away in the heat of the 20th century. Not, however, this conviction of inner rightness.

It is the chief charm of the people, and their greatest claim to irritability. We admire aplomb, but dislike arrogance. These are the obverse and reverse of this particular coin.

So certain is this inborn conviction of rightness, especially in what is called the upper classes, that when it is questioned, or even worse, challenged, the face of the proper Englishman wrinkles ever so slightly in astonishment. The answer, whether spoken or unspoken, is always the same:

"But you see, old boy, you're wrong. This is the way *we* do it. Always have."

Take the American reporter in London who recently flunked his driving test. Getting a license to drive in London is only slightly easier than winning a Ph.D. This is especially true for the foreigner.

The Yankee had been driving for 25 years all over the world, including New York, Paris and Baghdad, each of which presents special and not easy problems for the motorist. He took the test. He thought he had done fine. He was informed by his English driving inspector that he had flunked. "Why?" asked the Yank.

"You don't steer the British way, old chap."

The British way to steer, it turns out, is to keep your hands at all times at a position roughly approximating "ten minutes to two" on a clock's face. You "tread" the wheel by using one hand to guide and the other opening and closing to steady the wheel. You must *never* cross hands, or end up with your hands in other than the ordained position.

After a driving course in a British motoring school the

reporter went back to the same inspector, steered British, and passed.

This Billy-be-damned Zeitgeist was admirably suited to a life whose rigors consisted chiefly in civilizing the lesser breeds. It threw up an extraordinary type of public official, like Lord Curzon, who could dismiss an entire nation by remarking that the French "were not the sort of people one would take along on a tiger shoot."

Curzon himself took on the sub-continent of India as if he were competing for a literary prize at Oxford. But the intellectual and moral aplomb which brought Curzon the viceregal throne was also the arrogance which cost him it, after a famous power struggle with his military commandant, Lord Kitchener.

It's different, here and now. Despite the Beatles, and Carnaby street, and some other things, the English still have rather too much moral rigidity for their own good. Unlike Germany and France and some other countries, the English have not changed as much as the world has, recently.

This rigidity hurts in many areas, but especially in salesmanship. Even the things which the English still produce superlatively well go a-begging in many of the bazaars of the world.

Can this be because there is something essentially servile about the salesman's role that rubs the educated British wrong? The salesman has to abase himself before his product, and in favor of it.

It may be that "Steer British" is not an attitude that can be exported any longer, and that, until it suffers a severe change, precious little else will be exported either.